TURNER, WHISTLER, MONET

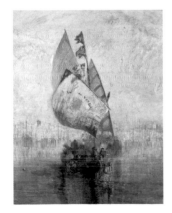

Publisher and Creative Director: Nick Wells
Development and Picture Research: Melinda Révész
Project Editor: Polly Willis
Editor: Sarah Goulding
Designer: Jake

Special thanks to: Chris Herbert, Geoffrey Meadon, Sara Robson, Helen Tovey, Claire Walker

FLAME TREE PUBLISHING
Crabtree Hall, Crabtree Lane
Fulham, London, SW6 6TY
United Kingdom

www.flametreepublishing.com

First published 2005

07 08 06

5 7 9 10 8 6

Flame Tree is part of the Foundry Creative Media Company Limited

The CIP record for this book is available from the British Library.

ISBN 1 84451 257 6

Every effort has been made to contact copyright holders. We apologize in advance for any omissions
and would be pleased to insert the appropriate acknowledgement in subsequent editions of this publication.

While every endeavour has been made to ensure the accuracy of the reproduction of the images in this book,
we would be grateful to receive any comments or suggestions for inclusion in future reprints.

Printed in China

TURNER, WHISTLER, MONET

Author: Tamsin Pickeral Foreword: Michael Robinson

J. M. W. Turner, The Sun of Venice Going to Sea

**FLAME TREE
PUBLISHING**

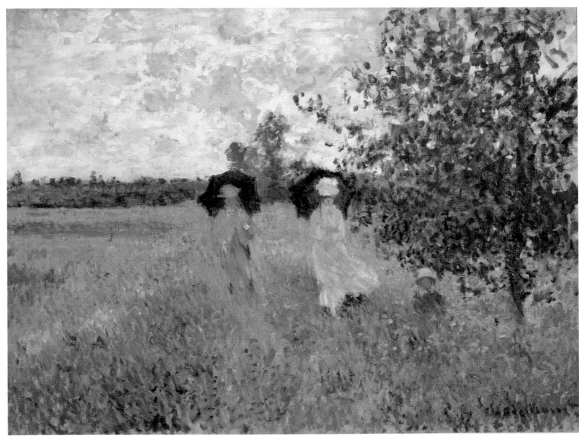

Claude Monet, Promenade Near Argenteuil

Contents

J. M. W. Turner, The Angel Standing in the Sun; James Whistler, The Storm – Sunset; Claude Monet, Impression: Sunrise, Le Havre

J. M. W. Turner, Petworth House: Figures In The White Library, Possibly Lord Egremont; James Whistler, Arrangement In Grey And Black No. 1: Portrait Of The Artist's Mother; Claude Monet, The Dinner

J. M. W. Turner, Venice: San Giorgio Maggiore at Sunset, from the Hotel Europa; James Whistler, Nocturne in Blue and Silver: The Lagoon, Venice; Claude Monet, San Giorgio Maggiore, Venice

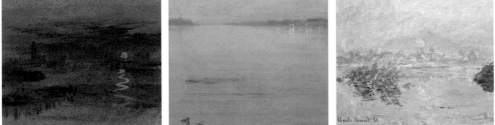

J. M. W. Turner, The Scarlet Sunset; James Whistler, Nocturne: Blue and Silver – Cremorne Lights; Claude Monet, Sunset

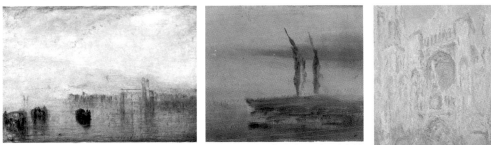

J. M. W. Turner, Returning from the Ball (St Martha); James Whistler, Nocturne: Blue and Gold, St Mark's, Venice; Claude Monet, Rouen Cathedral, Effects of Sunlight, Sunset

How To Use This Book

The reader is encouraged to use this book in a variety of ways, each of which caters for a range of interests, knowledge and uses.

- The book is organized into five sections: **Life**, **Society**, **Places**, **Influences** and **Techniques**.
- **Life** broadly covers the lifetimes of Turner, Whistler and Monet, providing a snapshot of how they and their work changed during the course of their careers.
- **Society** shows how the wider world in which they lived had a bearing on their work, and explores their different interpretations of it.
- **Places** looks at the different geographical locations in which they lived and worked, and how their feeling about a place is represented in their work.
- **Influences** reveals who and what provided the greatest influence for each painter, and how they in turn were a source of inspiration and ideas for one another.
- **Techniques** delves into the different techniques used by the three. Always experimental, they often had to come up with new ways in which to express themselves on canvas.
- The text provides the reader with a brief background to the work, and gives greater insight into how and why it was created.

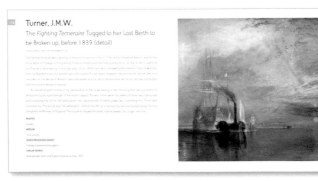

2. Name of artist, by surname then forename

3. Date of painting (if known)

1. Title of work

130 Monet, Claude

Promenade near Argenteuil, 1873

9. Picture credit

4. Information about the work and the context within which it was created

8. Location the work was created (if known)

7. Medium in which the work was created (if known)

6. Series, period or movement to which the work belongs (if known)

5. Other works, either from the same or other artists, with similar styles, techniques or subject matter.

Foreword

"I never saw an ugly thing in my life." John Constable

Set against the background of a burgeoning Industrial Revolution in England and its blight on the landscape, this comment, made in the early nineteenth century, was based on the Constable's vision of an alternative Arcadian landscape, a vision that the artist never deviated from. His contemporary, J.M.W. Turner, however, actually embraced aspects of the modern industrial world in his depictions of the English landscape. For him, industrialisation and its resultant pollution was an aesthetic challenge, an opportunity to capture the transient effects of light and inclement weather on the industrial landscape. This book examines that challenge, by Turner, and also by two other nineteenth-century artists who shared a deep admiration for him, James Whistler and Claude Monet. For all three, the urban landscape was every bit as beautiful.

Turner's early work was almost entirely in watercolour, through which he learned to suffuse colour in his paintings, creating an expression of the ethereal qualities of nature. This development of the late eighteenth-century Sublime aesthetic became Turner's hallmark as his paintings became increasingly Romantic. Although he continued to work in watercolour throughout his life, his oil paintings, with their meticulously built-up glazes, are imbued with the same visual effects. An inveterate traveller, Turner's continual trips to the Continent from the early 1800s increased his awareness of the fleeting nature of light, and from the 1820s onwards, his paintings become less concerned with subject matter and more about light and its effect on the landscape, particularly the urban landscapes and harbours of Britain, Italy and France. His late works are still among the most poetical and spiritual landscape paintings ever produced, and at the time of his death in 1851, there was no natural successor to his genius.

Whistler began his career as a Realist painter in the style of the French artist Gustave Courbet, but in 1871 he began a series of Nocturne paintings of London's River Thames. Like Turner, Whistler became less interested in the motif as subject matter and more as a pretext for exploring the atmosphere of a location. A seasoned traveller himself, Whistler extended his range of motif, recreating the atmosphere of other urban locations as disparate as Venice and

Valparaiso. What he took from Turner, was the use of a coloured ground to enhance the paint colours that create the industrial landscape's vaporous atmospheres. As he later recalled in his Ten O' Clock lecture, the factory chimney became his *campanile*. His approach to these paintings, which were devoid of anecdote, led to his declaration of an 'art for art's sake' in which paintings need fulfil no other function than to provide aesthetic pleasure.

Like Whistler, Monet was also in awe of Turner's gifts of creating atmosphere in a painting. During his brief exile in London during 1870–71, Monet became familiar with Turner's work at the National Gallery. Over the next 30 years Turner's influence on Monet became more pronounced, with a heightened use of colour for atmospheric effect particularly during his series paintings of the 1880s and 1890s. But it was during a further visit to London at the turn of the century that Monet's painting adopted the vaporous atmosphere synonymous with Turner, in his paintings of the Thames. Monet positively revelled in the atmospheric effect of London's fog, the grey mist and a barely visible sun, that fostered a tonal unity in these pictures. He too eschewed topographical detail in favour of the essence of a place.

Although *Turner, Whistler, Monet* is a potted history of three extraordinary individual talents within their respective social milieus, the book also assesses their contribution to landscape painting in the round, since between them they changed the criteria for assessing the discipline. The architect of this change was Turner, who introduced a number of key innovations for viewing and painting landscape. An example was the depiction of the urban landscape from water level, a characteristic adopted by Whistler and Monet, in deference to Turner. What they all shared was an embrace of the modern, in its depiction and in the development of a new painting technique to express such modernity. Their progress toward the elimination of detail in favour of mood and sensation clearly anticipates twentieth-century abstraction. It was the beginning of the modern movement in painting that saw a move away from academic painting to one in which Charles Baudelaire's *Heroism of Modern Life* was celebrated. What *Turner, Whistler, Monet* shows is that the worldly knowledge of these three artists was based on their sensations alone. For them the nineteenth century was not just an Arcadian dream.

Michael Robinson, *2005*

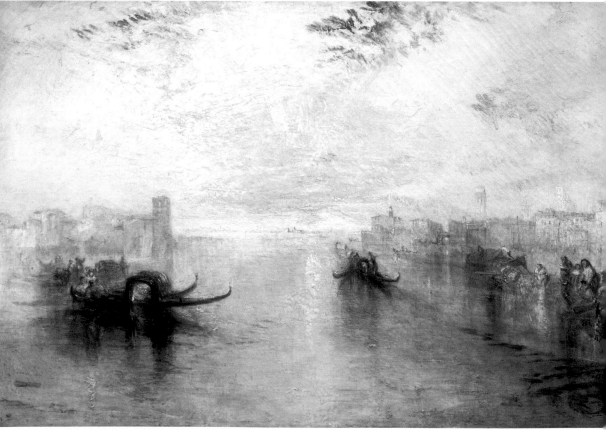

J.M.W. Turner, St Benedetto, Looking towards Fusina

Introduction

Three different countries; the dawn of industrialism, the ravages of war, new inventions, architectural endeavours and the generation of modern society, and against this background shines the brilliance of three artistic giants. Turner, Whistler and Monet preside over their own unique vision of the world around them. They were three creative wheels turning in different machines, and yet the cogs of artistic development inevitably overlap. Turner, who was born in 1775, died in 1851, the year in which Monet was an 11-year-old boy drawing caricatures of his school teachers in France, and Whistler was 17, a young man entering the military academy at West Point in America. Decades separated Turner from Whistler and Monet, and geography divided them, but as progress gathered speed through Turner's lifetime and the steamboats and trains roared into being, the world became a smaller place.

Turner the man, is an elusive figure who hovers on the peripherals of his paintings and sketches. He was hugely prolific during his life, and apart from his exhibition oils and watercolours, has left a legacy of sketchbooks and drawings done during his extensive travelling. His work leaves us with volumes of information about his painting, his techniques and his influences, but little about his essential being. What is clear is that there was the public Turner and the private man, and his work falls into two categories that reflect this. Those that were executed to be exhibited, and those works never intended to be seen. It is the latter of the two, seen in his sketches and watercolour drawings that capture the passing moment for us. He uses a freedom of expression that conveys the scene around him in the most impressionistic manner. As he neared the end of his life the disparity between the techniques in his highly finished exhibition pieces and his private sketches drew closer and closer, perhaps best demonstrated in *Rain, Steam, Speed*, first exhibited in 1844.

Turner, unlike Whistler or Monet, was closely connected with the Royal Academy, an institution that played a central role within his life. As he was accepted, and became integral to the Royal Academy, so Whistler and Monet struggled for recognition from such lofty artistic bodies. No reference to Turner is, of course, complete without mentioning the name John Ruskin. Ruskin was one of Turner's greatest advocates. His admiration for the artist, and his perception of Turner's art shaping his art criticism as a whole, formed the basis for the stout five-volume tome of *Modern Painters*. Ruskin did not, however, always interpret Turner's work quite as the artist would have liked, and this

caused some tension in the relationship. As Ruskin was Turner's champion, he was Whistler's nemesis. The Whistler/Ruskin lawsuit brought about the artist's financial ruin, and severely damaged his patronage. The debonair Whistler bounced back, and later retaliated with his famous Ten O'Clock lecture delivered in 1885.

The age of Romanticism was in full swing during Turner's life, and his work is closely associated with the terms: sublime, Romantic, picturesque and colourist. The grandiose ruggedness of the Swiss Alps particularly enthralled Turner, as did the beauty of Italy, especially Venice. These, along with lakes, the sea and boats, were a constant source of inspiration for him, and Monet also returned again and again to these themes. The quiet, shimmering light of Venice was captured by both artists using different techniques; Monet would go on to paint the canals in Amsterdam, the river Seine, the sea and perhaps most famously of all, his pond at Giverny. It is interesting to note that for a short period between 1805 and 1810 Turner painted from a small boat on the Thames, producing a number of fresh, Impressionistic works most comparable to John Constable's oil sketches. Many years later Monet would paint from his studio boat, floating along the Seine around Argenteuil, and recording the surrounding countryside under different weather conditions and at different times of the day. Whistler, too, took to the water, and was rowed up the Thames at night by the Greaves brothers. He would sketch the sleeping river and city and then return to his studio and produce his series of Nocturne paintings, the most magical and atmospheric of his works.

It is Turner's quality of reinvention that makes him so outstanding for his time. He could move effortlessly between oils and watercolours, paint Classically inspired landscape scenes such as *The Festival Upon the Opening of the Vintage at Macon*, in 1803, and follow it with the sublime *Shipwreck* two years later. The Dutch seventeenth-century painters, especially Van de Velde and Albert Cuyp were an inspiration to him, seen in *Tabley, Windy Day*, 1808, but just as easily he could turn to fantastical, mystical pieces such as *Death on a Pale Horse*, and *Angel Standing in the Sun*, 1846. Around 1830 he painted *Fire at Sea*, which depicted man in an eternal – and futile – struggle with the elements, and the pre-eminently peaceful *Evening Star*, two totally different pictures in mood and feel. Turner's treatment of subject matter, his handling of paint and his expression of mood, be it terror or repose, paved the way for succeeding artists to further expand their creative signature.

Whistler was the consummate cosmopolitan, American by birth, fluent in French, and circulating within English and French groups of artists, poets and intellectuals. He lived mainly in London, but spent much of his time in France where he enjoyed the company of Henri Fantin-Latour, Alphonse Legros and later the Symbolist poet Stéphane

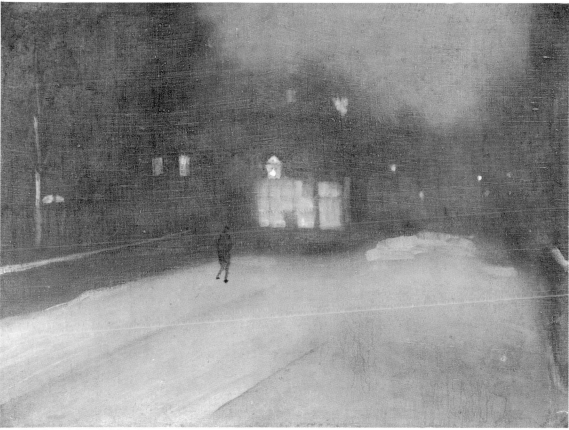

James Whistler, Nocturne in Grey and Gold: Chelsea Snow

Mallarmé. In England he was in contact with the Pre-Raphaelites, Dante Gabriel Rossetti, John Everett Millais and William Holman Hunt. Whistler was the ultimate in cross-cultural synthesis, working at first towards an aesthetic culmination through the realist trends of Gustave Courbet, the decorative elements of Oriental art and the arrangement of Diego Velásquez. He later rejected Courbet and turned instead to Jean-Auguste-Dominique Ingres, the Classical revivalist, for inspiration. Whistler would become a bridge between the theories of realism and the idealism of 'arts for art sake'. The decorative element of his art was paramount, but was always within a recognisable landscape. Whistler's vision of art was similar to Oriental traditions where the painting itself is part of the larger aesthetic whole; the frame, the walls behind the painting, the room itself. He often designed his own picture frames, and sometimes designed the dresses for his female portraits. His decorative skills were given the ultimate showcase in F. R. Leyland's Peacock Room: an exquisite artistic achievement. Where Whistler found the influence of Oriental art in his approach to decorativeness, Monet derived a form of naturalism from Japanese prints, especially those of Hokusai.

Turner's personal life remains shadowy, in contrast to Whistler's which is wonderfully recorded, even down to the incident when he threw his brother-in-law, Francis Seymour Haden, through a plate glass window after a disagreement.

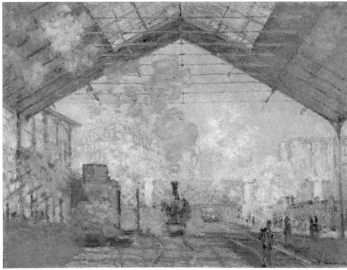

Claude Monet, The Gare, St. Lazare

The dandy and eccentric Whistler would seem at odds with Monet, but the two were friends and stayed with each other on more than one occasion. As the British art establishment had rejected Whistler, Monet and the Impressionists were systematically rejected and ridiculed by the French Salon. Had it not been for the concerted efforts of the art dealer Paul Durand Ruel, the Impressionists would have struggled to keep afloat. By the end of Monet's life however, he had finally achieved the financial security that had so haunted him through his career.

'I have always had a horror of theories; my only virtue is to have painted directly in front of nature, while trying to depict the impressions made on me by the most fleeting effects.' Spoken by the father of Impressionism, Monet. He spent the last decades of his life exploring the relationship of colour to light, working with a dedication and single aim that is humbling in its enormity. His later series paintings, those of the poplars, the haystacks, London, Rouen and the waterlilies, were the result of hundreds of canvases, hours of work and endless self criticism and doubt. The work of the Impressionist painters, notably, Monet, Auguste Renoir, Camille Pissarro, Alfred Sisley and Berthe Morisot, has widely been accepted as the forerunner of Modern art, manifested through Neo-impressionism, Fauvism, Cubism and Abstract art. Much as Monet had 'a horror of theories', it was his use of colour, and the theories of contrasting colours that formed the basis for his painting. Paul Cézanne said late in his life, 'I was very pleased with myself when I discovered that sunlight cannot be reproduced, but that it must be represented by something else – by colour.' This perfectly encapsulates Monet's later work.

James Whistler, St Ives

Turner opened the doors for the development of new approaches to art, through which stepped Whistler and Monet. The formal arrangement of Whistler's pictures into a cohesive aesthetic whole, and his paring down of elements and colour to produce a harmony of expression were second to none. In turn, Monet's brilliant use of colour to evoke light, reflections, atmosphere and depth through water provided the foundations for the emergence of Modern art.

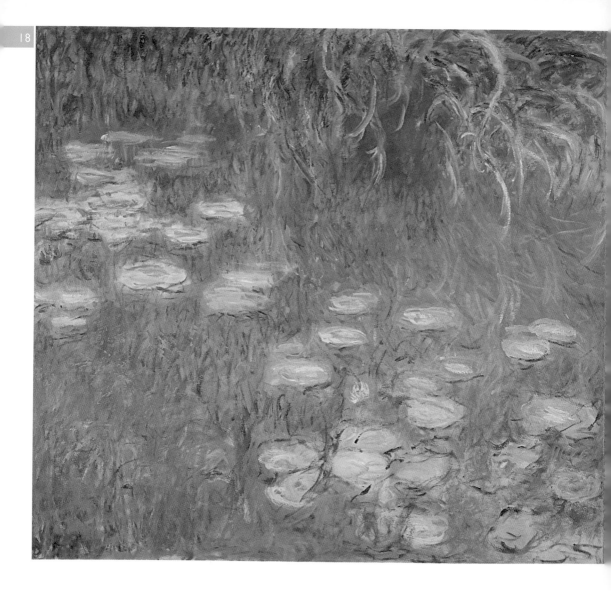

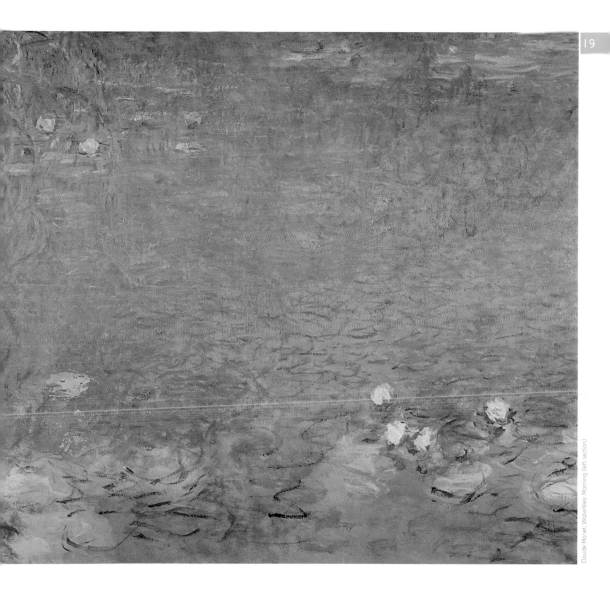

Turner, Whistler, Monet

Life

Turner, J. M. W.

Fishermen at Sea, exhib. 1796

Joseph Mallord William Turner was born in 1775, the son of a London barber, and grewup in the hubbub of the Covent Garden area. He first experienced the countryside at the age of 10, when he lived temporarily in Brentford. During his life he travelled across Britain and Europe absorbing the landscape and scenery, filling hundreds of sketchbooks. He first studied drawing with Thomas Malton Jr., an architectural draughtsman, and was accepted as a student at the Royal Academy (RA) in 1789.

His extraordinary artistic talent was quickly recognized and in 1796 he sent 10 watercolours, and his first oil painting, *Fishermen at Sea*, to be exhibited in the annual RA exhibition. The picture was well received, and his use of 'natural and masterly' colour, and effective rendering of moonlight on water, was duly noted by the critics. This early work shows the influence of the popular marine paintings of Philip James de Loutherbourg (1740–1812), Claude Joseph Vernet (1714–89) and Joseph Wright of Derby (1734–97), but already Turner was adding a new dimension through his subtle use and treatment of light. The picture's turbulent fishing boat rolls before the Needles off the Isle of Wight, an area that Turner had visited the year before. *Fishermen at Sea* is an early indicator of his scientific interest in the play of light on atmosphere and the nuances of colour and tone that would become central to his later works.

PAINTED

London

MEDIUM

Oil on canvas

SERIES/PERIOD/MOVEMENT

Sublime

SIMILAR WORKS

Barges at Flatford Lock John Constable, 1810

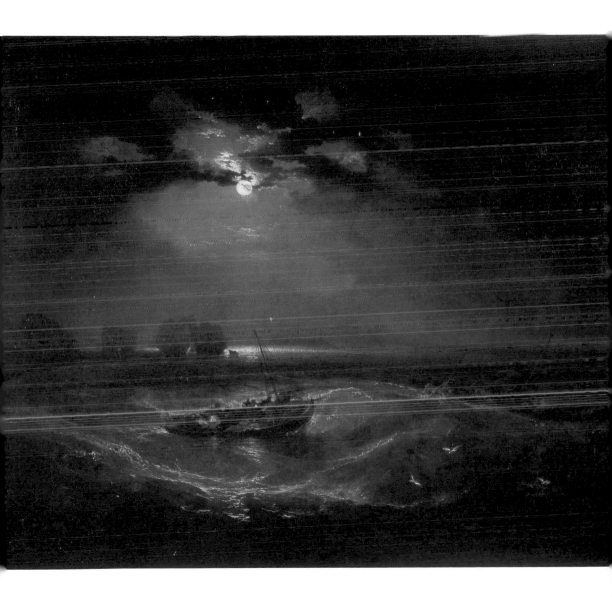

Turner, J. M. W.

Study of Seated Male Nude, Raised Left Arm, Holding a Staff, 1798

At this time Turner was still living at home, although it was far from a happy one. His mother suffered from mental illness, resulting in violent tantrums, and his parents' marriage was clearly turbulent. Turner bitterly resented his mother, but formed a close relationship with his father, especially after his mother was hospitalized in a mental institute. This early traumatic home environment doubtlessly coloured Turner's own approach to relationships and life in later years. He was notoriously independent, never married, and kept his affairs clouded in secrecy.

As a student of the RA Turner would have worked in the Plaister Academy, drawing from casts, then progressing on to life models. Records show that he attended life classes on an irregular basis until 1799, which demonstrates his will to learn and improve, especially in a genre outside that in which he excelled – namely landscape.

This study of a seated male nude is a technical piece with some awkwardness in form and perspective. However, already Turner's handling of colour, the soft tonalities and the play of light and dark are starting to evolve as a precursor to his later mastery and innovativeness.

PAINTED

London

MEDIUM

Paper, unique

SERIES/PERIOD/MOVEMENT

Life drawing, early

SIMILAR WORKS

A Shipwreck (Male Nude) Theodore Gericault, 1817

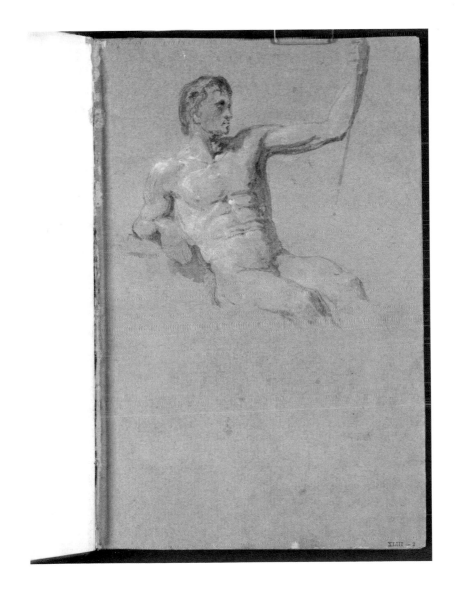

Turner, J. M. W.
Self Portrait, *c.* 1799

By 1799 Turner had more commissions than he could execute and, together with Thomas Girtin (1775–1802), had developed a distinguished early watercolour style. Both Turner's and Girtin's work would have been influenced by the watercolours of John Robert Cozens (1752–97), whose work John Constable (1776–1837) described as 'all poetry'.

In the same year Turner stood for election as an Associate of the RA. He was accepted and was the only Associate to be chosen in 1799. Around the same time he met the actress Sarah Danby, who became his mistress and is believed to have been the mother of two of Turner's children, although they never married. During this period he moved to Harley Street in London, an area that was fashionable and burgeoning, sharing his accommodation with John Thomas Serres (1759–1825), the marine painter.

His self-portrait of 1799 shows a confident, well-heeled artist, a far cry from his early life in Covent Garden. His *Self Portrait* owes a debt to the Dutch school of Old Masters and is a sombre, yet determined reflection of the artist about to take the art world by storm.

PAINTED

London

MEDIUM

Oil on canvas

SERIES/PERIOD/MOVEMENT

Self-portrait

SIMILAR WORKS

Thomas Girtin John Opie, *c.* 1800

Self Portrait Thomas Gainsborough, 1759

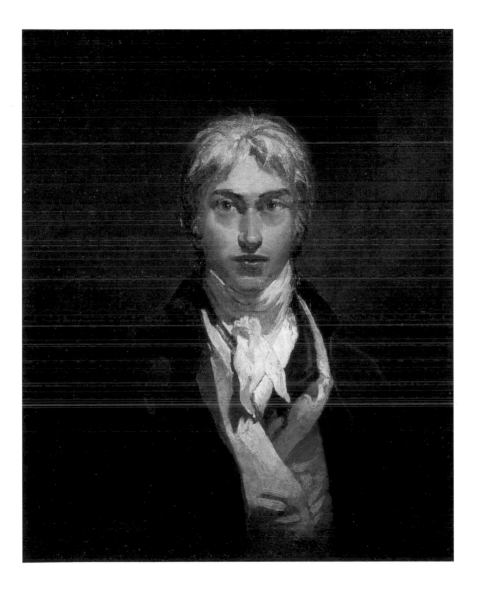

Turner, J. M. W.

From Liber Studiorum, Norham Castle on the Tweed, c. 1806

In 1802 Turner was elected as a full Royal Academician and changed his signature from W. Turner, to the eloquently grandiose, J. M. W. Turner RA. In 1804, Turner opened his own gallery, and by 1806 Turner had travelled extensively across Britain, seeming to favour the North, and had visited Paris and the Swiss Alps. In the autumn of 1806 Turner stayed with William Frederick Wells (1762–1836), the notable watercolourist, at his house at Knockholt and it was at his behest that Turner embarked on the *Liber Studiorum*. 'The book of studies' evolved into a huge collection of watercolours and engravings, a project that Turner worked on over a period of 20 years or more. It was intended to publish the *Liber* engravings in 20 instalments of five plates. Each plate underwent a complicated process of production with the majority of them being based on watercolour designs by Turner, from which his engravers could work.

Norham Castle was one of the castles that he visited frequently, and drew and painted often. It provided him with the perfect picturesque subject matter that was so popular at the time. The precise use of line within the picture was typical of Turner's early watercolour style, as is the perfect harmonious balance of the composition.

PAINTED

London

MEDIUM

Watercolour on paper

SERIES/PERIOD/MOVEMENT

Liber Studiorum

SIMILAR WORKS

Morpeth Bridge Thomas Girtin, 1802

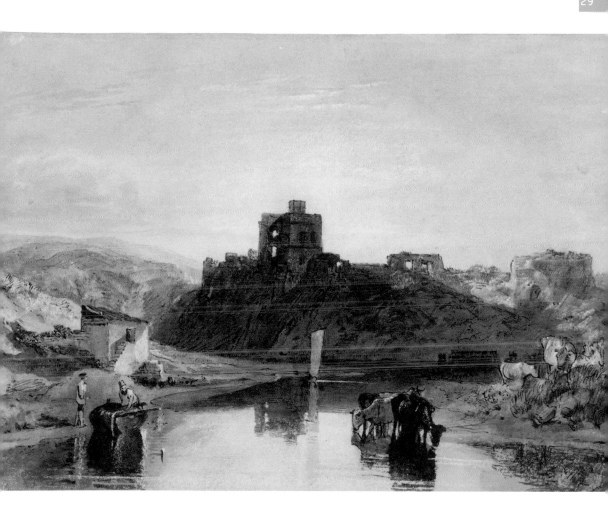

Turner, J. M. W.

From Liber Studiorum: Marine Dabblers, c. 1808

The first part of the *Liber Studiorum* was published in June 1807 and in the November of the same year Turner was elected as Professor of Perspective at the RA. This was a prestigious honour and one that Turner greatly valued. He even on occasion added the initials P. P. to the end of his growing signature. He retained the rank of professor until he retired from the role in 1837. Despite Turner's increasing acclaim, he was however met with steady hostility from some camps, most notably that of Sir George Beaumont (1753–1827), a wealthy baronet who was a benefactor of the National Gallery and a landscape artist in his own right.

The Marine Dabblers, 1808, was one of the plates that appeared in part VI of the Liber series and was published in June 1811. Also in this edition was the etching, *Junction of Severn and Wye*, which is significant as being the first plate that Turner drew, engraved and etched himself, and is widely thought to be one of the finest Liber plates. *Marine Dabblers* is an energetic beach scene with an interesting spatial arrangement. The foreground is imposing and dominates the composition, creating a shallow progression through the picture.

PAINTED

London

MEDIUM

Pen and ink and watercolour on paper

SERIES/PERIOD/MOVEMENT

Liber Studiorum

SIMILAR WORKS

A View on the Stour near Dedham John Constable, 1822

A Harbour David Cox, date unknown

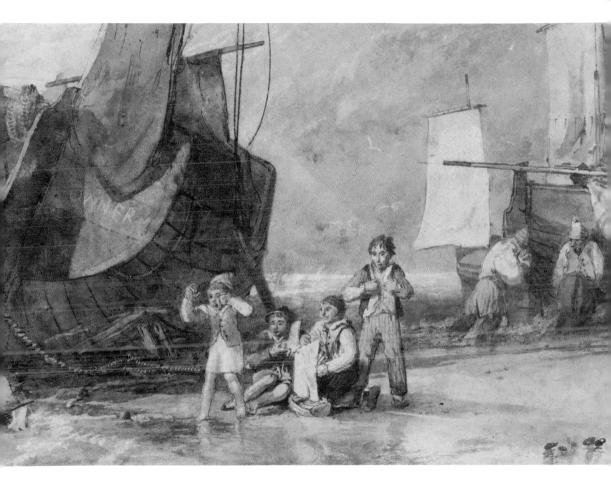

Turner, J. M. W.

Basic Perspective Construction of a House, Lecture Diagram 36, c. 1810

January 1811 saw the first of a series of six perspective lectures delivered by Turner as the new Professor of Perspective at the RA. Part of his commitment as Professor was to present six lectures a year. These were to discuss the principles of linear and aerial perspective and basic geometry, in terms that were readily understood. He produced over 200 diagrams and drawings to illustrate his lecture, of which *Basic Perspective Construction of a House* is one. Over the course of the years Turner revised and rewrote many of his lectures and there are now over 40 scripts for lectures surviving, most of which are in the British Library.

Turner had studied perspective extensively as a young artist under the guidance of his early mentor Thomas Malton Jr. and had a clear and in-depth understanding of the major principles involved. Thomas Malton Sr. was the author of one of the most comprehensive studies of perspective written in the eighteenth century and undoubtedly Turner would have read this. Turner had also spent some time working as a draughtsman for the architects James Wyatt and Thomas Hardwick.

PAINTED

London

MEDIUM

Pencil and watercolour on paper

SERIES/PERIOD/MOVEMENT

Perspective lecture diagrams

SIMILAR WORKS

Section of the Rotunda, Leicester Square Robert Mitchell, 1801

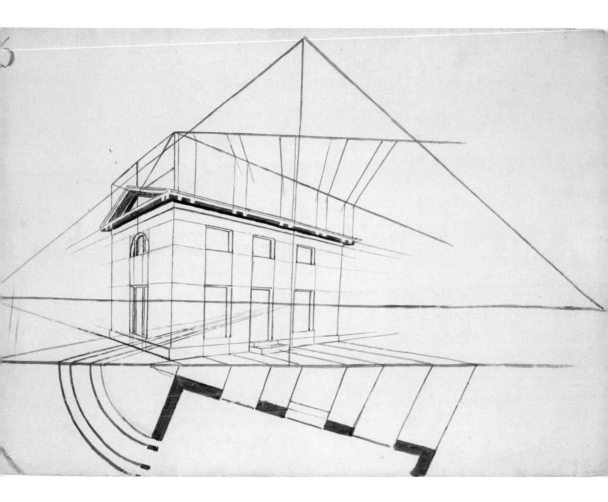

Turner, J. M. W.

Snow Storm: Hannibal and his Army Crossing the Alps, exhib. 1812 (detail)

Turner had purchased a plot of land in Twickenham in 1807 and in 1812 building began there on Sandycombe Lodge, Turner's own home that he designed during the period of his perspective lectures at the RA. That same year he exhibited his dramatic oil painting, *Snow Storm: Hannibal and his Army Crossing the Alps*, which was well received by the critics. This painting is one of the first examples of Turner turning traditional compositional elements on their head. He has concentrated the spatial organisation in a circular, as opposed to horizontal and vertical arrangement, and this was a technique that he would increasingly return to. The depth and gravity of the storm far overshadows the depravity occurring in the foreground, so that which would conventionally be the focus of the painting's subject, becomes secondary to the power of nature. Turner's depiction of the storm and the strange eerie light of the wet, blown, atmosphere was based on an actual storm that he experienced while staying in Yorkshire with his close friend Walter Fawkes, the politician and landowner.

PAINTED

London

MEDIUM

Oil on canvas

SERIES/PERIOD/MOVEMENT

Sublime

SIMILAR WORKS

The Storm Diaz de la Peña, 1871

An Avalanche in the Alps Philip James de Loutherbourg, 1803

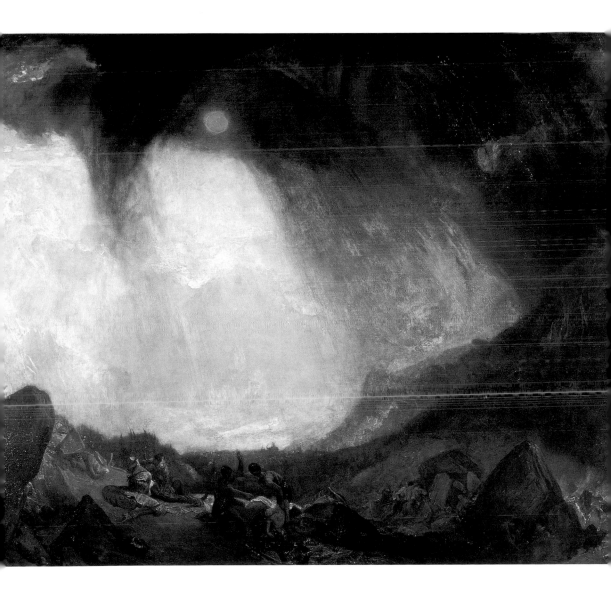

Turner, J. M. W.

From Como and Venice Sketchbook, Venice: The Punta della Dogana, with the Zitelle in the Distance, 1819

© Tate, London 2005

Turner made a brief trip to Belgium in 1817, and then to Holland and the Rhine Valley in 1818. In 1818 he was commissioned by the publisher John Murray to complete a series of watercolours for engravings based on drawings made by James Hakewill (1829–98) during his Italian tour in 1816 and 1817. The comparison of Turner's watercolours made for Hakewill, with those done for himself after his first trip to Italy in 1819 is extraordinary. The stiffness of the Hakewill copies is gone completely and the four watercolours that Turner produced from his trip to Venice are amongst some of his finest work. Venice, which had long been inspirational to artists, poets and writers, was an enlightening experience for Turner. His appreciation of the luminosity, the light reflected from buildings to water and back, and the beauty of the then decaying city, was enormous. Venice would become central to the development of Turner's later style. His first trip to the city was short, but he made detailed drawings that were later worked into paintings, and he also painted the four watercolours. These paintings appeared in his Como and Venice sketchbook on consecutive pages and show Turner's brilliant handling of light and delicate use of muted colour to evoke the atmosphere of the scene.

PAINTED

Venice

MEDIUM

Watercolour on paper

SERIES/PERIOD/MOVEMENT

Venice

SIMILAR WORKS

View from Isola Borromea, Lake Maggiore J. R. Cozens, c. 1783

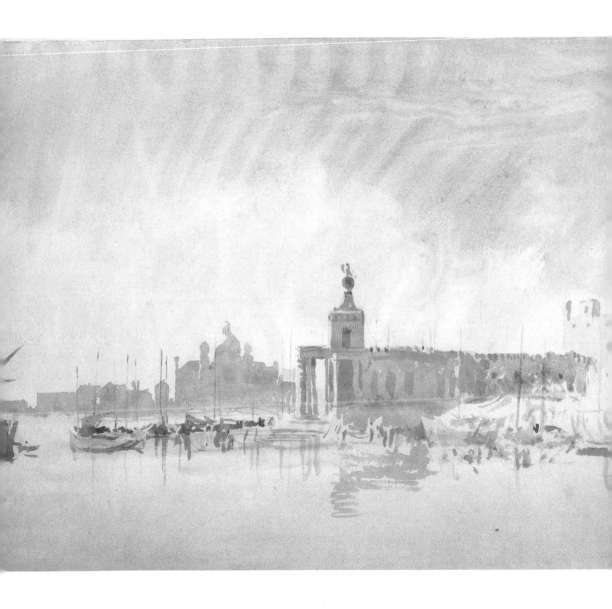

Turner, J. M. W.

Brighton Beach, with the Chain Pier in the Distance, from the West, c. 1827

Brighton was an up-and-coming town that appealed to the bourgeois and was benefiting from improved transport and facilities. It was rapidly becoming the favourite seaside venue for Londoners on holiday, and was undergoing a sustained building and renovation programme. The new Marine Parade was built, as was the Prince Regent's Pavilion, and in 1823 the Chain Pier was finished. Turner produced several paintings of Brighton from the early 1796 watercolour, *Brighthelmstone*, which depicted the town as the fishing village it was, to the oil painting, *Brighton on Sea, c.* 1828 commissioned by Lord Egremont. Constable painted a similar view to that seen in Turner's watercolour, *Brighton Beach, with the Chain Pier in the Distance from the West*. It is thought that Turner's picture may have been painted in response to Constable's, which was hung in the RA in 1827. Constable was not overly impressed with the burgeoning town and referred to it as 'Piccadilly by the seaside'. In this particular oil, Turner focuses on the energy of the fishing boat and the rolling movement of sea and sky, rather than the new Chain Pier which can just be made out in the distance.

PAINTED

Brighton

MEDIUM

Oil on canvas

SERIES/PERIOD/MOVEMENT

Brighton

SIMILAR WORKS

Beach at Brighton, The Chain Pier in the Distance John Constable, 1827

Sailing Boats on Southampton Water John Linnell, 1819

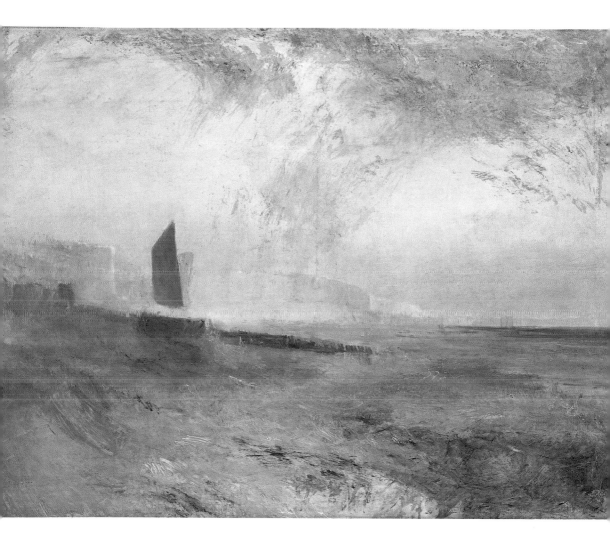

Turner, J. M. W.
Chichester Canal, *c.* 1828 (detail)

Walter Fawkes, one of Turner's greatest friends and patrons, died in 1825 and four years later the artist's father died. Lord Egremont (1751–1837), another of Turner's patrons invited him to his country estate, Petworth, which was to become the regular haunt of Turner over the years. He was provided with his own room in which to paint, and he embarked on a series of canvases designed to fit into panels in the Petworth dining room (the Carved Room). Lord Egremont had first purchased work by Turner in 1802, although there are two watercolours by Turner of the Petworth Church that date back to 1792, indicating a long affinity between the artist and Lord Egremont. Petworth was home to an impressive collection of art, both Old Masters and works from contemporary artists, and would have provided Turner with a valuable reference library of masterpieces. Lord Egremont himself lived a colourful life and was reputed to have 43 children who all lived at Petworth with their mothers. This seems highly unlikely, but is an indication of the frivolity and enthusiasm that the house was home to.

Lord Egremont had some financial interest in Chichester Canal, which was opened in 1822, and remained an investor until 1826. This study for the final oil on canvas is beautifully worked and compositionally appears much as the finished painting did. Turner made regular visits to Petworth from 1827 until the time of Lord Egremont's death in 1837.

PAINTED

Petworth House, Sussex

MEDIUM

Oil on canvas

SERIES/PERIOD/MOVEMENT

Series of panels for the Carved Room at Petworth House

SIMILAR WORKS

The Avon at Clifton Francis Danby, *c.*1821

Lincoln Cathedral from the River Peter De Wint, *c.* 1825

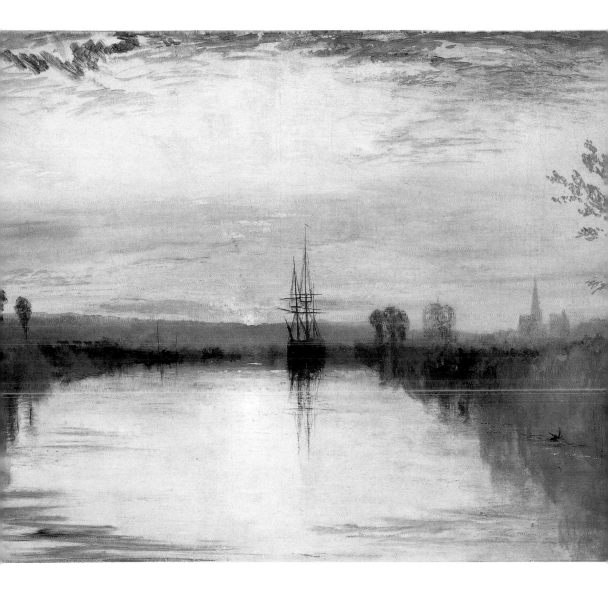

Turner, J. M. W.

The Burning of the Houses of Parliament, c. 1834–35 (detail)

On 16 October 1834 the Houses of Parliament went up in flames, an event that had a resounding impact on Turner, and when people flocked to the burning buildings in fascination, he was among them. It is not insignificant, as this was an area of London he had spent much of his childhood exploring, going up and down the Thames from his home in Covent Garden. The night of the fire Turner took his sketchbooks with him and finding a boat, sketched the scene from the river. His hasty sketches, done in pencil and in watercolour, were later used as a reference for two oil paintings of the scene.

The scene was the perfect subject matter for Turner, offering him the forum to paint those things that he loved the most, the effects of water, light, atmosphere and colour. The smoke and heat that he evokes in this watercolour is both acrid and hot to the viewer, and behind the haze he has captured the buildings precisely and finely through his careful use of line and form.

PAINTED

London

MEDIUM

Watercolour and gouache on paper

SERIES/PERIOD/MOVEMENT

The Burning of the Houses of Parliament sketchbooks

SIMILAR WORKS

Naples or Land of Smouldering Fire Alfred William Hunt, 1871

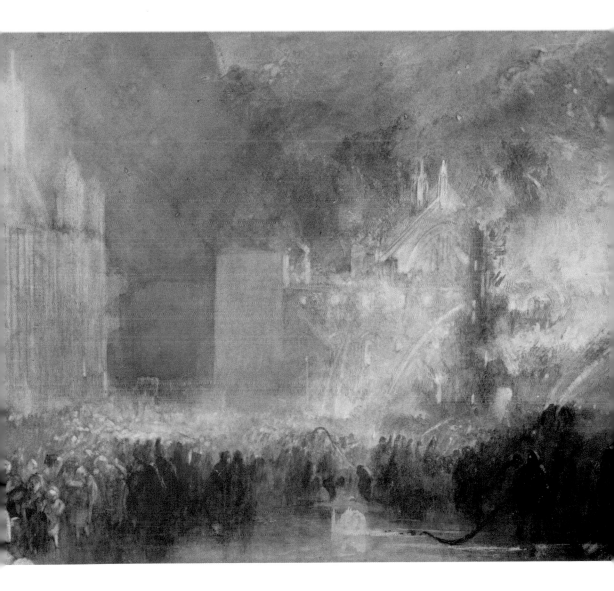

Turner, J. M. W.

Peace – Burial at Sea, exhib. 1842

Peace – Burial at Sea was exhibited at the RA in 1842 with the accompanying words from Turner's 'Fallacies of Hope',

> The midnight torch gleamed o'er the steamer's side
>
> And Merit's corse was yielded to the tide.

The painting was conceived as a memorial to Turner's friend and contemporary, Sir David Wilkie (1785–1841), who had died on board a ship on his way back from the Middle East in 1841. The critics were hostile to the unusual painting that has often been described as both Turner's most famous and least successful work. Chiefly up for reproach was the blackness of the ship and her sails, to which Turner replied, 'I only wish I had any colour to make them blacker.'. The dark tonality and funereal aspect of the painting does, however, succinctly indicate the purpose of the picture as a memorial. It is interesting to note the inclusion of a mallard, which is probably a reference by the artist to his middle name, and possibly indicative of the personal subject of this painting to Turner. It was exhibited next to *War. The Exile and the Rock Limpet*, a painting of Napoleon on St Helena executed in a predominantly red palette in direct contrast to that of *Peace*.

PAINTED

London

MEDIUM

Oil on canvas

SERIES/PERIOD/MOVEMENT

Memorial

SIMILAR WORKS

The Burial at Sea of Sir David Wilkie George Jones, 1842

Combat of the Kearsarge and the Alabama Edouard Manet, 1864

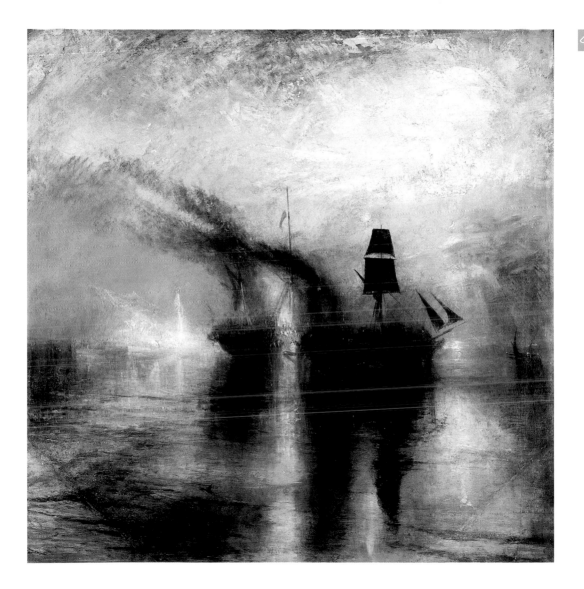

Turner, J. M. W.

The Angel Standing in the Sun, exhib. 1846

In his later years, Turner was looked after by Mrs Booth; a wealthy widow, whose acquaintance he had first made when lodging with her during his trips to Margate. The nature of their relationship was never made clear, although Turner took to calling himself Mr Booth, in an effort to remain somewhat anonymous. In 1846 Turner, Mrs Booth and her son, an engraver, moved to Davis Place, Chelsea. Increasingly in his old age Turner had been beset with pessimism. He never gained the knighthood and royal recognition that he deserved, while some of his contemporaries did, and this was to be a permanent thorn in his side.

Angel Standing in the Sun was exhibited at the RA in 1846 alongside *Undine Giving the Ring* to Massaniello. They were the last examples of Turner's pairing of contrasted pictures. Angel is a darkly morbid subject, symbolic of Turner's despair and journey towards death, but painted with brilliant luminosity creating a startling disparity of content and treatment. The painting calls to mind the work of William Blake (1757–1827) in its mystical tone and handling. Both this and *Undine* received mixed reviews, with Turner's once fiercest supporter, John Ruskin (1819–1900), describing them as 'painted in the period of decline'.

PAINTED

London

MEDIUM

Oil on canvas

SERIES/PERIOD/MOVEMENT

Late period

SIMILAR WORKS

The Arlington Court Picture (The Sea Of Time and Place) William Blake, 1821

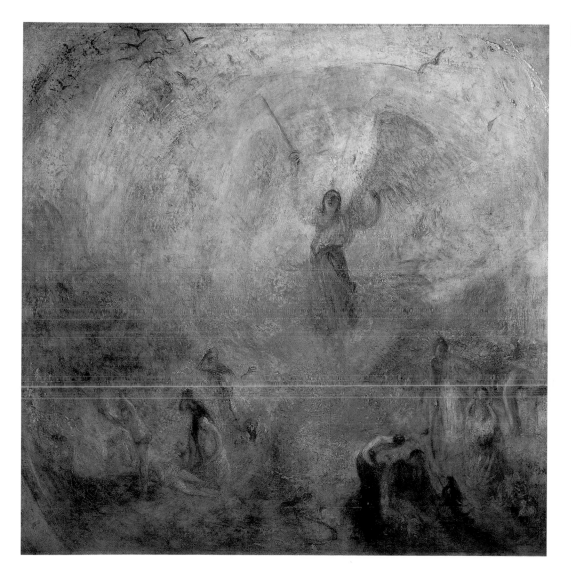

Parrott, William

J. M. W. Turner at the Royal Academy, Varnishing Day, c. 1846

John Ruskin was born into a different generation and came from a different social background from Turner, but became his greatest advocate. He finally produced *Modern Painters*, a staggering tome that focused on Turner's qualities as a painter. At the age of 17 Ruskin was already championing Turner's cause with his pen and it was a tradition that was to continue. Turner and Ruskin did not meet until 1840, as the artist was entering the last decade of his life, and the first volume of *Modern Painters* was published in 1843. For the last few years of his life Turner lived as a virtual recluse, and died on 19 December 1851. He was buried in St Paul's Cathedral.

William Parrott (1813–69) has captured the ageing artist, intent on applying the finishing touches to his canvas on varnishing day. Varnishing days were designated by the RA to allow members and associates to make alterations to their canvases after they had been hung in order to maximize their effect within the crowded hanging confines. There were generally three varnishing days allocated and Turner, allegedly, would use this time virtually to work up a canvas from little more than a sketch to the finished piece. The atmosphere at the RA was highly competitive and artists would consistently attempt to outshine neighbouring pictures with final touches to colour, tonality and effect.

PAINTED

London

MEDIUM

Oil on canvas

SIMILAR WORKS

Turner on Varnishing Day Thomas Fearnley, 1837

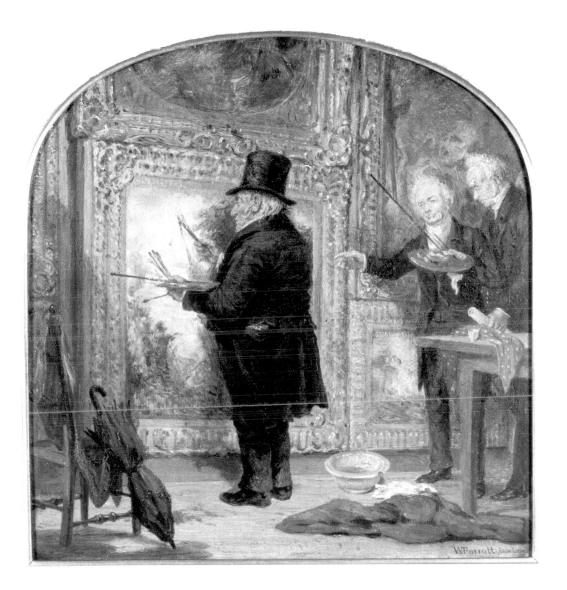

W.Parrott

Whistler, James

Ingres' Roger Deliverant Angelique, 1857

James Abbott McNeill Whistler was born in Lowell, Massachusetts, in 1834, the son of Major George Washington Whistler, a civil engineer. In 1842 Major Whistler was sent to Russia to work on the St Petersburg to Moscow railroad and was joined by his family in 1843. Whistler entered the Imperial Academy of Fine Arts in St Petersburg in 1844, where he received drawing lessons. The family returned to America in 1849 and in 1851 Whistler entered the prestigious West Point Military Academy. Whistler was very proud of his time spent here, even though he was discharged prematurely in 1854 due to poor academic achievements; he excelled in his art classes, however. The same year he took up a post in the drawing department of the US Coast and Geodetic Survey where he became accomplished at topographical drawing and etching.

Whistler arrived in Paris in 1855 and studied with the academic artist, Charles Gleyre (1808–74) who followed the tradition of the Neoclassical painter Jean Auguste Dominique Ingres (1780–1867). *Inges' Roger Deliverant Angelique, 1857*, was a copy by Whistler of the original Ingres painting. At this time there was a fashion for copying Old Masters and Whistler had been commissioned to produce his *Anglique* painting along with three others for a whaling captain. The *Anglique* picture was painted in a thin, transparent manner, but with the use of warmer, richer colours than the original. Whistler later commented that the thinness of paint was all he could afford due to the low price he was paid for his work.

PAINTED

Paris

MEDIUM

Oil on canvas

SERIES/PERIOD/MOVEMENT

Copy, Neoclassical

SIMILAR WORKS

Angelica Saved by Ruggiero Jean-Auguste-Dominique Ingres

Whistler, James
At the Piano, 1858–59 (detail)

This was Whistler's first 'great' artistic statement, which, despite being rejected by the Paris Salon in 1859, was subsequently hung in the studio of the still-life artist Françoise Bonvin (1817–87), where it received great acclaim and admiration from his fellow artists. When Whistler arrived in Paris, he was immersed in an artistic culture revolving around three great traditions: that of the Romantic colourist Eugène Delacroix (1798–1863), the Classical draughtsmanship of Ingres and the startling Realism of Gustave Courbet (1819–77). In 1858 Whistler, Henri Fantin-Latour (1836–1904) and Alphonse Legros (1837–1911) formed the Societé des Trois, dedicated to promoting and supporting their own work. *At the Piano* nods to both compositional elements and the handling of genre seen in Fantin-Latour's and Legros' work, suggesting a close artistic environment and sharing of ideas between the three. *At the Piano* was also clearly influenced by Diego de Silva Velásquez (1599–1660), and the traditions of the Spanish and Dutch school of painters would be drawn on again and again by Whistler.

At the Piano was far more than simply a compositional and colouristic exercise for Whistler. The piano player is Deborah Haden, Whistler's half-sister, and the girl is his niece, Annie Haden. Both figures are dressed in traditional Victorian mourning clothes and are caught in a studied moment of reflection and reverence.

PAINTED

Begun London

MEDIUM

Oil on canvas

SERIES/PERIOD/MOVEMENT

Realism

SIMILAR WORKS

Mme Manet at the Piano Edouard Manet, 1867–70

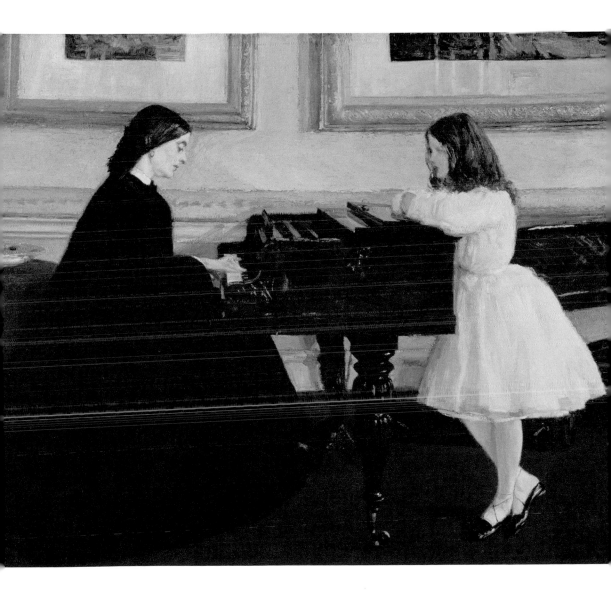

Whistler, James
Man Smoking a Pipe, 1859

Whistler returned to Paris via Dieppe at the beginning of 1859, having spent the winter in London. Although rejected by the Salon, *At the Piano* was highly praised by Gustave Courbet. Courbet had a significant influence on the young Whistler until in later years he moved away from Courbet's tradition. *Man Smoking a Pipe*, 1859, shows Whistler's influence by Courbet and again looks towards the tradition of the Dutch and Spanish school. A similar painting that makes an interesting comparison is Whistler's *La Mere Gerard, c.* 1855. Both pictures show his direct approach to the subject and similar treatment and handling of both faces.

It is thought that Whistler met the old man in his picture in Les Halles, where he was scratching a living selling crockery. Whistler has captured the man's life of hardship and weary tolerance with an extraordinary subtle perceptiveness. The painting belonged to Whistler's friend Charles Drouet (1836–1908) who bequeathed it to the Luxembourg Museum in Paris.

PAINTED

Paris

MEDIUM

Oil on canvas

SERIES/PERIOD/MOVEMENT

Realism

SIMILAR WORKS

Albert De Belleroche John Singer Sargent, 1882

Angelina Edouard Manet, 1865

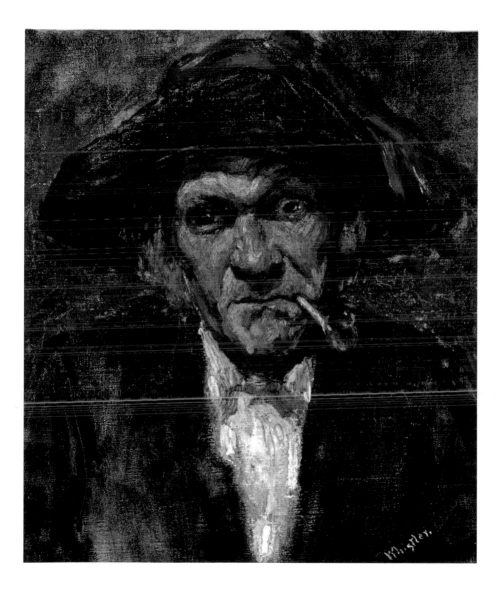

Whistler, James
Black Lion Wharf, Wapping, 1859 (detail)

In 1859 Whistler moved to London, although he spent the rest of his life making frequent trips back to France. He was a curious mixture, born an American, a fluent French speaker, and dividing his time between England and France. As a consequence his style was subjected to the influence of both the French Realists, headed by Courbet, and the English school of Sir John Everett Millais (1829–96), Dante Gabriel Rossetti (1828–82), William Holman-Hunt (1827–1910) and the British illustrators. During this early period he tended towards literary or narrative painting, in part a reflection of his work as an illustrator for the publication *Once a Week*. In London Whistler was encouraged by his brother-in-law, Francis Seymour Haden, to work from nature and to study the process of photography. Haden was a scientist, surgeon, amateur etcher and avid art collector, who inspired in Whistler a fascination for the theories of optics.

Black Lion Wharf, Wapping is from a series of engravings of the dock areas of London, which illustrate Whistler's fascination with the riverside working class. *The Thames* collection of engravings each depicts in careful detail the life and slow decay of London's industrial heart. The compositional element of broad horizontal planes and suggested verticals are again demonstrated, as Whistler's development of spatial realisation continued. The engraving combines extraordinary detail with suggested sketched elements, seen in the polarity between the resting dockworker at the front of the picture and the figures rowing.

MEDIUM

Etching on paper

PERIOD/SERIES/MOVEMENT

Thames Etchings, published in *Sixteen etchings of Scenes on the Thames and Other Subjects*

SIMILAR WORKS

Venetian Doorway and Gondolas Robert Frederick Blum, *c.* 1880

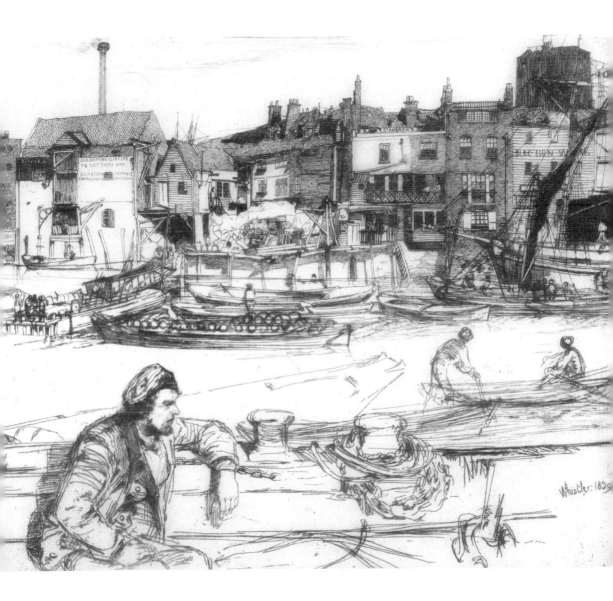

OLD SHIPPING CLIPPER
TO LET EVERY DAY
GLASGOW

ST ANDREWS

BLACK LION

Whistler. 1859

Whistler, James
The Last of Old Westminster, 1862

Whistler's depiction of the construction of the New Westminster Bridge captures the energy and excitement of a significant step towards London's emergence as a city of high industry and trade, but with the finest of touches. The details of men straining and labouring, the crowds gathering to watch, a hansom cab and carriage, suggest a hive of swarming activity that is dominated by the massive stillness of the bridge itself. Whistler demonstrates the keen attention to detail, perspective and linear accuracy, in line with his etching techniques that he learnt through his work in the Office of the Coast Survey in Washington, USA, as a young man. These were skills that would go on to form the foundation for his artistic development.

The title of the painting is something of a misnomer, since the Old Westminster Bridge had long disappeared. Whistler later referred to the painting as *The Westminster Bridge*, which would have been more accurate. The old bridge had been the subject of many painters, most notably Antonio Canaletto (1697–1768), who Whistler held in high regard. It is interesting that Whistler chose to depict the bridge in its still-unfinished state rather than waiting for the final unveiling. He hints at the grandeur to come by giving us just a glimpse of Thomas Page's design in the elegant pillar to the front of the composition that has had the scaffolding removed. The painting conveys the anticipation and excitement of the future, that of the New Westminster Bridge, but also perhaps Whistler's own vision.

PAINTED

London

MEDIUM & DIMENSIONS

Oil on canvas, 60.96 × 78.1 cm (24 × 30³/₄ inches)

PERIOD/SERIES/MOVEMENT

Westminster Bridge, series of three

SIMILAR WORKS

Old Battersea Bridge Walter Greaves, 1874

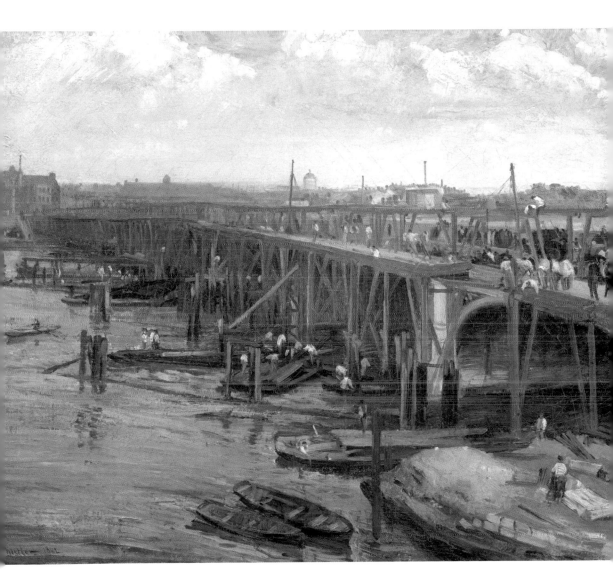

Whistler, James
Whistler in his Studio, 1865–66 (detail)

Whistler first met Rossetti and Algernon Swinburne (1837–1909) in 1862. The following year he moved near to Rossetti in Chelsea and through him met other members of the Pre-Raphaelite circle. Around the same time he took on two pupils, the Greaves brothers who were boat builders, and met E. W. Godwin, the architect whose wife he would later marry. By the end of 1863 Whistler was concentrating on his Oriental subjects and building his own collection of Japanese artefacts that would appear in his paintings. Back in Paris in April 1864 Whistler posed for Fantin-Latour's *Hommage à la Vérité: Le Toast* which was subsequently exhibited at the Salon with Whistler's *Rose and Silver: The Princess from the land of Porcelain*. Later that year Albert Moore (1841–93) replaced Legros as the third member of the Societé de Trois.

In 1865 Whistler had grand plans for the painting, *Whistler in his Studio*, which was to be a huge canvas depicting Whistler, Fantin-Latour and Moore in his studio surrounded by models in Oriental dress. The painting was conceived along the lines of Courbet's *The Painters Studio: A Real Allegory*, 1854–55, but was certainly never completed and is doubtful whether it was even started. However, two studies for the larger piece do exist. One of the two models is Jo Hiffernan, Whistler's Irish mistress, and the other is unknown. The sketchy lines and thin paint application show Whistler's artistic process, and the peculiar perspective handling of the mirror on the wall and the strong vertical emphasis of the painting elongates the figures.

PAINTED

London

MEDIUM

Oil on paper mounted on mahogany panel

SIMILAR WORKS

An Artist in his Studio Alfred Stevens, c. 1840–42

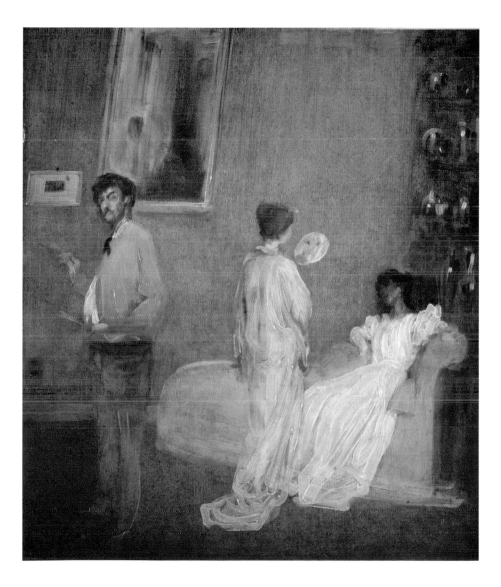

Whistler, James
Symphony in White, No. III, 1865–67

In 1855, a decade prior to Whistler's *Symphony In White, No. III*, Admiral Perry had been instrumental in opening Japan and from that time there had been a steadily increasing influx of all things Japanese to Europe. Whistler and many of his contemporaries became ardent collectors of Japanese art, artefacts and decorative elements, and these were increasingly evident in their work. Whistler embraced the Japanese culture of 'art' encompassing all aspects of display and decorum, to the extent that it was not only the painting itself that was the *objet d'art*, but the corresponding frame, the colour of the walls on which it hung and the room in which it was housed.

The figure on the left of the painting is Jo Hiffernan, Whistler's mistress and model of the period; that on the right is the professional model Milly Jones. The overriding decorativeness of the picture takes precedent from the subject and in turn becomes the subject, and in this way the two figures become a vehicle for Whistler's use of colour and atmosphere. The painting was greatly admired by his fellow artists and influenced both Edouard Manet (1832–83) in his *Berthe Morisot, Repose* 1870, and Edgar Degas (1834–1917) in his *Mlle Fiocre in the Ballet, La Source*, 1866–68. Whistler made several changes to the painting, most notably to the figure of Milly Jones, and then submitted it to the RA in May 1867. It was the first of Whistler's paintings to be given and exhibited under a musical title.

PAINTED

London

MEDIUM

Oil on canvas

PERIOD/SERIES/MOVEMENT

Symphony in White

SIMILAR WORKS

Berthe Morisot, Repose Edourd Manet, 1870

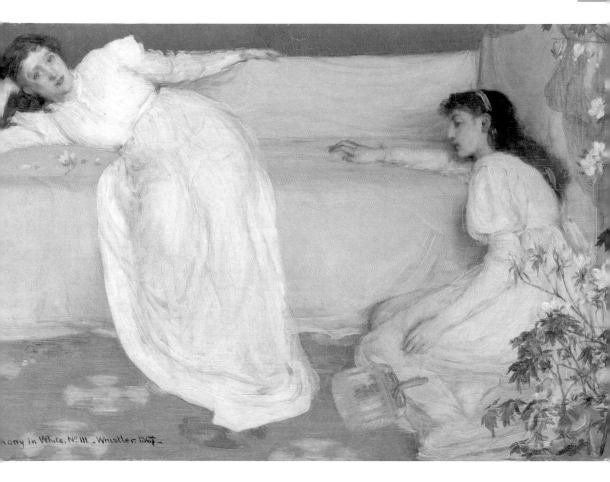

Whistler, James

Crepuscule in Flesh Colour and Green; Valparaiso, 1866

1866 was a turbulent year for Whistler, as he was struggling to define his artistic style at this time. His painting, *Whistler in his Studio*, of the previous year had not materialized, shattering his grand vision for the Realist piece, based on Fantin-Latour's *Homage to Delacroix*. Beset with feelings of inadequacy, and re-evaluating his Realist influences, Whistler dashed to Valparaiso to help Chile in her struggles with Spain. Whistler remained proud of his early, although undistinguished, military education and his 'heroic' trip to Valparaiso may have been fuelled by a desire to achieve military acclaim now, when he had failed to do so earlier. In the event, the Allied forces withdrew the night before the main attack began.

Artistically, the trip to Valparaiso marked a turning point for Whistler and on his return he renounced Courbet and his Realist followers. *Crepuscule in Flesh Colour and Green: Valparaiso* was one of two oil paintings that Whistler executed while there and shows his increasing interest in the effect of light and atmosphere. It is generally believed to depict the moments before Valparaiso was shelled. The painting captures the heavy foreboding and restless energy of pre-attack manoeuvring. While the solitary French Tricolour draws the eye into the centre of the canvas, the heavy presence of the war ships create tension with their verticality and mass. The masts in the background have been worked over with pencil, an interesting combination of techniques that proved highly effective.

PAINTED

Valparaiso

MEDIUM

Oil on canvas

PERIOD/SERIES/MOVEMENT

Valparaiso series

SIMILAR WORKS

Departure from Boulogne Harbour, 1864 Edouard Manet

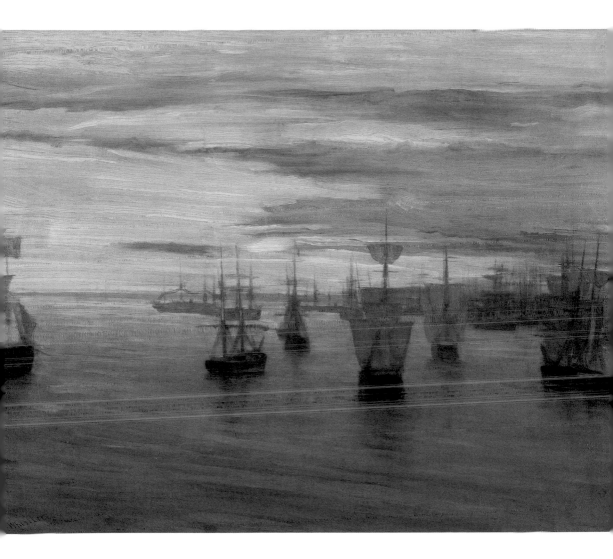

Whistler, James
Elinor Leyland, 1873

Whistler's relationship with his brother-in-law Francis Seymour Haden and his step-sister Deborah fell apart after a row with Haden in 1867. The two men never spoke again and it was some time before Whistler and Deborah were re-united. In August of the same year Whistler wrote his famous letter to Fantin-Latour in which he rejected the Realism of Courbet and wished he had studied more profoundly the Neoclassicism of Ingres.

For some years the wealthy shipowner F. R. Leyland (1831–92) had been Whistler's patron, commissioning various portraits of his family, and in 1869 Whistler made the first of his many trips to Leyland's home, Speke Hall. Leyland had an impressive collection of art and was also greatly interested in music. Leyland is largely credited with having inspired the use of the word Nocturne for Whistler's night-time paintings and also influenced Whistler in his musical theme for the Six Projects, the symphonies in colour that were to hang in his music room.

Elinor was Leyland's youngest daughter and Whistler's favourite model. He drew her many times, sometimes with her sister, but more often on her own and wearing heavily layered and frilled skirts, which were favoured by her father. Her pose is aggressive and dominant in this dry point, a similar one was also executed in pastels. Whistler invariably avoided sentimentality when depicting her and chose to focus on the 'perfect oval' of her face.

PAINTED

London

MEDIUM

Dry point

PERIOD/SERIES/MOVEMENT

Leyland portraits

SIMILAR WORKS

Study of a Girl in a Mob Cap James Tissot, c.1872

Whistler, James

Nocturne: Blue and Gold – Old Battersea Bridge, *c.* 1872–75

Whistler had a great affinity with the Thames and the life and atmosphere that the river and its bridges held. By the 1870s Whistler had rejected the influence of Gustave Courbet and was experimenting with new techniques to capture the essence of atmosphere, colour and light. He would set out at twilight, be rowed up the Thames by his studio assistants and absorb the tranquillity and unearthly life of the river at night. Unable to work up full-scale oil canvases in the boat, he would make sketches and then return to his studio to capture the essence of the scene on canvas there.

During this period Whistler created a series of Nocturne paintings, but *Blue and Gold – Old Battersea Bridge* was to become one of the most famous. The central motif of the bridge itself has been elongated and distorted. Whistler used the scene to convey the mood and colour, rather than provide an accurate topographical account. Figures appear shadowy and transient in the haze of early evening light, and the distant buildings along the Thames hover as mere suggestions in the failing light of day. From the moment the painting was first exhibited in 1877 at the Grosvenor Gallery it was the subject of great controversy and was later produced during the Whistler/Ruskin lawsuit. The British public seemed quite unable to appreciate the picture's beauty and Whistler was to become bitterly resentful of the lack of support shown to him.

PAINTED

London

MEDIUM

Oil on canvas

PERIOD/SERIES/MOVEMENT

Nocturnes

SIMILAR WORKS

Night Sketch of the Thames near Hungerford Bridge George Price Boyce, *c.* 1866

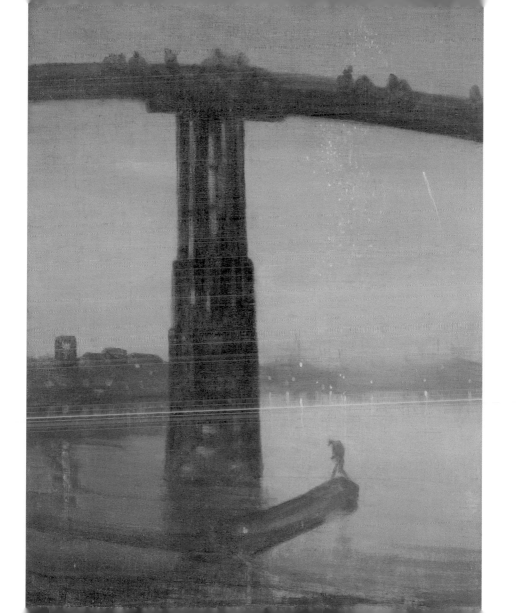

Whistler, James

The Storm – Sunset, 1880 (detail)

The Whistler/Ruskin lawsuit was to be devastating financially for Whistler. In 1877 Whistler had exhibited *Nocturne in Black and Gold: The Falling Rocket*, 1875. Ruskin had taken exception to the picture, writing that he, 'never expected to hear a coxcomb ask two hundred guineas for flinging a pot of paint in the public's face'. Whistler then sued Ruskin. He won his case but was only awarded a farthing as recompense. The cost of the trial, amongst other things, led to Whistler's bankruptcy. In 1879 the bailiffs took possession of his house and the creditors moved in. Shortly afterwards Whistler travelled to Venice, having been commissioned by the Fine Art Society for a set of 12 etchings. Whistler stayed for over a year and produced a huge volume of pastels, etchings and paintings. His interpretation and reaction to Venice is interesting because he focused on the city as a city, with all its bustle and life, whereas Turner's vision was one of tranquil calm and beauty. For Turner, the city was a vehicle to explore the effects of light and radiance from the water, where for Whistler the city itself was primarily the focus. He also chose scenes off the beaten track and away from the main tourist attractions.

The pastel *The Storm – Sunset* is hugely energetic, the speed with which he must have executed it translated in the fast lines and strokes, so that the immediacy of the storm itself vibrates from the picture.

PAINTED

Venice

MEDIUM

Pastel on paper

PERIOD/SERIES/MOVEMENT

Venice

SIMILAR WORKS

Storm Clouds: Sunset J. M. W. Turner, 1826

Sunset on the Seine at Lavacourt Claude Monet, 1880

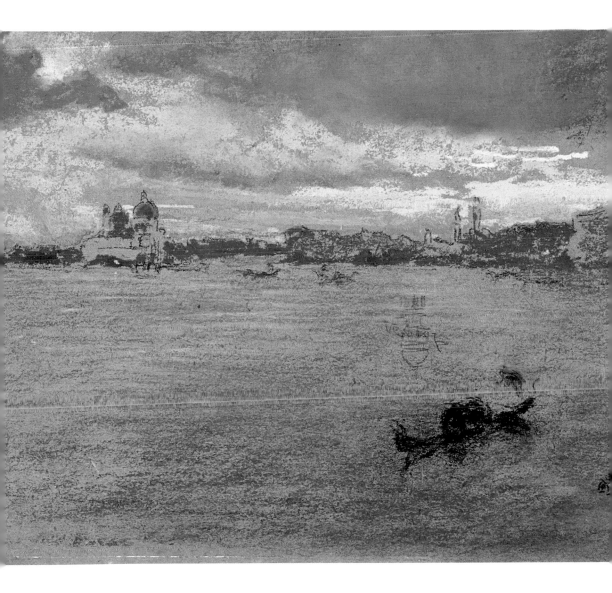

Whistler, James
Little Rose of Lyme Regis, 1895

In 1888 Whistler married Beatrice, the widow of his friend the architect Edward Godwin, and the pair moved to Paris. He was finally starting to receive the recognition that he so deserved and Americans flocked to his Parisian studio for portrait sittings. In Paris Whistler became friendly with the circle of Symbolist poets, painters and critics and was a frequent guest at the Tuesday-night gatherings, presided over by Stéphane Mallarmé (1842–98), the leading French Symbolist poet.

In 1892 there was a major retrospective of his work held in London. The critics and public were coming to an understanding of his artistic aims, but he was still received with warmth rather than fervour. By 1895 his beloved wife Beatrice was ill with cancer. Whistler and Beatrice travelled together from London to Lyme Regis, Dorset, to paint Rosie Randall, the daughter of the Major of Lyme Regis. Beatrice, unable to stay due to her failing health, returned to London, leaving Whistler to paint. It was a time of turbulent worry for the painter as he feared for his wife's health. The finished portrait reflects a sombre little girl, nervous and beautiful, with luminous dark eyes full of thought.

Beatrice died in 1896, and Whistler, devastated by her death, produced two haunting self-portraits. In 1901 he sold their Parisian house and moved back to London for the last time where he died on 17 July 1903.

PAINTED

London

MEDIUM & DIMENSIONS

Oil on canvas, 51.43 x 31.11 cm (20½ x 12¼ inches)

PERIOD/SERIES/MOVEMENT

Late portraits

SIMILAR WORKS

Dorothy John Singer Sargent, 1900

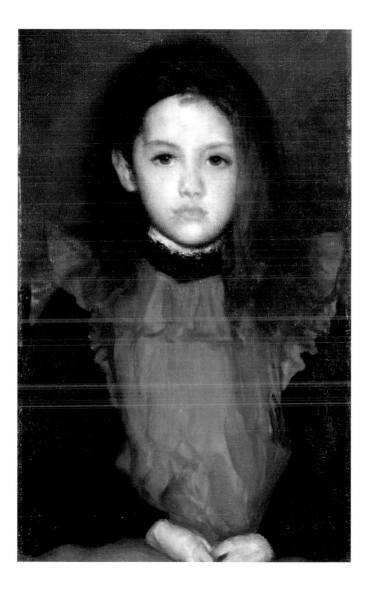

Monet, Claude
Still Life with Bottles, 1859

Claude Monet spent his childhood growing up in Le Havre, Normandy, where by all accounts he was rather on the wild side. In his own words, he was 'undisciplined from birth, they could never make me bend to a rule'. How true this would be in the grand scale of his artistic achievements. His early abilities were first recognized through his prodigious caricatures, and his skills were furthered through extra drawing classes at school. Around 1858 Monet made the acquaintance of Eugène Boudin (1824–98) the landscape painter, who was also living in Le Havre at that time. Boudin encouraged Monet to paint '*en plein air*' and had a significant influence on the young artist. Some 30 years later Monet wrote to him, 'I have not forgotten that it was you who first taught me to see and to understand.'. In 1859 Monet exhibited a collection of his caricatures in a local art-shop window, and then, using funds raised through their sale, headed for Paris.

The amateur rendering of his *Still Life with Bottles*, 1859, is apparent, and the perspective and composition is in line with an artist at the beginning of his career. However, it is interesting to note his early interest the effects of light and shadow and the reflection of light on solid objects, a precursor to a life spent developing his vision of light and atmosphere.

PAINTED

Paris

MEDIUM

Oil on canvas

SERIES/MOVEMENT/PERIOD

Still life

SIMILAR WORKS

The Salmon Edouard Manet, 1868–69

Still Life with Peaches and Melon Edouard Manet, 1866

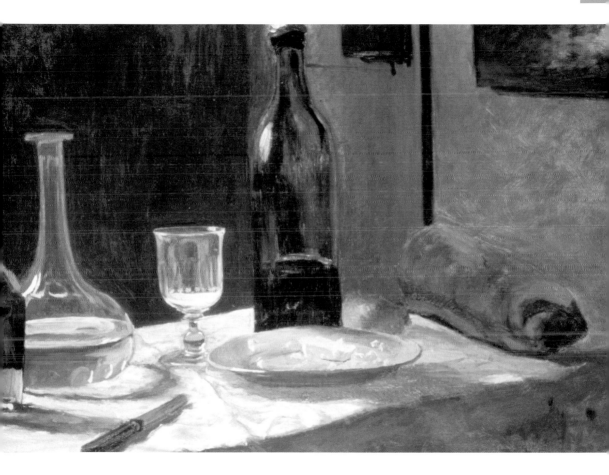

Monet, Claude
Petit Pantheon Theatral, 1860

In 1860 Monet enrolled at the Académie Suisse, a free academy that provided facilities and life drawing, rather than any formal instruction. It was here that he met Camille Pissarro (1830–1903) who advised him to study Camille Corot (1796–1875). Monet, however, favoured the work of the landscape artist Charles Daubigny (1817–78) and sought out the advice of Troyon (1810–65). At this time Paris was a Mecca of artistic talent and Monet, the provincial boy from Le Havre, would have been thrust into a whirlwind of new ideas and influences. At the time of Monet's arrival in Paris the city was in the grip of a mass modernization programme. New buildings were going up, the population was on the increase, commerce and industry were booming and social urban life was good. This was the setting for the new bourgeois, the sparkling wealthy, with the lifestyles and leisure time to match. Over the coming years, this was the subject of many of Monet's paintings.

Monet greatly admired the drawings of Honoré Daumier (1808–79), and his early caricatures such as *Petit Pantheon Theatral*, 1860, show Daumier's influence. His clean lines and witty depictions captured the very essence of his unwitting subjects. His skill was in part aided by his endless practising as a schoolboy, using his teachers as models.

PAINTED

Paris

MEDIUM

Pencil on paper

SERIES/MOVEMENT/PERIOD

Caricatures

SIMILAR WORKS

Behold our Nuptial Chamber Honoré Daumier, 1853

Landscapists at Work Honoré Daumier, 1862

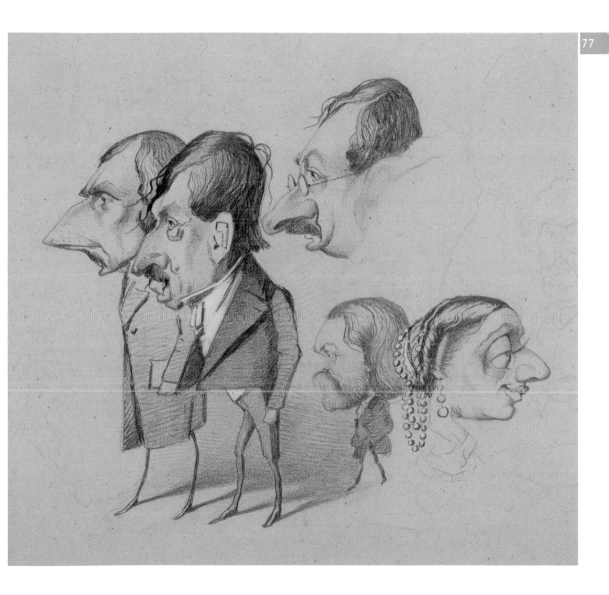

Monet, Claude
Le Déjeuner Sur L'Herbe, 1865–66

In 1861 Monet was briefly drafted into the army, spending two years in Algeria before ill health brought him home. He re-immersed himself in the Parisian art scene, painting at Gleyre's studio alongside, Pissarro, Auguste Renoir (1841–1919), Whistler, Frédéric Bazille (1841–70) and Alfred Sisley (1839–99). Monet was a great proponent of *plein air* painting and frequently painted at the forest of Fontainebleau. This was the popular site for the Barbizon school of landscape painters and the background setting for Monet's famous *Le Déjeuner Sur L'Herbe*, 1866. That he was drawing on Manet's earlier painting, *Le Déjeuner Sur L'Herbe*, exhibited at the Salon Des Refuses in 1863, is without question, but Monet took his subject of the same title much further. Where Manet's figures sit uncomfortably within the context of their landscape, Monet's become the landscape. His figures settle into the forest with all the normality and ease of the picnic itself and the whole scene becomes almost secondary to the treatment of light falling through the trees, the nuances of tone affected by light, and the play of light on colour and fabric. Monet's picnic was one of the first instances of an artist painting a figure composition in the open air in order to recreate the immediacy and authenticity of the moment immortalized in paint.

The painting was never finished. Monet made changes to it after criticism from Courbet and it was then damaged in storage, all that remains now are two fragments of the painting and several sketches and studies.

PAINTED

Forest of Fontainebleau

MEDIUM

Oil on canvas

SERIES/MOVEMENT/PERIOD

Plein Air, Impressionist

SIMILAR WORKS

Le Déjeuner Sur L'Herbe Paul Cézanne, 1869–70

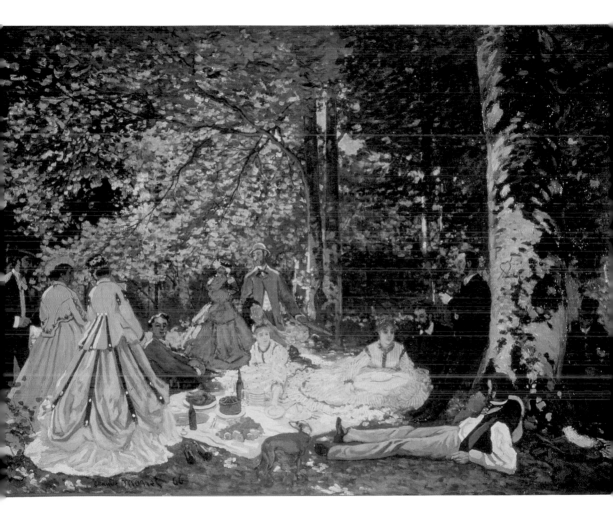

Monet, Claude
Women in the Garden, 1867

During the first half of 1866 Monet lived in the bustling district of Pigalle, a short distance from the famous Café Guerbois, a gathering place of artists and writers alike, which allowed a meeting of minds and a trading of visions and ideals on a grand scale. Monet, Renoir, Sisley, Bazille, Pissarro, Degas and Fantin-Latour formed the core of the progressive liberal group that supported and, for the most part, promoted each other's work. Monet's *Camille* and *The Pavé de Chailly* were accepted by the Salon jury in 1866, which was a huge triumph, both financially and personally for the artist.

Women in the Garden was painted in 1867 and Monet hoped to achieve the success of his previous year with it. The picture was on a monumental scale necessitating digging a trench to sit the canvas in to allow him to work on the top portions. All the women in the canvas were posed by Camille Doncieux, Monet's mistress, and later his wife. The dress of the figures expresses an enthusiasm for the modern turn of fashion as Monet demonstrates his *plein air* Realism and fascination with the effects of dappled light through leaves. To his bitter disappointment the painting was rejected by the Salon jury and his good friend Bazille stepped in and bought it on instalments to help Monet's struggling finances.

PAINTED

Ville d'Avray, outside Paris

MEDIUM

Oil on canvas

SERIES/MOVEMENT/PERIOD

Plein Air

SIMILAR WORKS

Family Reunion Frédéric Bazille, 1867

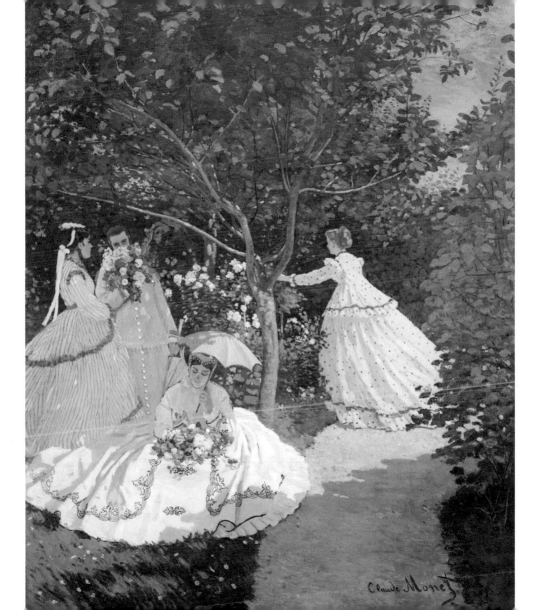

Claude Monet

Monet, Claude
The Red Cape (Madame Monet), c. 1870

In March of 1870 Monet heard of the Salon jury's rejection of his *Luncheon*, 1868–70, a disappointment made all the more bitter by the acceptance of virtually every other artists' offering. His good friend Daubigny resigned from the jury in protest. Monet and Camille Doncieux were married in June that year; a marriage frowned upon by Monet's family. Shortly thereafter Monet and his new wife travelled to Trouville for the summer. Napoleon III declared war on Prussia in July, while Monet continued to paint Parisians at leisure at the famous seaside resort. Throughout his life Monet ignored the stresses of politics in France at the time and chose to continue his paintings of light and beauty. Monet's great friend, and often patron, Bazille was killed during the French retreat and in October, Monet and his family fled to London, followed closely by Pissarro.

The Red Cape, 1870, is an intimate painting of Monet's new wife, Camille. It is believed that the painting was not exhibited to the public during his lifetime. She is caught in the fleeting instant as she turns towards the window, her red cape startling against the snowy background. The spatial composition with the subject behind the strong grid of the window is extraordinarily modern in conception and unusual within the greater framework of Monet's oeuvre.

PAINTED

Paris

MEDIUM

Oil on canvas

SERIES/MOVEMENT/PERIOD

Impressionist portrait

SIMILAR WORKS

View of a Pork Butcher's Shop Vincent Van Gogh, 1888

Fanny Claus on the Balcony Edouard Manet, 1868

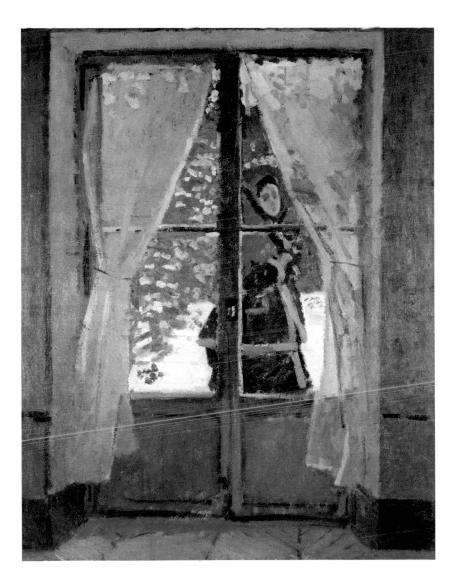

Monet, Claude

The Thames at London, 1871 (detail)

© National Museum and Gallery of Wales, Cardiff/www.bridgeman.co.uk

London was home to an increasing circle of French artists, sheltering from the military actions in their homeland. Daubigny, the landscape artist, introduced Monet to the dealer Paul Durand-Reul who had established a gallery in New Bond Street and who went on to become one of Monet's greatest supporters. Durand-Reul was a great advocate of the Impressionists and struggled to maintain his own financial stability through his tireless belief, against mainstream opinion, in the merit of their artistic endeavours. Monet and Pissarro met up through Durand-Ruel's gallery and visited the London museums together. The collection of Turners at the National Gallery and the works of Constable had a profound effect on Monet.

Monet's first trip to England only lasted seven or eight months and during this period his artistic output was small. The nuance of his painting is different and his London and Thames pictures are edged with sobriety, a detached quality suggesting the artist was not entirely at home with his new surroundings. His treatment of light, the reflection of light on water, and the evocation of the damp, watery atmosphere of the Thames echo Turner's earlier vision. In *The Thames at London*, 1871, Monet focuses the eye on the dark structures in the foreground with their strong diagonal composition, contrasting with the soft handling of the background, merging into the mists, cloud and sky. This is a technique that he would come back to frequently and which is also clearly demonstrated in *The Thames and the Houses of Parliament*, 1871, from the same period.

PAINTED

London

MEDIUM

Oil on canvas

SERIES/MOVEMENT/PERIOD

Impressionist landscape

SIMILAR WORKS

Entrance to the Port of Honfleur Johan Barthold Jongkind, 1864

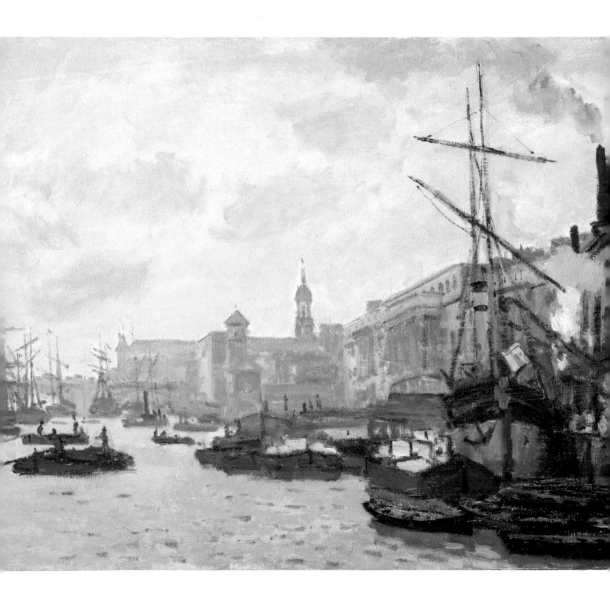

Monet, Claude

Impression: Sunrise, Le Havre, 1872

By November 1871 Monet had moved his family to Argenteuil. The war was over and Paris, shocked and ravaged to the core, was trying to rebuild itself. Monet found in Argenteuil the peace to continue developing his painting, towards an emerging synthesis of nature with modernization. The post-war years of the 1870s saw a hostile reaction to the work of Monet and his contemporaries, fuelled by the disparity between the depiction of the high life of the bourgeoisie and the recent horrifying effects from the civil war. The Impressionists use of unconventional techniques was viewed with suspicions of political subversion.

The Salon of 1873 again rejected Monet, Pissarro, Sisley, Degas and Renoir. At Monet's suggestion the group, with Berthe Morisot (1841–95), formed the Limited Company of Painters, Sculptors and Engravers and set about organizing their own exhibition that opened in 1874. *Monet's Impression: Sunrise*, painted in 1872, was one of the exhibits to be ridiculed by the critics. The translucent ethereal light of a misty sunrise and the ghostly structures looming in the haze, captured so perfectly by the artist, bore the brunt of derision. Louis Leroy, critic for the magazine *Charivari*, picked on the 'Impression' and the word was swiftly adopted to describe the new style of painting. The derisory nature of the term was corrected through the skilful diplomacy of Jules Castagnary, a member of the old Café Guerbois gang, who put the record straight some days later in *Le Siècle*.

PAINTED

Le Havre

MEDIUM

Oil on canvas

SERIES/MOVEMENT/PERIOD

Impressionist

SIMILAR WORKS

Nocturne in Black and Gold: Entrance to Southampton Waters James Whistler, c. 1870–80

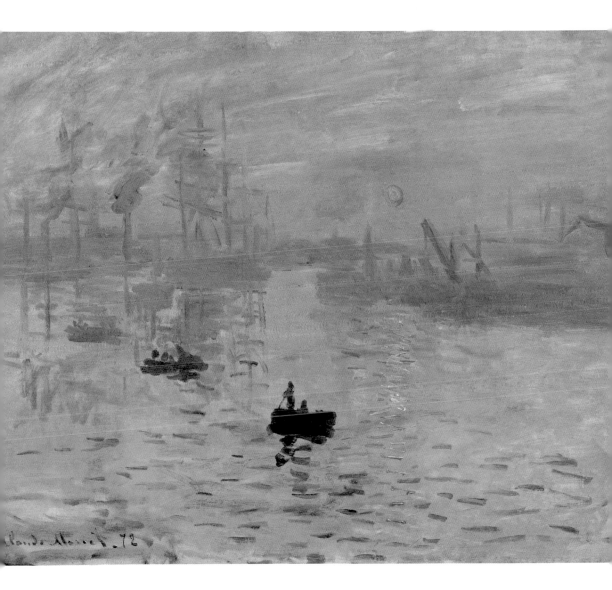
Claude Monet. 72

Monet, Claude
The Studio Boat, 1876 (detail)

On leaving London after the war in France was over, Monet first travelled to Holland for a short period of time, before returning to his homeland and settling in Argenteuil. Daubigny, a member of the Barbizon landscape school of painting, had for some time worked from a small flat-bottomed boat, converted into a studio, in which he would float up the Seine and Marne. Inspired by this, on Monet's arrival in Argenteuil he set about finding such a craft to convert and during his search met Gustave Caillebotte (1848–94), a wealthy young boat buff. Together they found Monet his floating studio, which then became the subject of a group of four paintings. The four studio boat images suggest a continuous journey up the river, a slow progression through the tranquillity of the luxuriant landscape. Monet's painting of 1876 captures the boat trailing quietly in a soft light, the seated figure bowed in thought and concentration. Manet, on visiting Monet in his new studio, also produced a painting of the unusual vessel, and Caillebotte, inspired by his artist friend, took up painting himself, producing paintings both from, and of, Monet's floating studio.

PAINTED

Argenteuil

MEDIUM

Oil on canvas

SERIES/MOVEMENT/PERIOD

Impressionist

SIMILAR WORKS

Claude and Camille Monet in the studio boat Edouard Manet, 1874

Le Seine au Bas-Meudon Pierre Prins, 1869

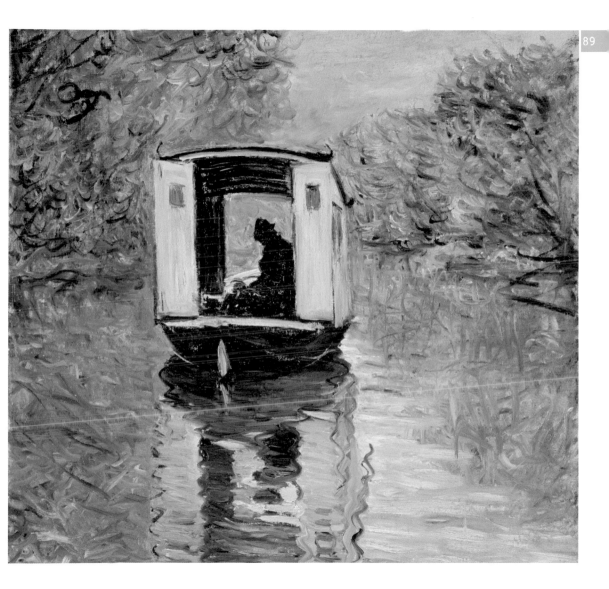

Monet, Claude
The Gare, St Lazare, 1877 (detail)

The second Impressionist Exhibition in 1876 was greeted with even more hostility and Monet was unable to sell any of his paintings during the show. In September of that year he travelled to the home of Ernest and Alice Hoschedé to paint four decorative panels. Alice would later become his lover, then his wife. In early 1877 Monet started work on a series of paintings of the Gare St Lazare, turning again to the subject of modern life. The great trains, belching steam and dominating diminutive figures, were the symbol of progression, the very essence of 'modern' and a giant step forwards for society and industry. Monet was fascinated by the steam-engines, the great hulk of their frame squatting on the tracks. The people in his series of paintings recede into incidentals against the bigger might of the train. He worked within the station and executed a huge number of drawings that he would work up in his apartment, situated nearby and rented for him by Caillebotte. Monet's Gare St Lazare series shows him evolving his treatment of steam and the effects of the steam on the atmosphere. His engines dominate the paintings, their utter solidity in direct contrast to the unquestionable vapour of their steam. The paintings were included in the third Impressionist Exhibition of April 1877 and were widely criticized.

PAINTED

Argenteuil

MEDIUM

Oil on canvas

SERIES/MOVEMENT/PERIOD

Gare St Lazare

SIMILAR WORKS

The Le Havre Train at Médan, photograph by Zola

Rain, Steam and Speed J. M. W. Turner, 1843

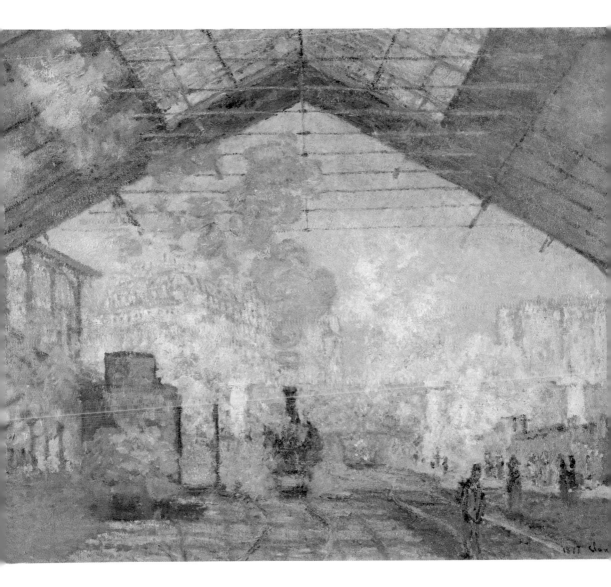

Monet, Claude

Haystack at Giverny, 1886

The decade between Monet's Gare St Lazare series and his Giverny Haystack painting was one of turbulent upheaval, bereavement, financial struggle and the establishment of political stability under the Republican regime. Camille died in 1879, and in 1881 Alice Hoschedé and her children joined Monet and his children in Poissy. By 1883 they had moved to Giverny, and Monet had finally come to be grudgingly accepted by the critics and was gaining the reputation of one of the leading landscape artists of the time. In the summer of 1884 Monet started to paint landscape scenes around Giverny that were in part reflective, in his treatment of colour, of the paintings he had produced from a trip to the Mediterranean at the end of 1883.

Haystack at Giverny, 1886, with the brilliant use of colour suggestive of the rolling fields of poppies and the strong horizontal planes with vertical accents, typifies Monet's treatment of his landscape subjects at this time. The scenery of Giverny was to provide him with the perfect quality of light and the topographical framework to evolve his continuing treatment of light and atmosphere. The Haystacks was a subject that he was to return to in the 1890s with his famous Haystack series, dedicated to the visualisation of reflective light through different periods of the day.

PAINTED

Giverny

MEDIUM

Oil on canvas

SERIES/MOVEMENT/PERIOD

Impressionist landscape

SIMILAR WORKS

The Haystack, Pontoise Camille Pissarro, 1873

Haystacks at Moret, Morning Alfred Sisley, 1891

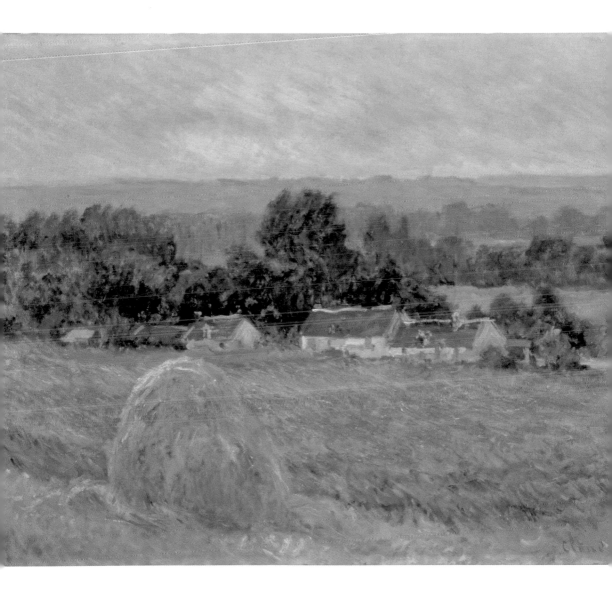

Monet, Claude

Printemps à Giverny, 1903

In 1886 Paul Durand-Reul, gallery owner and supporter of the Impressionists, organized an exhibition, *Works in Oil and Pastel by the Impressionists of Paris*, in the American Art Gallery, Madison Square, New York. The exhibition was a great success and Renoir later commented, 'we perhaps owe it to the Americans that we did not die of hunger'.

In 1887 Monet travelled to London, spending two weeks with Whistler, and in 1889 the exhibition *Impressions by Claude Monet*, opened in London at the Goupil Gallery. Monet's work was received well and his influence on Whistler was noted in the reviews.

Printemps à Giverny, 1903, was painted after a period of sustained activity on the London series, a massive undertaking that produced close to 100 paintings from 1899 to 1903. Monet was shortly to embark on his most famous group of paintings, the Waterlily series, inspired by the pond in his garden at Giverny. His increasing use of broad brushstrokes and creation of brilliant sunlight is seen in *Printemps à Giverny*, as he perfects capturing the essence of the fleeting moment.

PAINTED

Giverny

MEDIUM

Oil on canvas

SERIES/MOVEMENT/PERIOD

Impressionist landscape

SIMILAR WORKS

The Poplar Avenue at Moret Alfred Sisley, 1888

Verger en Fleurs, Matin de Printemps Pierre Prins, 1878

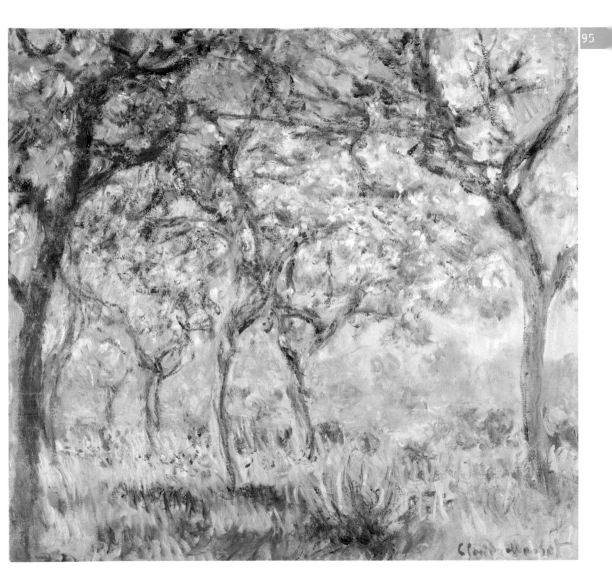

Claude Monet

Monet, Claude

The Doge's Palace in Venice, 1908

© Brooklyn Museum of Art, New York, USA, Gift of A. Augustus healy/www.bridgeman.co.uk

Monet and Alice finally travelled to Venice in October 1908. The trip was planned originally as a holiday for Monet who was still immersed in his Waterlily series. Venice, one of the great bastions of Old Masters and artistic tradition, had been the destination of the eighteenth-, nineteenth- and early twentieth-century landscape masters, amongst which were Turner, Richard Parkes Bonnington (1802–28), Whistler, Renoir, Manet, John Singer Sargent (1856–1925) and Paul Signac (1863–1935). It is not insignificant that Ruskin's *The Stones of Venice* had been printed in French translation in 1906, sparking an even greater interest in the city of artistic treasures.

The Monets stayed in some style in the Palazzo Barbaro, which was ideally located, and provided the artist with excellent views of the Grand Canal. He started a number of canvases, although he returned home with many of them unfinished. His sketches and memory allowed him to work up the paintings at a later date, in a similar way to his London series. *The Doges Palace in Venice*, 1908, offers an interesting perspective angle on the building, suggesting that the artist may have been close to the water in a boat, looking across and up. The clarity with which the reflective light is rendered is typical of his later painting techniques.

PAINTED

Venice

MEDIUM

Oil on canvas

SERIES/MOVEMENT/PERIOD

Impressionist Venice

SIMILAR WORKS

Canal in Venice Hercules Brabazon, *c.* 1890

The Grand Canal, Venice James Holland, 1835–55

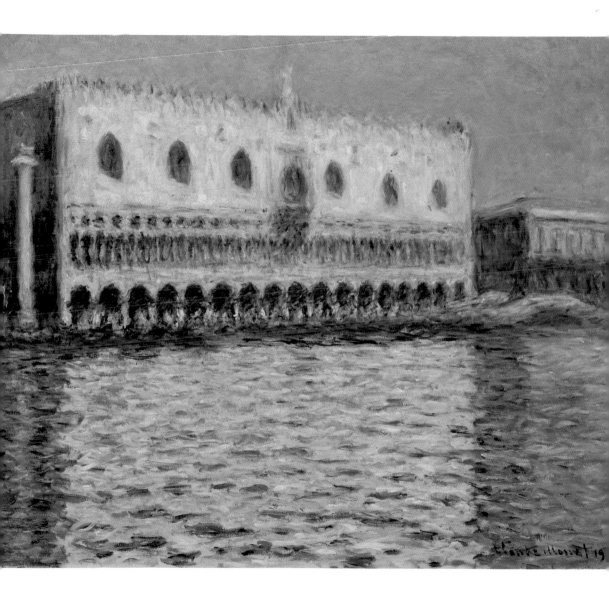

Monet, Claude

Waterlilies: The Japanese Bridge, or Japanese Bridge at Giverny, *c.* 1923

© Minneapolis Institute of Arts, MN, USA/www.bridgeman.co.uk

The elderly Monet suffered the devastating death of his wife Alice in 1911. She had long been the centre of his life, running his business affairs and providing him with endless support. In 1912 he was diagnosed with cataracts and in the same year his son Jean had a stroke. Monet virtually stopped painting for two years and Jean then died in 1914. The deterioration of his eyesight was horrifying to the artist who wrote, 'I realized with terror that I could see nothing with my right eye ... a specialist ... told me that I had a cataract and that the other eye was also slightly affected. It's in vain that they tell me it's not serious, that after the operation I will see as before. I'm very disturbed and anxious.'. In 1923 he was operated on three times to try and correct his right eye.

The brilliant fiery reds and yellows of *Japanese Bridge at Giverny, c.* 1923 are indicative of the impaired sight of the artist, seeing his bridge within a constricted palette. Yet it is the most evocative sum of colour and light and composition, the latter of which is transitory to the overall startlingly emotive effect.

PAINTED

Giverny

MEDIUM

Oil on canvas

SERIES/MOVEMENT/PERIOD

Waterlilies

SIMILAR WORKS

Rocks and Branches a Bibemus Paul Cézanne, 1900–04

Study for a Sluice Wassily Kandinsky, 1901

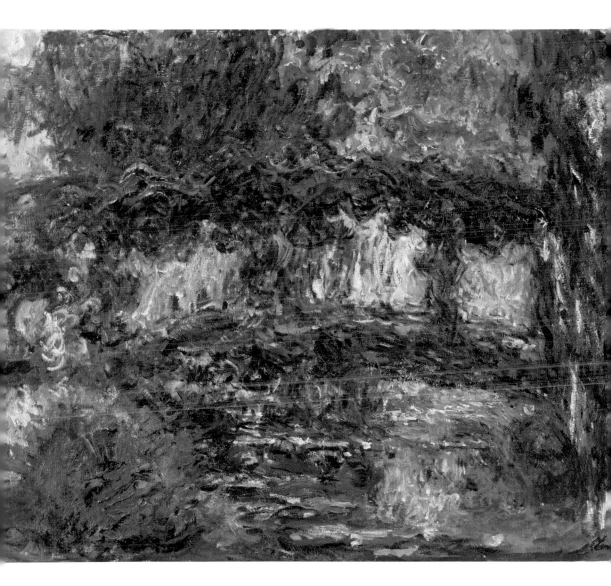

Manuel, Henri

Portrait of Claude Monet in front of his paintings, 'The Waterlilies', in his studio at Giverny, *c.* 1922

© Henri Manuel. Musee Marmottan, Paris, France/www.bridgeman.co.uk

The declaration of war on 1 August 1914 brought with it a mass exodus of Parisians from the capital. Monet's stepson, Jean Pierre Hoschedé, and his own son, Michel, were called up and Monet saw his family steadily disappearing from him, leaving just his daughter-in-law looking after his welfare. Typically of Monet, his paintings never revealed the despair, both personal and political, that was current during the war years. He embarked on a massive project, the *Grandes Decorations*, a huge series of studies of his pond and waterlilies. A vast undertaking in both numbers and scale. The paintings were executed in great strokes, the actual rendering of the paint itself adding to the rhythm and flow of the pictures themselves. The waterlilies are suggested, hinted, captured on canvas by colour and light and it is the depths of the water beneath them that create the biggest impact.

Henri Manuel (fl. 1900–38) sets the artist in the context of his pictures through his studio photograph. The elderly Monet is dwarfed by the sheer magnitude of his paintings, their physicality and the greater significance of their legacy to modern art. Monet died on 5 December 1926 and was buried at the cemetery in Giverny.

PAINTED

Giverny

MEDIUM

Black and white photograph

SERIES/MOVEMENT/PERIOD

The artist in his studio

SIMILAR WORKS

Monet's Studio, The Grandes Décorations photograph by Paul Durand-Ruel, 1917

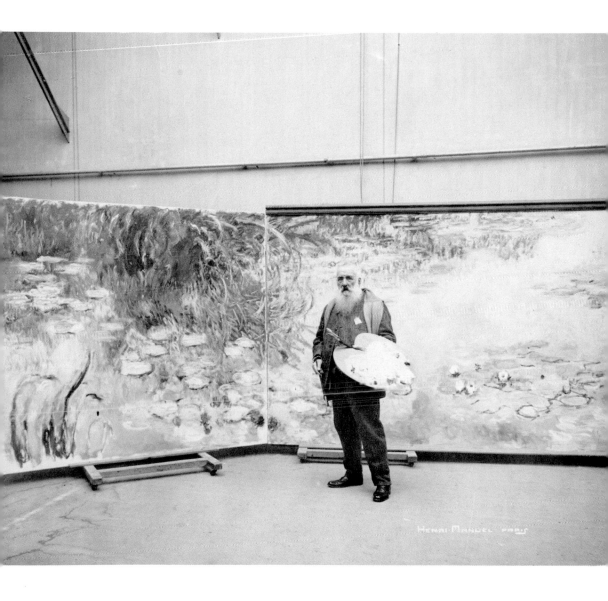

HENRI MANUEL PARIS

Turner, Whistler, Monet

Society

Turner, J.M.W.

Petworth Park: Tillington Church in the Distance, c. 1828 (detail)

Turner was born into an age of enormous growth and advancement. Over the course of his long life he became intensely interested in the designs and inventions that the Industrial Revolution gave birth to, and his fascination in science would come to be seen through the medium of his painting. Whilst the Industrial Revolution was booming, new theories and inventions were being propagated and transport was enabling a more mobile population. This freedom and liberation on the one hand, however, did not extend to the still strictly confined requirements of social and political correctness.

Petworth Park, home to the flamboyant Lord Egremont, wealthy landowner and one of Turner's greatest patrons, became a frequent haunt of Turner's. Egremont collected art and sculptures and enjoyed the company of artists. The atmosphere at Petworth Park at this time was, by all accounts, one of liberal acceptance beyond that of society at large. In spite of Egremont's open-minded attitude, Turner's *Petworth Park: Tillington Church in the Distance* was not especially liked by him. It was part of a series of four paintings due to be hung in the Carved Room at Petworth and depicts primarily, a beautiful picturesque scene. However, the inclusion of Egremont walking with his dogs may have been considered too informal by the lord, who replaced the picture with another Turner, *The Lake Petworth: Sunset, Fighting Bucks*.

PAINTED

Petworth, Sussex

MEDIUM

Oil on canvas

SERIES/PERIOD/MOVEMENT

Panels for the Carved Room at Petworth

SIMILAR WORKS

Hampstead Heath with the House Called the Salt Box John Constable, c. 1819

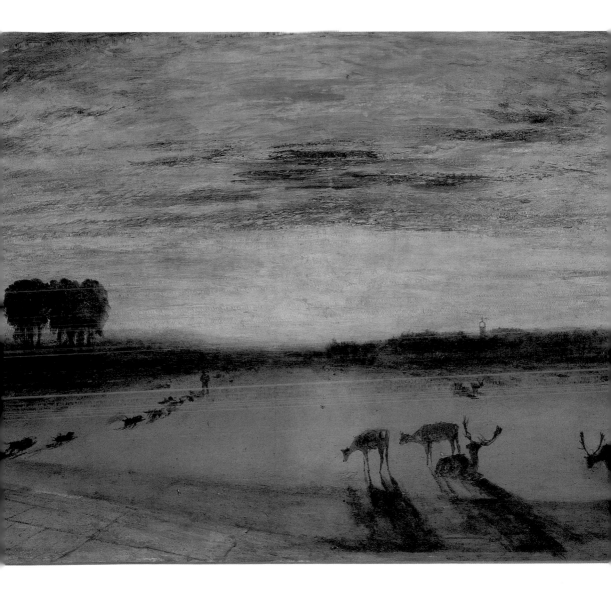

Turner, J.M.W.

Petworth, Sussex, the Seat of the Earl of Egremont: Dewy Morning, exhib. 1810 (detail)

© Petworth House, Sussex, UK / www.bridgeman.co.uk

Turner's acquaintance with Lord Egremont dates back to around 1792, based on two watercolours done by Turner of Petworth Church. It is not unreasonable to assume, however, that Turner's early visits to Petworth may have been inspired by the artist's wish to study Egremont's impressive collection of Old and New Masters, especially bearing in mind that the National Gallery had not yet opened. *Dewy Morning* was commissioned by Egremont after Turner had executed two paintings for Sir John Leicester of his home, Tabley House. What is particularly interesting about *Dewy Morning* is that it shows Turner's early technical innovation in his treatment of the paint. He had already used a white ground in the water and sky of his earlier Thames studies to create the luminosity of reflective water and damp atmosphere. He now applied white ground throughout the canvas of *Dewy Morning* and, as a result, the painting glistens with light and dewy vapour. The painting was greeted with a mixed reception by the critics, some of whom derogatorily called Turner and his imitators, 'The White Painters', and others who commented that the shadow of the boat was stronger than the boat itself and thus contrary to nature.

PAINTED

Petworth, Sussex

MEDIUM

Oil on canvas

SERIES/PERIOD/MOVEMENT

Landscape

SIMILAR WORKS

Harnham Bridge, Salisbury John Constable, 1820 or 1829

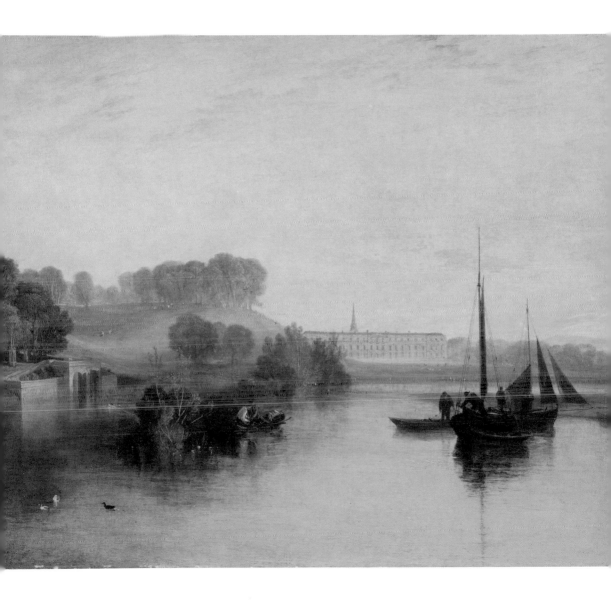

Turner, J.M.W.

Petworth House: Figures in the White Library, possibly Lord Egremont, 1827

During Turner's trips to Petworth House in 1827 he made a large number of drawings and studies that reflect an intimate relationship with Lord Egremont and his family. The social climate at Petworth was not reflective of that in the mainstream; it appears that Egremont lorded over his own kingdom at Petworth and this was probably largely due to his own partial exclusion from the 'society scene' due to his youthful lascivious liaisons. Turner's drawings from Petworth afford us now a fascinating glimpse at the relaxed social gatherings, and raise interesting questions regarding the nature of his relations at the house and his own social standing. He made intimate sketches of the interiors of the house, including bedrooms and guests, an indicator of his standing within the family. That Turner was the son of a barber is not insignificant. At that time social standing was hugely important and it is a testament to Turner, and a reflection on Egremont, that Turner was welcomed into the lord's family in the way that he was.

PAINTED

Petworth, Sussex

MEDIUM

Gouache and watercolour on paper

SERIES/PERIOD/MOVEMENT

Petworth sketches

SIMILAR WORKS

Harvesters Resting Peter de Wint, c. 1820

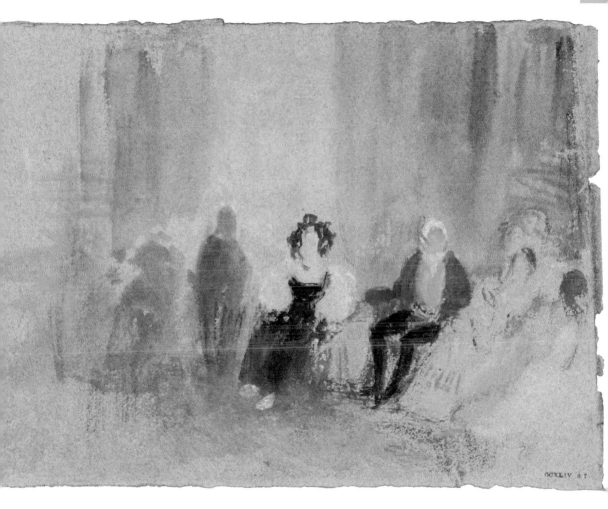

OCXLIV 8 7

Monet, Claude

A Corner of the Garden at Montgeron, 1876–77

© Hermitage, St Petersburg, Russia / www.bridgeman.co.uk

The nineteenth century in France was a time of great change on all levels. Paris was left reeling after the Franco-Prussian wars and the ensuing bloody and revolutionary Commune of 1871. Monet escaped to London in 1870, but returned to France at the end of 1871, and settled in Argenteuil. The rebuilding of Paris began immediately, industry and commerce were on the up, and the middle classes were becoming more affluent. This, combined with better transport, saw more people move from Paris to the surrounding countryside. In 1873 the reactionary Royalist General, Marechal MacMahon, adopted the *l'ordre moral*, tightening up already repressive social legislation and censorship. This was the backdrop to the first Impressionist Exhibition of 1874, which was generally poorly received and a financial disaster for the exhibitors.

In 1876 Monet was commissioned by Ernest Hoschedé to paint four large panels for his chateau at Montgeron. The timing was fortuitous. Monet's paintings had been selling for less and less, and he was struggling to stay afloat. He spent several months at Hoschedé's home working on the panels and other pictures, painting in the studio at Montgeron, and his studio in Argenteuil. *A Corner of the Garden at Montgeron* combines two of Monet's favourite subjects, water and flowers, and evokes the immediacy of a *plein air* painting, although it was probably finished in the studio. The barely discernible reflection of a woman is probably Alice Hoschedé, wife of Ernest, who Monet would eventually marry.

PAINTED

Montgeron

MEDIUM

Oil on canvas

SERIES/PERIOD/MOVEMENT

Impressionist, Hoschedé paintings

SIMILAR WORKS

The Pink House Camille Pissarro, 1870

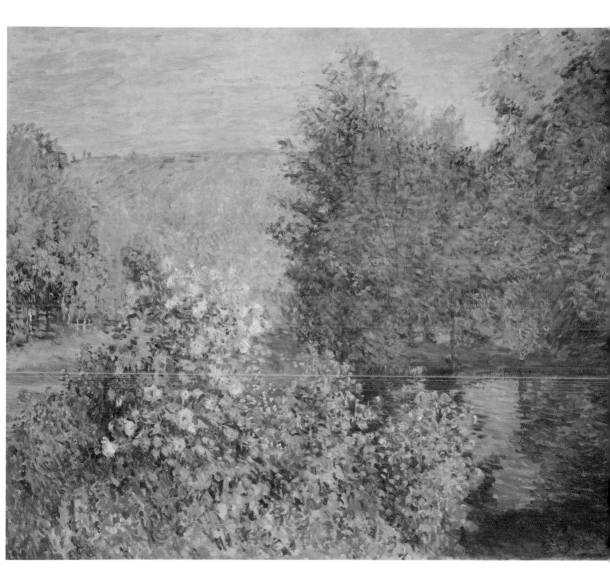

Monet, Claude
The Shoot, 1876

The second Impressionist Exhibition had been held in 1876, some months before Monet had been asked to the home of Ernest Hoschedé. In view of the repressively narrow political climate, the innovation of the Impressionists was treated suspiciously. Their challenging of the accepted art establishment, through their use of colour, effect and techniques, was deemed anarchic. They were thought of as revolutionary, seeking to create discord; as radicals, whose radical art was symbolic of their radical politics. Albert Wolff wrote in *Le Figaro*, 'five or six lunatics, one of them a woman ... have met ... to exhibit their works. Some people burst out laughing in front of these things – my heart is crushed by them. These so called artists describe themselves as the intransigents, the impressionists; they take canvas, colours and brushes, carelessly throw in some tones and sign the thing.'. It is difficult to comprehend now how the Impressionists could have been so misunderstood.

Securing the large commission from Ernest Hoschedé just a few months after the crippling attacks from the critics must have been manna from heaven for Monet. *The Shoot*, which was painted around this time, is an interesting composition where the dark figures sit rather uneasily amongst the Impressionist landscape. The spatial arrangement, however, is strong, aided by the trees on the right of the canvas in part balancing the figures to the left.

PAINTED

Montgeron

MEDIUM

Oil on canvas

SERIES/PERIOD/MOVEMENT

Impressionist, Hoschedé paintings

SIMILAR WORKS

Avenue of Elms at Tervueren Boulengers, 1871

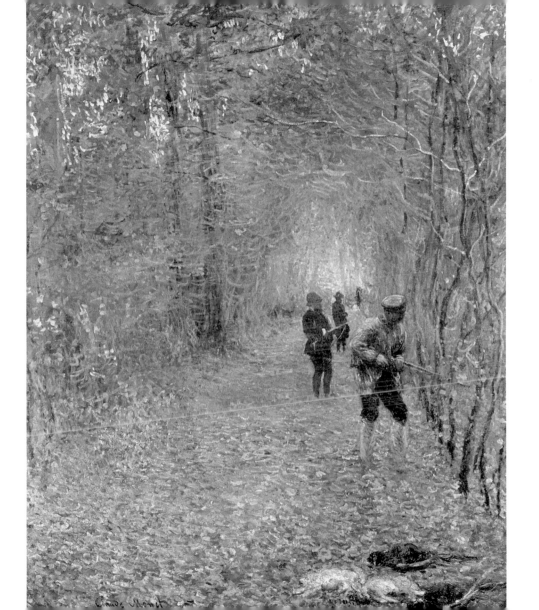

Monet, Claude

The Turkeys at the Chateau de Rottembourg, Montgeron, 1877

Monet sold no paintings from the second Impressionist Exhibition and around this time his style in landscape painting changed. He started to make a distinction between his paintings of modern life and those of nature. He no longer painted pictures of modern life within the countryside, choosing instead to keep this theme within the urban context of Paris. At Argenteuil he turned to painting time through nature, the same scene at different times of the day, and purely rural subjects, limiting his open-air pictures of modern life to either public parks or private gardens.

During the course of his stay at the Chateau de Rottembourg Monet painted *The Turkeys*, an innovative picture that placed the lowly turkey as the subject matter over the distant chateau, an unique inversion of propriety and place. The arrangement is unusual and distinctly modern, with the turkey popping up from the bottom of the canvas. The picture becomes very much a window on the moment and would, as such, suggest that it was executed *en plein air*, although this was probably not the case.

PAINTED

Montgeron

MEDIUM

Oil on canvas

SERIES/PERIOD/MOVEMENT

Impressionist, Hoschedé paintings

SIMILAR WORKS

The Farmyard Camille Pissarro, 1877

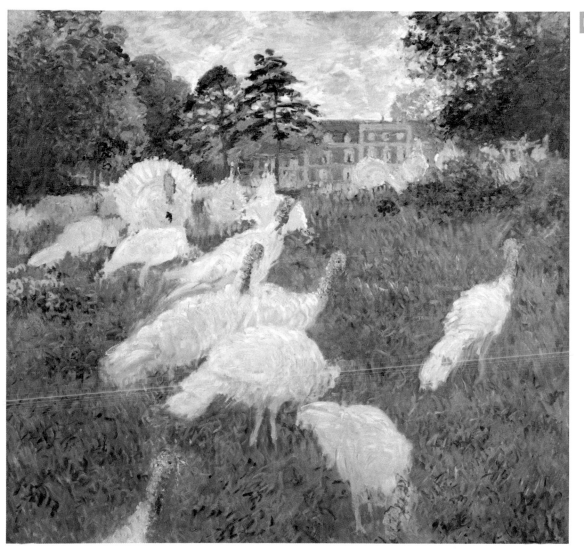

Whistler, James

Arrangement in Grey and Black, No. 2 Portrait of Thomas Carlyle (1795–1881), 1872–73

The growth and expansion that was burgeoning during Turner's lifetime continued at an escalating rate through the last half of the nineteenth century. Industry was booming, produce and people could be transported across the country easily and quickly with the new railway system, and Britain was at the top of the global power chain. There was a shift in power socially between those born rich and those who made their riches.

The Pre-Raphaelites were influencing artistic trends and a revived interest in all things Italian. Ruskin's *Stones of Venice* was published in 1851 and the same year saw *David Copperfield* and *Vanity Fair*; Thomas Carlyle was working on *Frederick the Great*. Carlyle near Whistler's Chelsea home, but it seems that they did not meet until 1872. Carlyle visited Whistler's studio and on seeing the portrait of the artist's mother, *Arrangement in Grey and Black; Portrait of the Painter's Mother*, 1871, agreed to sit for Whistler. Whistler's painting of Carlyle perceptively captures the fragility and depression of the writer and philosopher in his twilight years. The perfect balance of Whistler's arrangement and the muted tones of the background both emphasize the figure, but also synthesize the figure within the composition of shapes and forms.

PAINTED

London

MEDIUM

Oil on canvas

SERIES/PERIOD/MOVEMENT

Portraits, 1870s

SIMILAR WORKS

The Absinthe Drinker Edouard Manet, 1859

Greaves, Walter

Portrait of Whistler on the Thames, 1874

© Ferens Art Gallery, Hull City Museums and Art Galleries, UK/www.bridgeman.co.uk

The later years of the nineteenth century were the playing field on which William Gladstone (1809–98) and Benjamin Disraeli (1804–81) fought their political wars. In 1867, the Second Reform Bill was passed by Disraeli and the Conservatives in an attempt to win the support of the working classes. It was an unsuccessful bid, however, and the following year the Liberals, under Gladstone, won with a large majority. There followed a frenzy of reform bills and the Ballot Act, allowing voting to be secret. The trade unions were given legal status, the Anglican Church in Ireland was disestablished, universities were opened to men from all creeds and the hugely important Education Act of 1970 was implemented.

The year that Walter Greaves (1846–1930) painted his portrait of Whistler, Disraeli and the Conservatives had again been voted into power, much to the delight of Queen Victoria. Disraeli was intent on the expansion of the British Empire and in 1877 presented the queen with the title, Empress of India.

The Whistler, in Greaves' painting, is a supercilious figure, who stares haughtily from the canvas, an imposingly dark figure against the subtly painted boats in the background. Walter and his brother Henry were boat builders who later became friendly with Whistler and worked in his studio as assistants. Walter became Whistler's student and copied his methods and style. Walter spent much of his life in poverty until he was 'rediscovered' in 1911; sometime during the 1880s Whistler had fallen out with Walter and the two did not speak again.

PAINTED

London

MEDIUM

Oil on canvas

SIMILAR WORKS

Portrait of Theodore Duret Edouard Manet, 1868

Self Portrait Edward Degas, 1855

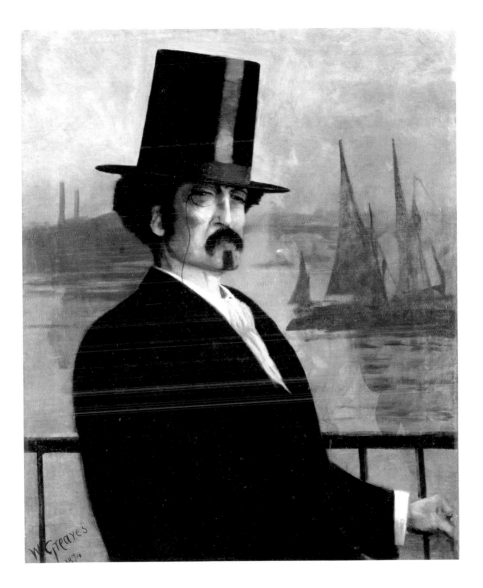

Whistler, James

Harmony in Flesh Colour and Black: Portrait of Miss Louise Jopling (1843–1933), 1877

© Hunterian Art Gallery, University of Glasgow, Scotland/www.bridgeman.co.uk

The Victorian era saw a rise in haute couture and fashion was becoming more available to a wider social group of women. Fashion and art have had a long relationship and during this period with the popularity of portraiture amongst the socially established and the socially up and coming, it became ever more important. With the increase in public art exhibitions, where portraits would be shown, the dress of the sitter became more and more relevant. In 1879 John Everett Millais (1829–96) painted Louise Jopling in a black dress with embroidered flowers that sparked a trend for dresses of a similar colour and design. Whistler referred to Millais' picture as a 'great work', and the two make an interesting comparison.

Whistler painted his portrait of Louise Jopling two years earlier, in 1877, and shows her from the back, in a creamy pink sheath-like dress, tied back over a black skirt with a long narrow train. Louise Jopling was a great friend of Millais and an accomplished artist in her own right, she was the first woman to be elected as a member of the Royal Society of British Artists.

PAINTED

London

MEDIUM

Oil on canvas

SERIES/PERIOD/MOVEMENT

Portraits

SIMILAR WORKS

Portrait of Mrs Robert Harrison John Singer Sargent, 1886

Mrs Charles Hunter John Singer Sargent, 1898

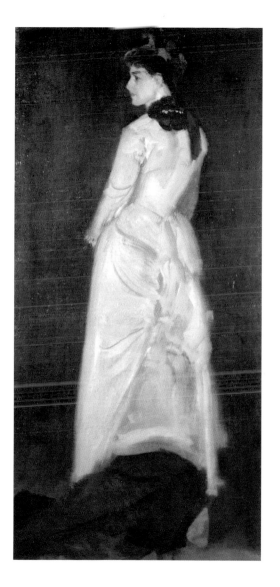

Whistler, James

Harmony in Pink and Grey: Lady Meux, 1881

After the Ruskin/Whistler lawsuit, and his ensuing bankruptcy in 1879, Whistler found himself relegated to the fringes of the society circles and was viewed as a 'risky' painter to associate with. This resulted in many of his late portraits being commissioned by clients who also found themselves unaccepted, or who simply didn't care. This in turn gave Whistler the freedom to explore costume, poses and techniques with his portraits that would not necessarily have been acceptable to his former conservative clients. Lady Meux was a case in point and one of the more colourful characters of this period. Born into a working-class family she met the young Henry Bruce Meux, the rich son of a baronet, in the Horseshoe Tavern in Holborn. The two married in secret and Henry showered his new wife with jewels and expensive clothing. She was never accepted by his family and was never received into the social circles that Henry had once been a part of.

Whistler painted two portraits of her, *Arrangement in Black No 5* and *Harmony in Pink and Grey*. Both pictures appear to have been painted primarily to highlight her obvious charms and wardrobe. The soft palette of pretty greys and pinks, and the exquisite rendering of Lady Meux's face, depict a society portrait at its best. There is no clue that the subject is anything other than the lady she appears to be, and the painting was greatly admired by the Meuxs who commissioned two more portraits of her, although one was unfinished and the other never started.

PAINTED

London

MEDIUM

Oil on canvas

SERIES/PERIOD/MOVEMENT

Late portraits

SIMILAR WORKS

Madame X (Madame Pierre Gautreau) John Singer Sargent

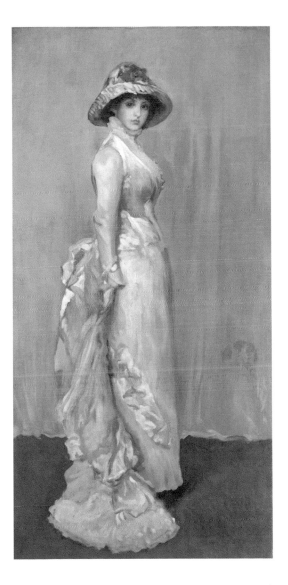

Monet, Claude
The Dinner, 1868–69 (detail)

Acceptance by the Salon spelt success for artists of the day and helped to secure commissions and wealthy patrons, although it did not accept the avant-garde of any kind. Monet began his long career with two canvases being accepted in 1865. They were well received and it was a sensible move by him to try and establish himself within the acceptable conservative constraints. By the following year he had embarked on the mammoth *Picnic*, a new approach to painting contemporary life and the beginning of his diversity from the mainstream of Salon art. He was to have only three more pictures accepted by the Salon, *Camille* and *Pavé de Chailly* in 1866, and *Ships Leaving the Jetties of Le Havre* in 1868.

By the end of 1867 Camille had given birth to Monet's son, Jean, and the family were in desperate financial shape. It is significant how the rejection from the art establishment increased the importance of family and the acceptance, support and stability that the family unit provides. *The Dinner*, 1868–69 shows the close family unit during the communal ritual of dinner. Monet was to again paint the family group, in *The Luncheon* 1868–69, an intensely personal painting of his own family; the artist's chair is significantly empty, awaiting his return. This painting was conservative in its subject and style and it would have been a huge disappointment to Monet when it was rejected by the Salon jury.

PAINTED

Le Havre

MEDIUM

Oil on canvas

SERIES/PERIOD/MOVEMENT

Impressionist, interior

SIMILAR WORKS

Luncheon in the Studio Edouard Manet, 1868

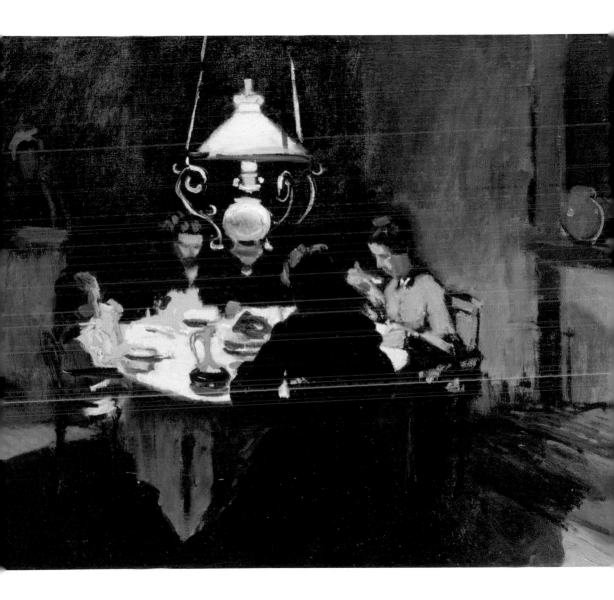

Monet, Claude
The Coal Workers, 1875

The Coal Workers, 1875 is unusual in that it is one of the few paintings Monet executed showing people at work within an industrial context. He has removed the human element of the labourers by focusing on the pattern and arrangement of the scene rather than the workers themselves. The figures on their planks are reduced to anonymity and become simply a decorative element within the larger composition. In 1875 an auction was held at the Hotel Drouot in which Monet, Berthe Morisot (1841–95), Sisley and Auguste Renoir (1841–1919) sold off their works. *The Coal Workers* was bought by a banker, but the overall outcome of the auction was very poor. The event was derided in the press by the critics, and marked the beginning of an eight-year period of severe financial difficulties for Monet. It is significant that at this time the new Republic had only been established for a few months, and MacMahon's *l'ordre moral* was in full swing, demanding a return to morally elevating art.

Monet rarely used industry as the primary subject for his paintings, with the exception of his La Gare St Lazare pictures of the late 1870s. He focused on painting the bourgeois at leisure and harmonious landscapes, over heavily industrial scenes. When factories do appear in his landscapes, they do so as distant images, with smoke plumes hovering hazily in the sky.

PAINTED

Asnières

MEDIUM

Oil on canvas

SERIES/PERIOD/MOVEMENT

Impressionist

SIMILAR WORKS

The Coast of Kujukuri in the Province of Kazusa Utagawa Hiroshige, 1853–56

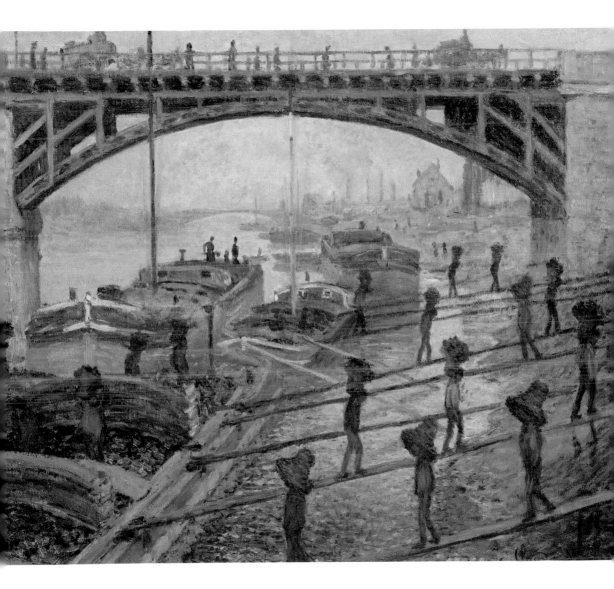

Monet, Claude
La Grenouillère, 1869

Monet and Renoir painted together at La Grenouillère. In a letter from Renoir to Bazille, he wrote, 'I'm almost always with my friend Monet ... we don't eat every day. All the same I'm happy because as far as painting goes, Monet is good company'. La Grenouillère was a popular holiday spot for Parisians, made all the more fashionable by the recent visit of the Emperor and Empress of the French Republic who had stopped there during a tour of the Seine. Both artists were struggling financially and their choice of subject in painting La Grenouillère would have been based on the assumption that the pictures would appeal to the bourgeois patrons of the area. It was Monet's wish to create a grand-scale painting for the Salon, although he ended up executing several smaller canvases.

La Grenouillère, 1869, was a small work that he would probably have executed for the most part *en plein air*. Although his subject matter is, on the surface, that of the middle classes enjoying their leisure time, the true nature of his painting is the reflection of light on the water. The figures in their Impressionist rendering lose their identity, becoming decorative elements in the overall pattern of light and colour. The composition is strong, emphasized by the sharp diagonal of the boats and the dominant central tree, so that the pictorial plane is broken into sections, which are then unified by the short brushstrokes he used to suggest the fragmented colours of reflections.

PAINTED

La Grenouillère

MEDIUM

Oil on canvas

SERIES/PERIOD/MOVEMENT

Impressionist, La Grenouillère group

SIMILAR WORKS

La Grenouillère Auguste Renoir, 1869

Monet, Claude

Promenade near Argenteuil, 1873

On his return from London Monet settled in Argenteuil, near Paris, which was experiencing a period of enormous growth as the Parisian population sought to move to the suburbs. Monet painted the town and its surrounding countryside exhaustively, documenting sights at different times of the day and under different weather conditions. Any aspects of the modernization process that he depicted, he transformed into something of beauty and harmony. This was a period when the artist looked to the family as a major content within his paintings, whether it was the family in the enclosed garden, or in the countryside. He continued to paint pictures of light and beauty, quite oblivious to modern changes of the times. Both Emile Zola (1840–1902) and Théophile Gautier (1811–72) expressed surprise that paintings in the Salon of 1872 made no references to the atrocities that had occurred in Paris and the surrounding areas during the blood bath of 1871.

During 1872 and 1873 Monet enjoyed an upturn in his finances mostly based on the purchases of Paul Durand-Ruel. He was able to provide a comfortable home and living for his family in Argenteuil and paintings such as Camille in the garden with Jean, and his *Nursemaid*, 1873, reflect this. Promenade near Argenteuil, 1873, is a typical painting of this period for Monet. The contented family group, probably based on his own family, are enjoying the benefits of a sunny day in beautiful countryside.

PAINTED

Near Argenteuil

MEDIUM

Oil on canvas

SERIES/PERIOD/MOVEMENT

Impressionist, Argenteuil

SIMILAR WORKS

The Fields Alfred Sisley, 1874

Monet, Claude

Portrait of Madame Louis Joachim Gaudibert, 1868

Louis Joachim Gaudibert was a successful industrialist from Le Havre, who paid for Monet to reside in a chateau near the town of Le Havre in order to undertake portrait commissions for his family. This was fortuitous timing for Monet, who had just been evicted from his lodgings in Bennecourt on the Seine and was virtually destitute. He wrote to his friend Bazille, 'Thanks to this gentleman in Le Havre who has come to my aid, I enjoy the most perfect tranquillity, since I am free from all worries, so I'd like to remain always in this situation in a corner of nature as tranquil as this.'.

The portrait of Mrs Gaudibert is unusual, both in the scheme of Monet's work, but also in his composition. Portraiture, although it could be lucrative, was not significant within Monet's work. By painting the subject facing away from the painter he chose a fairly unique pose, which could be argued to defeat the purpose of portraiture. The emphasis is placed on the dress of the subject instead of the subject herself. The movement through the fabric, and of her body and hands, suggests that she has just turned, giving the picture the photographic snapshot feel of the immediacy of the moment. An interesting comparison with this painting is that of Whistler's, *Arrangement in Black, No. 2: Portrait of Mrs Louise Huth*, where the pose of the figure is the exact opposite to Monet's.

PAINTED

Le Havre

MEDIUM

Oil on canvas

SERIES/PERIOD/MOVEMENT

Impressionist, portrait

SIMILAR WORKS

Arrangement in Black, No. 2: Portrait of Mrs Louise Huth James Whistler, 1870–72

Kate Perugini Sir John Everett Millais, 1880

Turner, J.M.W.

The *Victory* Coming up the Channel with the Body of Nelson, c. 1806–08 (detail)

The Battle of Trafalgar took place on 21 October 1805 off the Cape of Trafalgar on the Spanish coastline. It was the last great sea battle of the period, fought between the combined fleets of Spain and France and the British Royal Navy, and was the culmination of a long campaign. Nelson, on board the war ship *Victory*, was convinced of his own forthcoming demise and had said his farewells to friends and family. He was struck in the shoulder by a musket ball and, as he lay dying, Captain Hardy informed him the battle was won. Nelson's last words were 'Thank God I have done my duty'; he was the greatest hero of the time.

Turner travelled to sketch the *Victory* as she sailed into the Medway and produced a sketchbook of drawings, from which this pen and ink drawing was made. It should be noted that he has changed the view in the background from the way he would initially have seen it. He painted a number of scenes from the Battle of Trafalgar, including the massive picture commissioned in 1823, Battle of Trafalgar, which is the visual representation of both his patriotism and his love for the sea.

PAINTED

London

MEDIUM

Pen and ink and watercolour on paper

SERIES/PERIOD/MOVEMENT

Nelson sketchbooks

SIMILAR WORKS

The Death of Lord Viscount Nelson, James Heath after Benjamin West

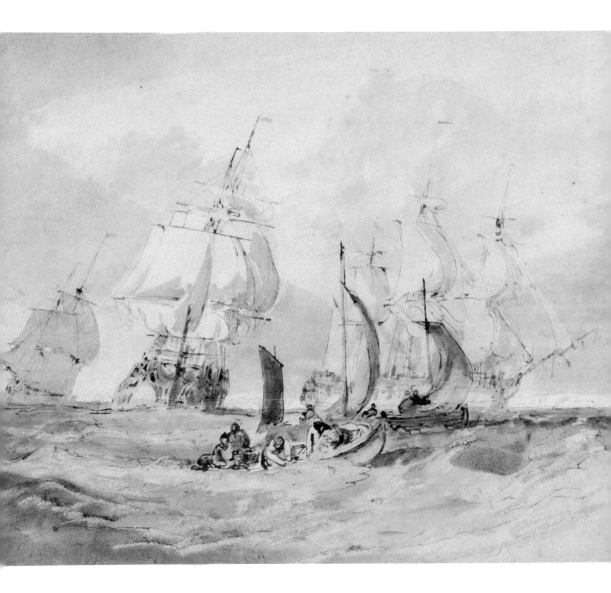

Turner, J.M.W.

The Battle of Trafalgar, as seen from the Mizen Starboard Shrouds of the *Victory*, 1806–08

The resounding victory of the British at the Battle of Trafalgar was a national triumph that cemented an overriding British patriotism of the time. Finally the nation's maritime supremacy was unquestionable and the long fear of invasion by Napoleon was gone. To that gain, however, Nelson, the British hero, was dead, sacrificed for the sake of the people. On hearing of his death people flocked to greet his warship, *Victory*, as she sailed home bearing his body into the Medway, before being anchored off Sheerness. Turner quickly produced *The Battle of Trafalgar, as seen from the Mizen Starboard Shrouds of the* Victory articulating the energy and passion of the recent event onto canvas. The picture was exhibited at Turner's gallery in 1806, but was criticized for its unfinished look. He later reworked the painting and showed it at the British Institution in 1808, where it was received much more favourably and his use of strong chiaroscuro and rich colour was duly applauded.

PAINTED

London

MEDIUM

Oil on canvas

SERIES/PERIOD/MOVEMENT

Trafalgar Commemorative pieces

SIMILAR WORKS

Sketch for Battle of Trafalgar Clarkson Frederick Stanfield, 1833

Battle of Camperdown Philip James de Loutherbourg, 1799

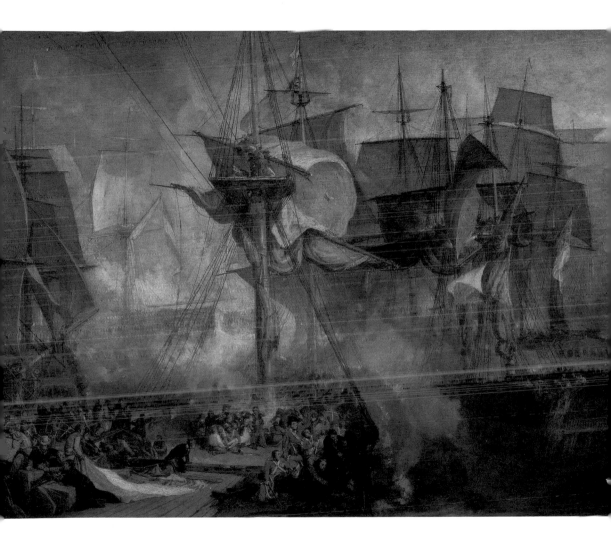

Turner, J.M.W.

The *Fighting Temeraire* Tugged to her Last Berth to be Broken up, before 1839 (detail)

© National Gallery, London, UK/www.bridgeman.co.uk

The *Fighting Temeraire* was a warship of 98 guns that was launched in 1798 and accompanied Nelson's ship *Victory* at the Battle of Trafalgar. In this painting Turner commemorates the final journey of the old ship as she is towed up the Thames to be broken up. In the later years of the 1830s there was a renewed public interest in the old warships from the Napoleonic era that would have partly inspired Turner's vision. However, the painting can also be seen as a comment on the decline of Britain's mercantile power and his use of the evocative setting sun strongly symbolizes both this and the demise of the ship.

An interesting point to note is the juxtaposition of the fragile beauty of the old sailing boat being pulled to its destruction by the squat strength of the steam tugboat. This was a time when the advent of steam was taking hold and surpassing that of the old sailing boats; the advancement of steam power was something that Turner was fascinated by. The picture was first exhibited in 1839 at the RA, accompanied by two lines paraphrasing Thomas Campbell's 'Ye Mariners of England': The flag which braved the battle and the breeze, / No longer owns her.

PAINTED

London

MEDIUM

Oil on canvas

SERIES/PERIOD/MOVEMENT

Trafalgar Commemorative pieces

SIMILAR WORKS

Seascape with Yacht and Tugboat Gustave Le Gray, 1850

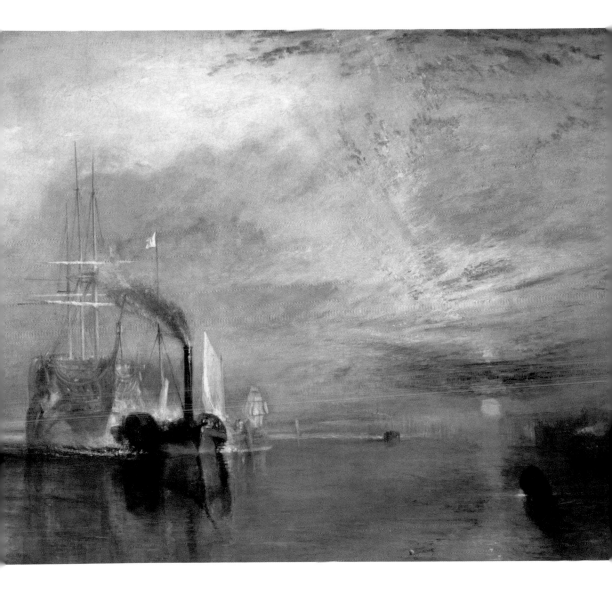

Turner, J.M.W.

Rain, Steam and Speed, The Great Western Railway, before 1844 (detail)

© National Gallery, London, UK/www.bridgeman.co.uk

The technological advances during Turner's lifetime came thick and fast. The advent of steam power, first in boats and then on the railways, had a massive effect on the population. Suddenly travel was an option to those who could afford it, and it was the start of the 'shrinking world' that we now experience, where no place is too far. Queen Victoria had come to the throne in 1837 and that same year Euston Station, the first railway station in London, was opened. The following year saw the first electric telegraph and in the six years, from 1836 to 1841, the Great Western Railway was built by Brunel, running from London to Bristol.

Turner's innovative depiction of a steam train cutting a swathe through the country remains one of his most famous paintings. It was stunningly modern in its visualisation and became hugely influential to the French Impressionists. Ruskin was unenthusiastic and the rest of the media was divided between amazement and admiration. The painting has been identified as showing a bridge over the Thames at Maidenhead, and the story goes that Turner was on the train during a storm and put his head out of the window so that he could observe the effect, getting soaked in the process.

PAINTED

London

MEDIUM

Oil on canvas

SERIES/PERIOD/MOVEMENT

Late works, effects of nature, energy

SIMILAR WORKS

Rainstorm Over the Sea John Constable, c. 1824–28

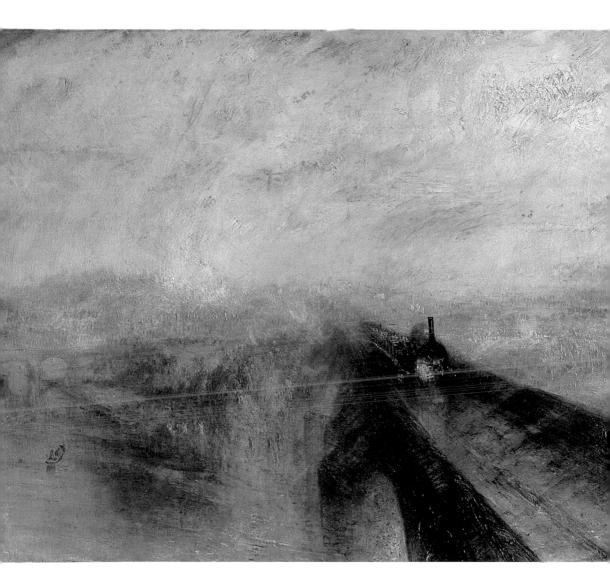

Turner, J.M.W.
Heidelberg, *c.* 1844–45 (detail)

In the nineteenth century, with the improvement of transport, the middle and upper classes were able to travel more easily, widely and frequently. Touring Europe, the grand tour, was highly fashionable amongst those that could afford it. Any trip to Rhineland was not complete without a visit to the picturesque town of Heidelberg, whose sprawling castle ruins, stone bridge and spectacular surrounding countryside were the subject of countless artists' paintings.

Turner made several trips to the town, first in 1833 and then again in the 1840s. He produced many drawings, two finished watercolours, watercolour sketches and an oil painting that was never exhibited. This painting alludes to the short-lived court of Elizabeth, sister of Charles I, who was known as the Winter Queen. She married Frederick Elector Palatine in 1613 and lived for a short time in the grand castle at Heidelberg before spending most of her life in exile after Frederick's failed attempt to hold the crown of Bohemia. Turner has chosen to depict the castle as it would have appeared during her time there.

PAINTED

London

MEDIUM

Oil on canvas

SERIES/PERIOD/MOVEMENT

Late works

SIMILAR WORKS

An Avalanche in the Alps Philip de Loutherbourg, c. 1803

Cwm Trefaen William Holman Hunt, c. 1855

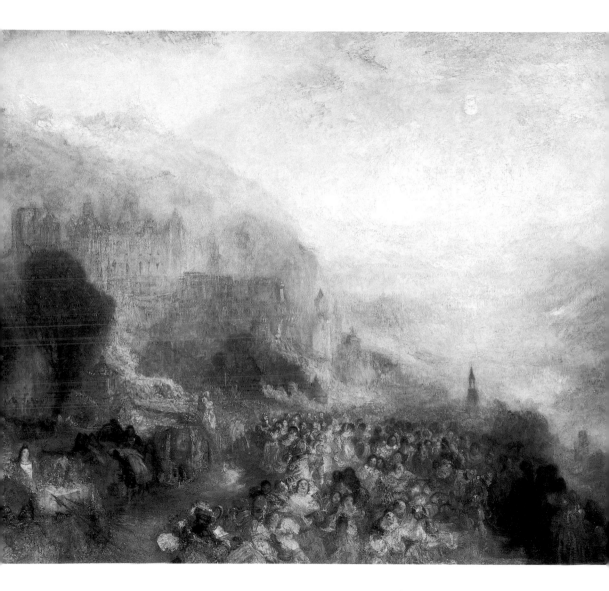

Turner, J.M.W.

Ancient Rome; Agrippina Landing with the Ashes of Germanicus, exhib. 1839 (detail)

The National Gallery in Trafalgar Square was completed in 1838 by William Wilkins (1778–1839) and was a significant event for artists and the public alike. At the same time, work was forging ahead on the Fitzwilliam Museum at Cambridge. The same year saw the first electric telegraph, the establishment of the Anti-Corn Law League by Richard Cobden and the publishing of the People's Charter. Turner's friend and patron, Lord Egremont, died in November 1837, leaving him with a gaping sense of loss and signalling the end of an entertaining era; that of the Petworth visits.

Around this time Turner painted a pair of pictures, *Ancient Rome; Agrippina Landing with the Ashes of Germanicus* and *Modern Rome – Campo Vaccino*, following on from his paired pictures the year before of Ancient Italy and Modern Italy. *Agrippina Landing with the Ashes of Germanicus* was a popular subject with painters of the time as an *exemplum virtutis* – virtuous example – of a dutiful wife. Germanicus, nephew to the Emperor Tiberius, died in Antioch and his widow Agrippina brings his ashes home, actually landing in Brindisi, not Rome.

Both paintings were criticized in their use of colour, especially the yellow and, 'in their distraction and confusion, represent nothing in heaven or earth, and least of all that which they profess to represent, the co-existent influence of sun and moon', *Blackwoods Magazine*.

PAINTED

London

MEDIUM

Oil on canvas

SIMILAR WORKS

Entrance to Pisa from Leghorn Sir Augustus Wall Callcott, exhib. 1833

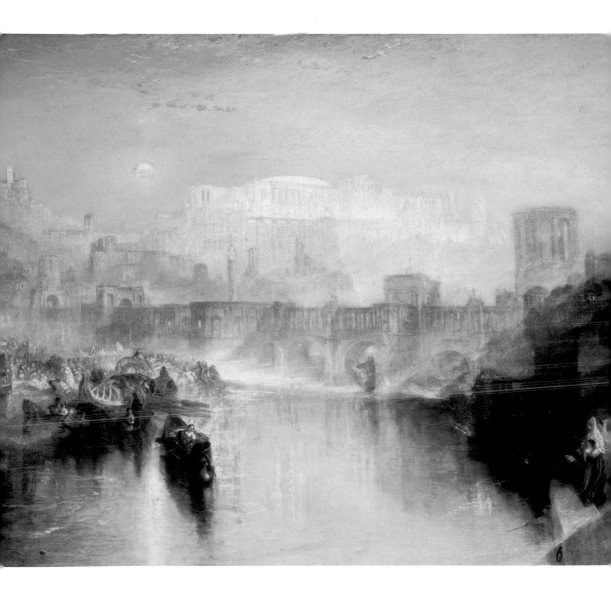

Monet, Claude

The Rue Saint-Denis, Celebration of June 30, 1878

© Musee des Beaux-Arts, Rouen, France, Lauros/Giraudon/Bridgeman Art Library/www.bridgeman.co.uk

By 1877 Monet was again in financial turmoil. Camille was pregnant and desperately ill and they had to leave their home of seven years in Argenteuil, begging not to have their possessions seized. Added to this was the bankruptcy of Ernest Hoschedé, one of Monet's main patrons, and the sale of his effects, including many of Monet's canvases. Monet and Camille moved from Argenteuil to Paris for a short time, during which period he painted mainly pictures of contemporary life within their urban context.

The Exposition Universelle, designed to promote the regeneration of France, especially Paris, opened on 30 June 1878. The day was marked with a national holiday, Fête du 30 Juin, which was the first national holiday to be observed since 1869. Monet produced his painting as a brilliant evocation of the gaiety and energy of the day. He used the bird's-eye view that both he and Pissarro favoured and executed the picture with strong, fast brushstrokes and contrasting jewel-like colour with the dark of the crowds. Highly Impressionistic, the crowds merge into one seething mass of humanity with no face, becoming secondary to the flags. His use of perspective is especially interesting, the dominant flag in the middle of the canvas being disproportionately large in view of the vanishing point of the street below it.

PAINTED

Paris

MEDIUM

Oil on canvas

SERIES/PERIOD/MOVEMENT

Impressionist

SIMILAR WORKS

The Fourteenth of July at Marly-le-Roi Alfred Sisley, 1875

The Rue Mosnier Decked with Flags Edouard Manet, 1878

Whistler, James

Arrangement in Grey and Black No. 1, Portrait of the Artist's Mother, 1871

This painting has become one of Whistler's best-known and reproduced, but achieved little recognition at the time of its execution. It was Whistler's aim with this, and subsequent portrait paintings such as that of Thomas Carlyle, to achieve a balance with the arrangement of colour and form while capturing the essence of the character of his subject. He used the plain and austere background of his grey-walled studio and placed his mother in the monumental seated pose, reminiscent of Canova's (1757–1822) portrait of Napoleon's mother at Chatsworth. That he has looked to Diego de Silva Velásquez (1599–1660) and Frans Hals (1581–1666) is without question, but his image also evokes the folk art of silhouette. The quiet repose of his mother, her patience and acceptance of the losses she has endured, through the death of her husband and two children, is clearly represented.

The picture was almost rejected by the RA in 1872 and was criticized for being overly severe and barren. With reference to this Whistler suggested to Walter Sickert (1860–1942) that the addition of 'a glass of sherry and the bible' might have satisfied the critics; a particularly humorous comment in light of his mother's devout Christianity.

PAINTED

London

MEDIUM

Oil on canvas

SERIES/PERIOD/MOVEMENT

Portraits, 1870s

SIMILAR WORKS

Mrs Edwin Edwards, Charles Keene

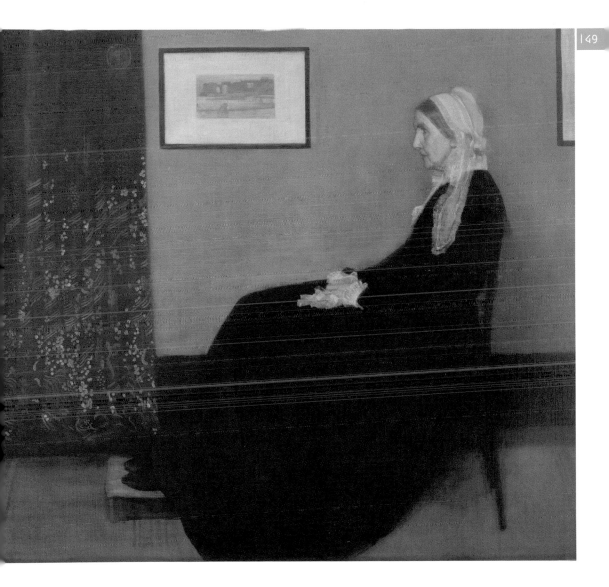

Jeckyll, Thomas & Whistler, James
The Peacock Room, 1876–77

During the second half of the nineteenth century all things Oriental were highly fashionable. The opening of Japan in 1855 had sparked an influx of Japanese and Oriental art and artefacts to Europe, and Whistler and many of his contemporaries were avid collectors. In 1862, at the International Exhibition in London, a great number of Chinese and Japanese exhibits were on show, as well as contemporary decorative arts of Oriental inspiration by the likes of Marshall and Faulkner & Co. The decorations in the Peacock Room are Oriental in inspiration and were finished using a highly lacquered technique similar to that used on Japanese works.

The Peacock Room scheme was commissioned by F. R. Leyland to decorate the dining room in his London home. Thomas Jeckyll (1827–81) worked on adapting the room to house Leyland's collection of porcelain, and Whistler was to arrange the colour scheme. The exact nature of Whistler's commission is not clear, but he exceeded his original guidelines and became carried away with his exquisite blue and gold Peacock design. Leyland only paid half of Whistler's bill, as he believed Whistler had far exceeded the original commission. Whistler continued with the room and then organized a press view of it in 1877, without consulting Leyland. His former patron was so incensed by Whistler's audacity that he ordered him never to set foot in his house again. Whistler held Leyland largely responsible for his ensuing bankruptcy.

PAINTED

London

MEDIUM

Various

SERIES/PERIOD/MOVEMENT

Decorative

SIMILAR WORKS

The New Moon Fan Charles Conder, 1896

Whistler, James
Three Figures: Pink and Grey, 1868–78 (detail)

In 1865 Whistler and Fantin-Latour invited Albert Moore to join their Societé des Trois after Legros had departed. Moore was the master of depicting toga-draped Classical ladies and Whistler was an admirer of his work. In 1867 there was an exhibition of Ingres' work in Paris, which was reflective of the growing fashion in England for all things Classical. Whistler turned his back on the Realism of Courbet and embraced the Classical pose of Ingres; his contemporaries, Rossetti and Edward Burne-Jones (1833–98) had also absorbed elements of Ingres' style into their own. It was against this climate that Whistler embarked on the Six Projects, a series of six oil sketches made for a frieze commissioned by F. R. Leyland. At this time Whistler was working from a studio near to the British Museum where he would have seen the extensive collection of Tanagra statues. He later adapted his posed female figures from these statues, executing the Six Projects with the Classical drawing of Ingres, the colour of Delacroix and the adornment of Japanese painting.

The pictures, of which *Three Figures: Pink and Grey* is one, are without narrative content and are purely decorative, evocative of mood and atmosphere. His use of colour through this series, which is unfinished, is handled beatifully, from rich and vibrant to soft and delicate and, as such, the Six Projects remain one of his most outstanding achievements in palette and tone.

PAINTED

London

MEDIUM

Oil on canvas

SERIES/PERIOD/MOVEMENT

The Six Projects

SIMILAR WORKS

Mirror of Venus Edward Burne-Jones, 1867

Whistler, James

Study for Symphony in Flesh Colour and Pink: Mrs Leyland, 1871–74

The relationship of Whistler with F. R. Leyland, one of his most significant patrons, was often turbulent, made more so perhaps by Mrs Leyland. Whistler and the Leyland women got on well, he was at one point briefly engaged to Mrs Leyland's sister, Elizabeth Dawson, and often accompanied the women in Leyland's absence. Frederick and his wife Frances were thought to be having marital problems during the 1870s which was during the period that Whistler was spending long periods of time drawing and painting the family members. *Symphony in Flesh Colour and Pink: Mrs Leyland* is one of his most famous portraits, and Whistler made many sketches for the final piece, of which this is one.

This study was probably executed using a different model, since Whistler has left out any detail of the face. He would have used Maud Franklin to pose in the dress and she would later become his mistress. The dress itself was unusual. Firstly Whistler had himself designed the gown, even though Frances was keen to wear a different robe in black velvet. Secondly the style of the dress was not entirely in keeping with the fashions of the day, but was based upon the 'tea gown', a flowing dress that was new to Victorian society and did not achieve real popularity until the late 1870s.

PAINTED

London

MEDIUM

Chalk and pastel on brown paper

SERIES/PERIOD/MOVEMENT

Leyland Portraits

SIMILAR WORKS

Dorothy Barnard John Singer Sargent, 1885

Whistler, James

Nocturne in Black and Gold, the Falling Rocket, *c.* 1875

This painting was at the root of the Ruskin/Whistler libel suit that led to Whistler's financial ruin in spite of winning the case. He was famously awarded a farthing in damages and no costs, and he never forgave the British art establishment. Ruskin heavily criticized the painting, with the ensuing media circus doing untold damage to Whistler's reputation as an artist and greatly limiting his patrons. The wider focus of the case, however, was Whistler's argument of 'art for art's sake' that was to have a far more profound effect on the traditional ideas of the art establishment. The hostility and furore that Whistler's painting caused was pre-emptive of the attitude towards the Impressionist painters, felt in both England and France.

Whistler's picture depicts a fireworks display at Cremorne Gardens, although the subject of the picture is secondary to the atmospheric effects it creates. Throughout the trial Whistler referred to his paintings as 'arrangements', 'symphonies' and 'nocturnes', avoiding the word 'picture', which could wrongly imply to the jury a realistic view. Whistler's greatest concern with this series of paintings, his Nocturnes, was not the subject, but the effect, and it was this notion that was so misunderstood by much of the contemporaneous society. In Whistler's own words, 'Art should be independent of all clap-trap – should stand alone, and appeal to the artistic sense of eye or ear, without confounding this with emotions entirely foreign to it, as devotion, pity, love, patriotism, and the like.'.

PAINTED

London

MEDIUM

Oil on wood

SERIES/PERIOD/MOVEMENT

Nocturnes, Impressionist

SIMILAR WORKS

Boulevard Montmarte by Night Camille Pissarro, 1897

Monet, Claude
The Beach at Trouville, 1870

In 1869 press censorship had been lifted, which had resulted in vitriolic oppositional publications, revelling in the new media opportunities. Simultaneously the working classes were swelling with resentment against the emperor resulting in a huge demonstration in January 1870. Against this, Monet continued to paint his charming depictions of the middle class at leisure. In June of that year Monet married Camille against fierce opposition from his family and they then travelled to Trouville to spend the summer months painting. The painter Eugène Boudin (1824–98) had had great success with his paintings of Trouville, which was a popular holiday destination, and Monet no doubt wished to follow suit. It was during that summer season that Napoleon declared war on Prussia and at the end of the season Monet fled to London.

The spatial arrangement of *The Beach at Trouville*, 1870, is unusual, with a frieze-like structure with the figures pressed up into the foreground and a wide, virtually empty background, with a distinct lack of middle ground. The two people, probably Camille and the nanny, are typical in their lack of interaction with each other. Monet's figures invariably exist as contained within their own world, irrespective of those around them.

PAINTED

Trouville

MEDIUM

Oil on canvas

SERIES/PERIOD/MOVEMENT

Impressionist

SIMILAR WORKS

The Harbour of Lorient, Brittany Berthe Morisot, 1869

Beach at Trouville Eugène Boudin, 1863

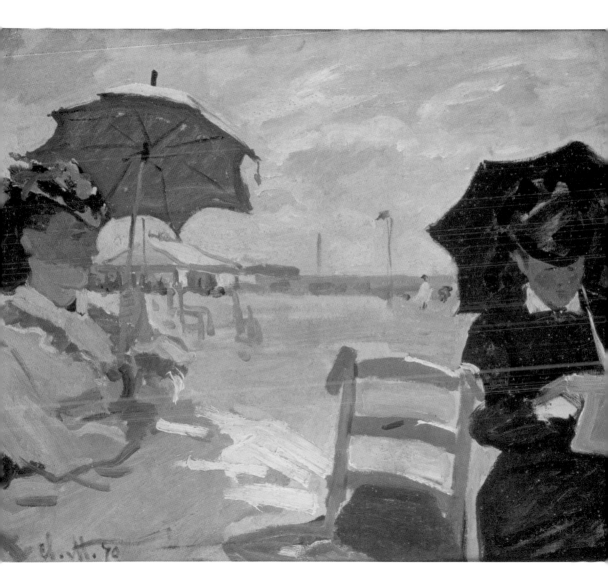

Turner, Whistler, Monet

Places

Turner, J.M.W.

London from Greenwich Park, exhib. 1809

Turner had a long association with water, both with the sea in his marine paintings and especially with the Thames, which he painted and sketched continuously throughout his life. At this time, the Thames had become symbolic of Britain's growing marine, commercial and imperial power, and was the artery that led directly to the heart of the country – London. Turner's depiction of London in the Greenwich Park painting, however, is as a faint skyline beyond and behind both the silvery reflection of the busy Thames and the topographically detailed Royal Naval Hospital and the Queen's House. He places a curious contrast between the countryside, seen in the foreground, and the city, which he chose to use as the painting's subject. He exhibited the work with the following accompanying verses,

Where burthen'd Thames reflects the crowded sail,/Commercial care and busy toil prevail,/Whose murky veil, aspiring to the skies,/Obscures thy beauty, and thy form denies,/Save where thy spires pierce the doubtful air,/As gleams of hope amidst a world of care. These words would suggest that, despite the beautiful detailing of the grand historic buildings and the patriotism attached to them, Turner was far from impressed with the pollution and industrial activity of the capital city. It is interesting to note that he has included P.P. to his signature, referring to his election to Professor of Perspective at the Royal Academy (RA) in 1807.

PAINTED

London

MEDIUM

Oil on canvas

SERIES/PERIOD/MOVEMENT

Views of London

SIMILAR WORKS

View on the Thames – Greenwich in the Distance Patrick Nasmyth, 1820

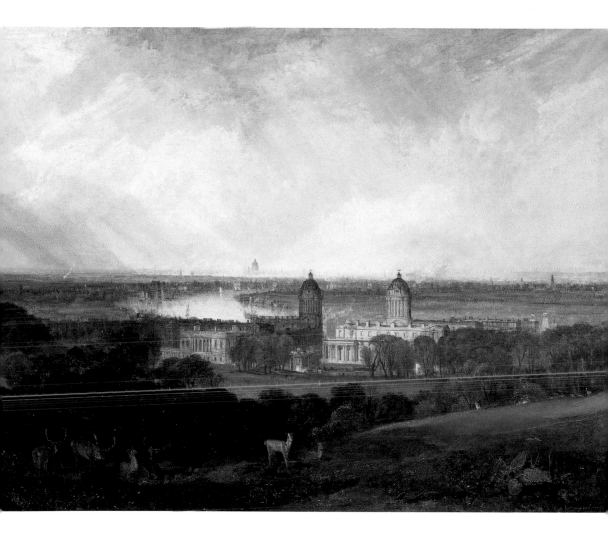

Turner, J.M.W.

Old Blackfriars Bridge, 1795

Turner and London seem to have had a curious relationship. Turner was born in London and lived there for most of his life, participating actively in academic, intellectual, scientific and artistic circles, and always hovering within the umbrella of the RA. Strong though his ties were with the city, he was first and foremost a landscape painter, looking to the coast and the countryside for most of his inspiration. The paintings that he made of London often allude, in the subtlest of ways, to the unpleasant consequences of the Industrial Revolution.

Early in his career Turner came into the fold of Dr Thomas Monro. Monro was an amateur painter and collector, who had a large number of drawings and prints by Dutch, Flemish and Italian masters. He encouraged artists, such as Turner and Thomas Girtin (1775–1802), to make copies from these drawings at his house.

This finely drawn watercolour was made in 1795 and appears to be chiefly an exercise in perspective, although beautifully handled. Turner has included incredible detail in a finely linear manner and has painted the bridge from an unusual angle and low viewpoint. This picture says nothing about London as a city of industry and demonstrates Turner's interest in the effects of the sun shining on the water and off the stone of the bridge – something that would become increasingly important to him through his career.

PAINTED

London

MEDIUM

Watercolour on paper

SERIES/PERIOD/MOVEMENT

Early view of London

SIMILAR WORKS

A View of the New London Bridge British school, c. 1831

Whistler, James
The Little Pool, No. 2, 1861

© Leeds Museum and Galleries (City Art Gallery) UK/www.bridgeman.co.uk

Whistler's etchings of the Thames, and the busy life along it, focused on the working-class bare bones of industry and commerce. He would depict the docks of Rotherhithe in their shambolic disarray and the nitty-gritty of the energy behind the growth of London's industry. Here, in *The Little Pool, No. 2*, the river sweeps away and out of sight, a narrow channel between the lines of boats awaiting direction. The two figures concentrate, unaware of the presence of the painter. This was an eavesdropping technique that he used often. The etching has been swiftly done, leaving the impression that Whistler happened upon the scene and quickly drew it as he went about his business. What is interesting is that Whistler knew the figure, so that what appears a random scene was probably posed. The man standing is Serjeant Thomas, who was also a patron to Alphonse Legros (1837–1911) and William Holman Hunt (1827–1910). The figure sketching is Percy Thomas and the ghostly boy is Ralph Thomas. This etching was number 10 in the Series of *Sixteen Etchings of Scenes on the Thames and other Subjects*.

PAINTED/ETCHED

London

MEDIUM

Etching

SERIES/PERIOD/MOVEMENT

Series of Sixteen Etchings of Scenes on the Thames and other Subjects

SIMILAR WORKS

Le Pont-au-Change Charles Meryon, 1861

L'Abside de Nortre-Dame de Paris Charles Meryon, 1861

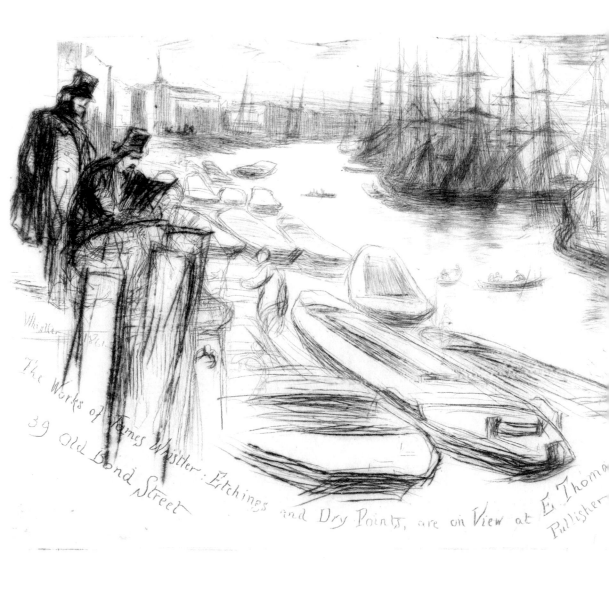

Whistler. 1861.

The Works of James Whistler: Etchings and Dry Points, are on View at E. Thomas Publisher

39 Old Bond Street

Monet, Claude

Parliament at Sunset, 1904

Monet had already visited and painted London on three separate occasions by the time of his last major London series. It was the effects of industrialism that Turner resented in his painting, that gave Monet the perfect subject to explore his favourite theme. The intense smog, generated through the belching commercialism, provided Monet with the aesthetic medium through which to convey his paintings of light and atmosphere. There was nowhere else where this particular effect was caught so well as in London and, as such, the disharmonious and ugly consequence of London's industrial growth was transformed into a thing of beauty in the hands of Monet.

His late London series produced around 95 canvases, which were grouped around three themes, Charing Cross Bridge, Waterloo Bridge and the Houses of Parliament. Monet and Whistler were on friendly terms, having lodged together for a period of time. Monet's subtitle to his *Houses of Parliament*, 1901, of *Symphonie en Rose*, was a clear debt to the musical titles that Whistler gave his paintings. Monet's paintings of the Houses of Parliament were almost always painted at sunset, or early evening, which afforded the greatest light effect on the buildings. Although the buildings were themselves the nerve centre of the burgeoning capital, he rarely painted any activity in these pictures, using the buildings as a pictorial motif to demonstrate the changing effects of the sinking sun.

PAINTED

London

MEDIUM

Oil on canvas

SERIES/PERIOD/MOVEMENT

Late London series

SIMILAR WORKS

Dulwich College Camille Pissarro, 1870

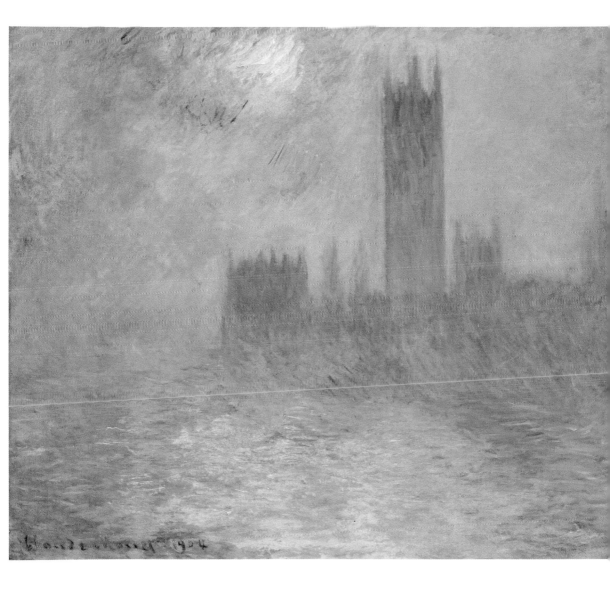

Whistler, James

Thames – Nocturne in Blue and Silver, c.1872–78

Whistler's Nocturne paintings can best be summarized in his own words, 'By using the word "nocturne" I wish to indicate an artistic interest alone, divesting the picture of any outside anecdotal interest which might have been otherwise attached to it. A nocturne is an arrangement of line, form, and colour first. The picture is throughout a problem that I attempt to solve. I make use of any means, any incident of object in nature, that will bring about this symmetrical result.'.

In trying to paint from nature to capture the immediacy of the moment and effect, Whistler was running into problems. His formal training in painting techniques were not conducive to the *plein air* methods that he needed to use to evoke the moment truly. He would drift down the Thames at night and sketch the scenes before him while committing them to memory. He would then immediately return to his studio and paint the scene, using the techniques of the British Watercolourists. By applying his paint swiftly and in thin layers, he was able to work much faster. *Nocturne in Blue and Silver* is one of the darker more mysterious of his Nocturne paintings and shows the view from Chelsea looking towards Battersea Reach. Whistler's series of Nocturne paintings constituted a 'series' by the very fact that they were all painted at night and were the artist's exploration of light, colour, atmosphere and effect. The series of Monet's, such as his Late London works took the same, or very similar, subject and painted it under different conditions.

PAINTED

London

MEDIUM

Oil on canvas

SERIES/PERIOD/MOVEMENT

Nocturnes

SIMILAR WORKS

Blackfriars Bridge; Moonlight Sketch George Price Boyce, 1863

Monet, Claude

Charing Cross Bridge, La Tamise, 1900–03

During Monet's trips to London he would always stay at the Savoy Hotel, which afforded him an excellent view of Waterloo Bridge in one direction and Charing Cross Bridge in the other. He painted a huge number of canvases of each of his subjects and would have many canvases on the go at one time. He worked extremely quickly and would, depending on the weather conditions and light, either start a new canvas, or continue working on one that was closest to the conditions at the time.

The distinct horizontality of these paintings, especially those of Charing Cross Bridge and Waterloo Bridge, have been likened in compositional format to Turner's technique of counterbalancing the verticality of the sun and its reflection with the horizontal planes of the bridges. Charing Cross Bridge was designed to bring trains from south London over the Thames and into Charing Cross Station. Turner's strong depictions of the bridge show the trains bustling across, their steam mixing and intermingling with the heavy opaque fog for which London was famous.

PAINTED

London

MEDIUM

Oil on canvas

SERIES/PERIOD/MOVEMENT

Late London series

SIMILAR WORKS

Sunrise – Gold and Grey James Whistler, 1884

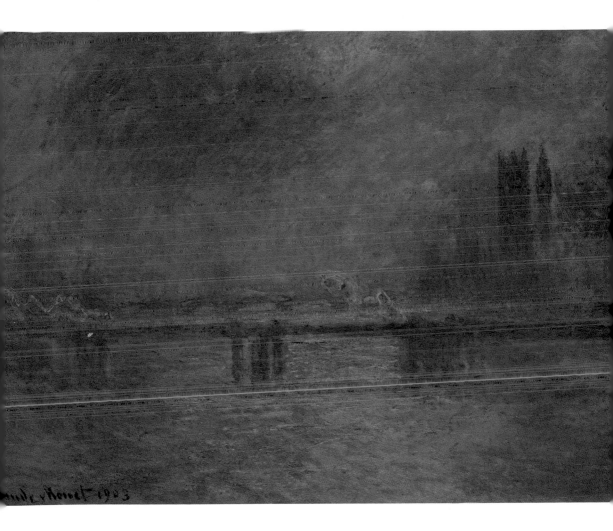

Whistler, James

Grey and Silver: The Thames

© Hunterian Art Gallery, University of Glasgow, Scotland/www.bridgeman.co.uk

The paintings of both Whistler and Monet of the Thames in London use the river and its surrounding buildings as a vehicle to convey their atmospheric effects. As such, the Industrial Revolution, which was in full swing, appeared secondary within the context of their art to the greater importance of portraying light. The chimneys were most often hazy, distant and ghostly, and the bilious smoke and outpourings transformed to something lovely. This cannot be said, however, for Whistler's *Grey and Silver: The Thames*. The pervading atmosphere in this painting is one of dreariness, the lighting is murky, the dominant tonality depressing and the factory chimneys more prominent. The sky is heavy and has the appearance of pressing down upon the buildings, further compacting the already small margin of open air against the sluggish river. There is none of the brilliance of atmosphere, no pinpricks of light to suggest any relief from the gloom. Even *Nocturne: Grey and Silver*, which was painted on a dark night, its subject barely discernible, is more up lifting than *Grey and Silver: The Thames*. The former being a picture in the dark, the latter a dark picture.

PAINTED

London

MEDIUM

Oil on canvas

SERIES/PERIOD/MOVEMENT

The Thames

SIMILAR WORKS

The Seine at Port Villez Claude Monet, 1894

Night sketch of the Thames near Hungerford Bridge George Price Boyce, c. 1866

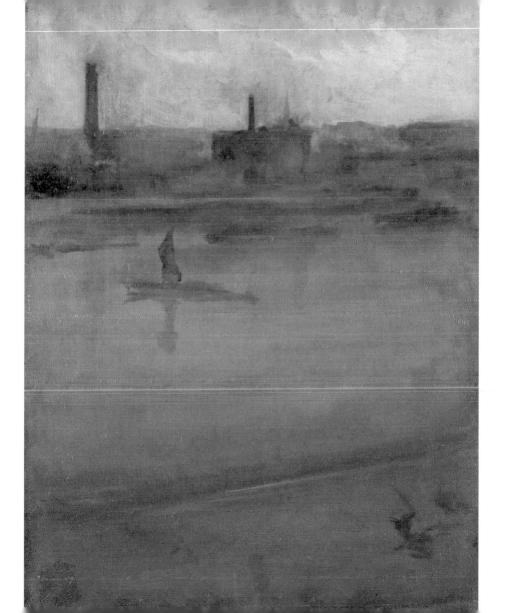

Turner, J.M.W.

The Thames above Waterloo Bridge, *c.* 1830–35

Turner was both a romantic and a realist, the combination of which are felt through out his paintings. He was hugely interested in the new inventions and technology of his time, the advances in chemistry, geology, astronomy and optics, and, of course, the work of Michael Faraday in the development of modern-day storage and distribution of electricity. He was fascinated with how things worked and why they worked, and the development of industry as seen through the landscape. The advent of steam, both for ships and trains was of huge consequence to Turner, not least because he utilized their efficiency in his extensive travels and frequently depicted them in his paintings. His attitude towards the industrial changes occurring in London is somewhat ambivalent, however: where the smoke in Monet's paintings becomes part of the sky, Turner's industrial exhaust sits boldly dark and uneasily.

The Thames above Waterloo Bridge comments on the effect of commerce on the city. The city itself is barely visible, the bridge in the subject a ghostly shape hovering beneath an onslaught of modern activity. The steamboat, the chimneys and the dark smoke blotting the sky are all images of the new age captured in a fantastic riot of colour and energy. This London is a place of drama, action and modernity, and it contrasts sharply with Constable's, *Waterloo Bridge from Whitehall Stairs*, 1817, a sparkling, clear scene complete with the royal yacht.

PAINTED

London

MEDIUM

Oil on canvas

SERIES/PERIOD/MOVEMENT

Impressionist

SIMILAR WORKS

The Opening of Waterloo Bridge John Constable, exhib. 1832

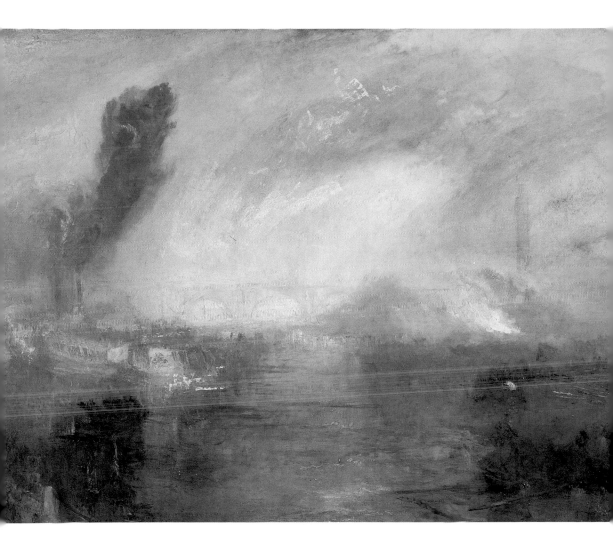

Turner, J.M.W.

Battersea Church and Bridge, with Chelsea beyond, 1797

Turner's early training with the architectural draughtsman Thomas Malton gave him the basics in perspective and picturesque topographical techniques that Turner then expanded on throughout his training at the Royal Academy. His output of precise linear and detailed drawings, sketches and etchings during his life was phenomenal, and quite at odds with the Impressionistic oils such as *The Burning of the Houses Of Lords and Commons*, 1835, in his later years. The influence of Paul Sandby (1730–1809), largely accredited with being the pioneer of watercolour sketches, can be seen Turner's early watercolours.

The delicate colouring of *Battersea Church and Bridge, with Chelsea Beyond*, 1797, reflects both Malton and Sandby, though run through with Turner's already indomitable flair. This view of the Thames pays no regard at all to the growth of London's industry, but appears as a tranquil tribute to a beautiful city, along Classical lines. The treatment of the reeds in the foreground is an interesting departure from the style of the rest of the canvas and predicts the energy with which some of his later oil painting would be imbued.

PAINTED

London

MEDIUM

Pencil and watercolour on paper

SERIES/PERIOD/MOVEMENT

Early watercolour sketches

SIMILAR WORKS

View of the Thames from Somerset House Paul Sandby

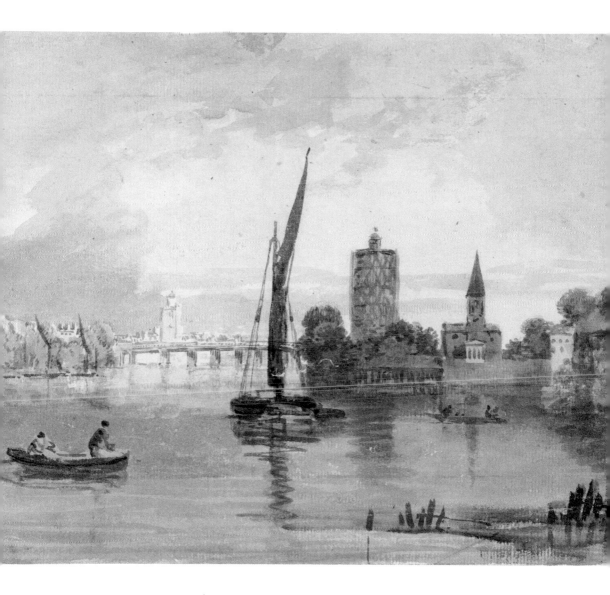

Whistler, James

Nocturne, Blue and Silver: Battersea Reach, *c.* 1872–78

© Isabella Stewart Gardner Museum, Boston Massachusetts, USA/www.bridgeman.co.uk

Whistler painted the area on the Thames surrounding Battersea time and time again, from slightly different angles and using different tonal bases. It was not an entirely surprising choice since he was living close by in Lindsey Row. His different views of Battersea were, however, united by one factor: the delicacy and exquisite handling that he applied. His series of Nocturne paintings were perhaps the pinnacle of his career with regard to his experiments of light and atmosphere. Even keeping each canvas within a small tonal range he still creates a density and richness of colour that is quite extraordinary. The mists rising from the Thames in the dusk light of *Nocturne, Blue and Silver: Battersea Reach* shroud the ghostly boat and lights, creating a mystical atmosphere with minimal pictorial elements. The key to the pictures' impact is their very simplicity, so that the colour and overall decorative effect becomes the subject, over the subject itself.

His depictions of London evoke a city dreamy in quiet brilliance. The sleeping capital appears restful and magical, where the reality of Victorian London, night-time or not, was far from the harmonious image Whistler provides us with.

PAINTED

London

MEDIUM

Oil on canvas

SERIES/PERIOD/MOVEMENT

Nocturnes

SIMILAR WORKS

Ciel d'Orage sur Dieppe Pierre Prins, 1880

Kensington Gardens, Afternoon Haze Paul Maitland

Whistler, James

Nocturne in Grey and Gold: Chelsea Snow, 1876

© Fogg Art Museum, Harvard University Art Museums, USA, Bequest of Grenville L. Winthrop/www.bridgeman.co.uk

Whistler's Nocturne paintings were originally entitled by the artist, as 'Moonlight' pieces, until his patron F. R. Leyland, suggested the use of the musical term Nocturne. Leyland was himself a keen amateur piano player and had also been instrumental in the use of 'Symphonies' to describe some of Whistler's other works. Whistler later wrote to Leyland referring to the use of 'nocturne'. 'I can't thank you too much for the name 'Nocturne' as a title for my moonlights! You have no idea what an irritation it proves to the critics and consequent pleasure to me, – besides it is really so charming and does so poetically say all I want to say and no more than I wish.'.

The Nocturne in Grey and Gold: Chelsea Snow, 1876, is quite possibly one of the most enchanting of all the Nocturne paintings, with the solitary figure heading towards the glowing warmth of a Chelsea pub on a winter night. The lights against the darks of the painting, and the reflection of the snow and the windows of lights, create an utterly fantastic atmosphere that is at once both frostily cold and warmly alluring. Whistler said of the picture, 'I care nothing for the past, present or future of the black figure, placed there because the black was wanted on that spot. All that I know is that my combination of grey and gold is the basis of the picture.'. This highlights Whistler's use of subjects as decorative elements, placed within the canvas to produce the cohesive whole of his colour objective.

PAINTED

London

MEDIUM

Oil on canvas

SERIES/PERIOD/MOVEMENT

Nocturnes

SIMILAR WORKS

View of Heath Street by Night Atkinson Grimshaw, 1882

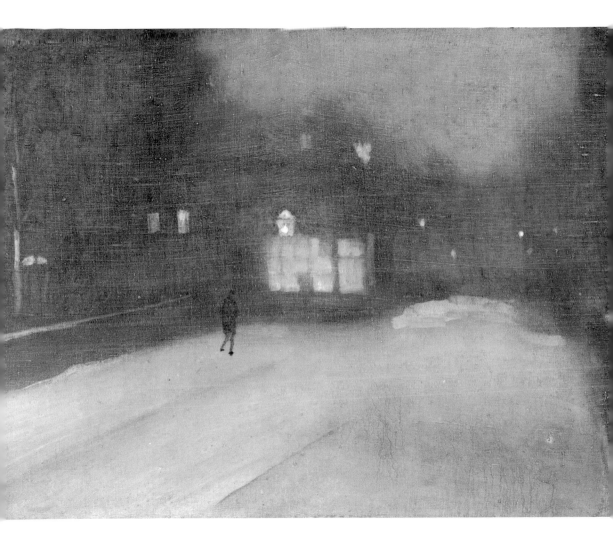

Whistler, James

Battersea Reach from Lindsey Houses, *c. 1864–71*

The peculiar quality of light that the London smog created was appreciated by very few people at the time. The smog, which on occasion became so thick that it was coined 'pea soup', was an inconvenience, dangerous and a hazard to one's health. To take this and turn it into something of beauty was the gift of the artist. Whistler credited himself with being the first to make the fog his subject and turn it into an aesthetic phenomenon, although clearly Monet, in different ways, did too. *Battersea Reach from Lindsey Houses* is believed to have been painted over a long period of time, between 1864 and 1871. The thin translucent coats of paint would indicate that it had been painted relatively quickly, so it is interesting that this is not the case. Whistler has taken the classic Victorian promenade and turned it on its head, for why are the ladies promenading when the fog is so thick that there is barely anything to see? The fashionable Victorian promenade paintings were for the most part concerned with depicting ladies in festive mode under a brilliant sun. The three figures in Whistler's painting show a clear reference to his interest in oriental art and decoration with their pose and parasols. They are a rich and dark contrast to the rest of the painting, which hovers beneath the dense fog with silhouettes shimmering in and out of focus.

PAINTED

London

MEDIUM

Oil on canvas

SERIES/PERIOD/MOVEMENT

Battersea Reach

SIMILAR WORKS

The Bridge Philip Wilson Steer, 1887

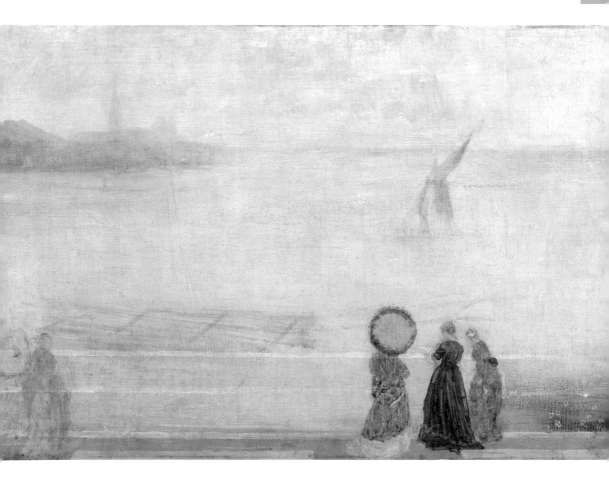

Whistler, James

Nocturne: Blue and Silver — Chelsea, 1871

This was the first in the series of Nocturne paintings that Whistler executed, and depicts the view from Battersea Bridge across the Thames to Chelsea, with the tower of Chelsea Old Church barely visible on the right hand side. According to correspondence written by the artist's mother, this was the second painting that Whistler had done on the same day, having earlier painted *Variations in Violet and Green*. This daylight portrayal of a similar view as the Nocturne shows the influence that Japanese and Oriental art was having on Whistler's work. The Nocturne picture of Chelsea was painted on a wooden panel, his colours being applied over a dark grey primer that helps to achieve the glowing luminosity and translucent beauty of the scene.

The artist Edward J. Poynter (1836-1919) wrote to Whistler after seeing both views of Chelsea in 1871, saying, 'perhaps you will allow me to say how very much I admire both the paintings, but especially the moonlight, which renders the poetical side of the scene better than any moonlight picture I ever saw.' This was high praise indeed. Poynter was one of the great Victorian Classical painters and was firmly established within the British art establishment — a privilege that Whistler never enjoyed. Poynter went on to be elected President of the RA in 1896, and was Director of the National Gallery from 1894 to 1904.

PAINTED

London

MEDIUM

Oil on wood

SERIES/PERIOD/MOVEMENT

Nocturnes

SIMILAR WORKS

Whitby Fishing Boats John Singer Sargent, 1885

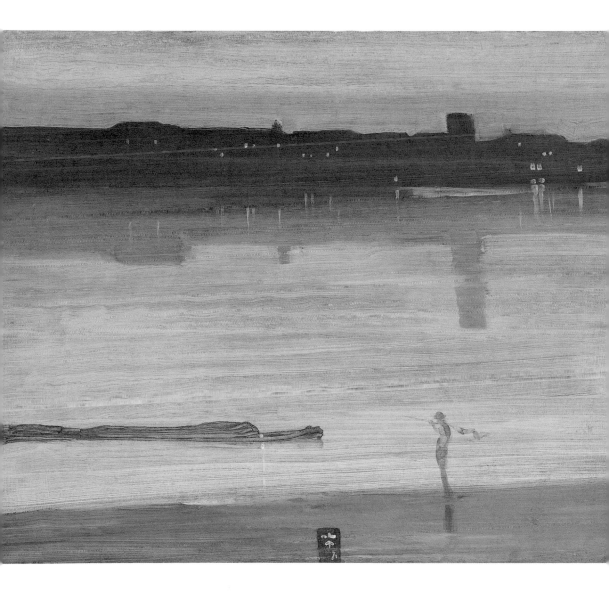

Turner, J.M.W.

A Villa, Moonlight (A Villa on the Night of a Festa di Ballo), for Roger's 'Italy', 1830, c. 1827

Due to the political climate in France and the outbreak of war in 1793, Turner was not able to visit Italy until 1819, at which time he made a six-month tour, taking in all the major cities. Italy was, and is, the realization of artistic heritage and learning for every artist and Turner was no exception. In spite of being a revolutionary artist for his time, his artistic training was firmly established through the Italian tradition and he was well versed in the Italian Old Masters through copies and engravings of the original works. On his first trip he filled 23 sketchbooks with drawings and details, documenting his journey and every aspect of Italian culture and life. He then used his sketchbooks as reference to work up finished paintings and drawings on his return to London. *A Villa, Moonlight* was one of a series of drawings to be etched for the 1830 edition of Samuel Roger's poems, *Italy*. These etchings were imaginative reconstructions rather than accurate topographical depictions and were designed to capture the romance and ancient grandeur of the country. The images themselves were tiny, delicate and evocative, and their publication led to further commissions for Turner. The young John Ruskin (1819-1900) received a copy of *Italy* as a thirteenth birthday present; in later years he became Turner's greatest advocate.

PAINTED

London

MEDIUM

Pen and ink, pencil and watercolour on paper

SERIES/PERIOD/MOVEMENT

Illustrations for Roger's *Italy*

SIMILAR WORKS

Conway Castle after Sir George Beaumont Thomas Girtin, c. 1800

Monet, Claude
Villa at Bordighera, 1884

Monet travelled to the Mediterranean at the end of 1883 and spent the first few months of 1884 in Bordighera on the Italian Riveria, and in Menton on the French Riviera. The Mediterranean had a profound effect on Monet, especially with regard to the brilliance of the sun and the resulting vividness of the colours that he saw around him. His pictures of Bordighera in particular show the verdant foliage and exotic lushness that produced a riot of colour. During this trip he chose to paint 'tourist' views and these may have been influenced by contemporary guidebooks to the area. The depiction of tourist views was a popular subject, made more so by the increasing travel of the middle classes, and was an extension of some of his earlier paintings such as *La Grenouillère*, 1869. His Mediterranean pictures of the 1880s, however, were purely landscapes and tended not to depict the bourgeois at leisure.

Monet worried about how these paintings would be received on his return to France and, once he had returned, he greatly reworked many of them. In a letter to Alice Hoschedé he described his use of colour and his anxieties that the pictures would not be correctly interpreted. 'Obviously people will exclaim at their untruthfulness, at madness, but too bad – they say that when I paint our own climate. All that I do has the shimmering colours of a brandy flame or of a pigeon's breast, yet even now I do it only timidly.'

PAINTED

Bordighera

MEDIUM

Oil on canvas

SERIES/PERIOD/MOVEMENT

Impressionist

SIMILAR WORKS

House and Tree Paul Cézanne, c. 1873

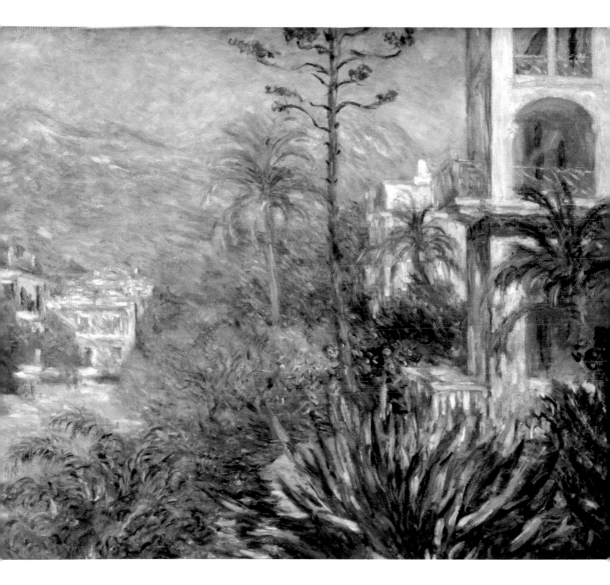

Turner, J.M.W.

View of Orvieto, Painted in Rome, 1828

Turner travelled to Rome for the second time in 1828 and spent three months there, during which time he lodged with the artist Charles Eastlake (1793–1865). Unlike his first trip, which was primarily devoted to recording views and details in sketchbooks, on his second trip he worked in a studio and produced three finished oil paintings, which is the only instance known of him working in oils on canvas while abroad.

View of Orvieto was based on several sketches that he made of the scene and is a topographically accurate view, whilst also incorporating elements from the work of the Classical landscape painter Claude Lorrain (1600–82). Turner was a great admirer of Lorrain and his influence can be felt in many of Turner's works. Italy was the one country above all others that Turner was passionate about, on an artistic, cultural and historic level. The particular light and atmosphere, which Monet was also affected by, inspired Turner to create some of his greatest heroic works. Shortly before his return to London, Turner exhibited his three finished oils in Rome: *View of Orvieto, Painted in Rome*, *Vision of Medea* and *Regulus*. The paintings attracted a large number of visitors, but were not well received, in spite of their obvious homage to Italy. Although Turner returned to Italy, he never again visited Rome.

PAINTED

Rome

MEDIUM

Oil on canvas

SERIES/PERIOD/MOVEMENT

Italian

SIMILAR WORKS

The Roman Campagna Jean-Baptiste-Camille Corot, 1826

Lake Avernus and the Island of Capri Richard Wilson, c. 1760

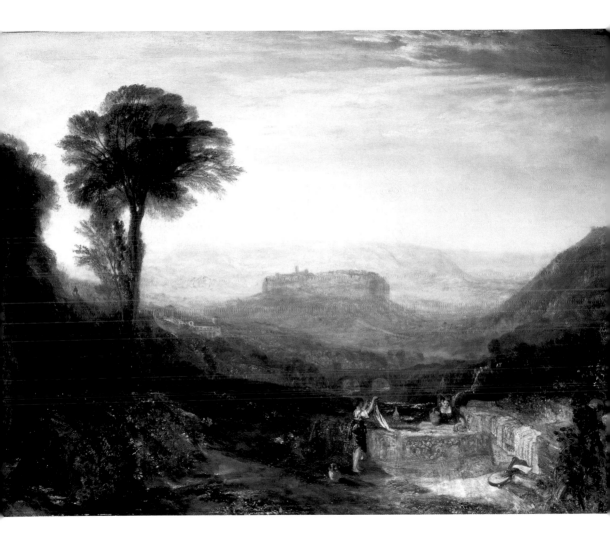

Turner, J.M.W.

The Rio San Luca, alongside the Palazzi Grimani, with the Church of San Luca, *c.* 1840

Turner made three, or possibly four, trips to Venice, seeing the city first in 1819 when it was suffering a period of decline from its former position of one of the biggest commercial and cultural centres of Europe. It was at that time part of the Austrian Empire and the city was staggering under the heavy taxes imposed upon it. Although in a period of decay, Venice was, however, at its most romantic and was a focal point for artists and writers. All of Turner's trips were surprisingly short, although incredibly productive in terms of sketches and drawings, which he used at later dates to work up oil paintings.

Unlike Monet, many of Turner's depictions of Venice include small figures in boats, or some reference to life within the city. Whistler would take this and expand on it, showing Venice as a bustling metropolis. Turner's affinity for water, rivers and the sea was lifelong and invariably captured in paint. Venice, with her network of canals, was the perfect subject matter for the artist. His drawings and watercolours, especially, portray the city and her waterways within the context of extraordinary beauty. The Rio San Luca watercolour is a case in point with its delicate colouring, fine line drawing and broad colour washes.

PAINTED

Venice

MEDIUM

Gouache, pencil and watercolour on paper

SERIES/PERIOD/MOVEMENT

Venice

SIMILAR WORKS

Scene in Venice, Hercules Brabazon

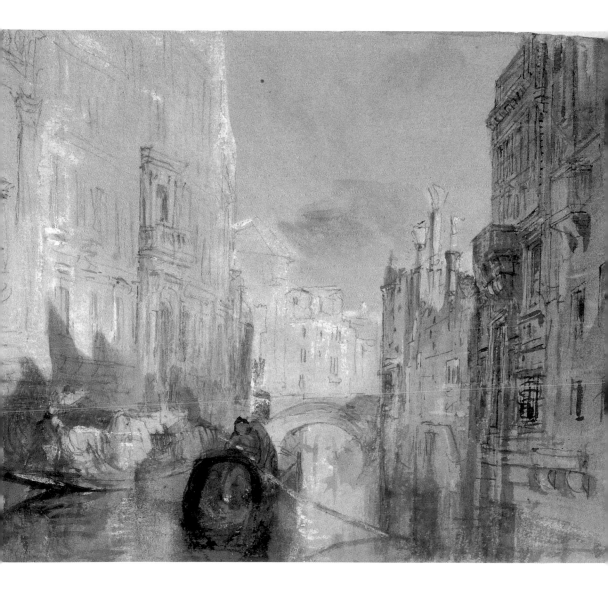

Whistler, James

Upright Venice, 1879–1880 (detail)

Whistler arrived in Venice under fraught circumstances. He had recently won the libel case against Ruskin, a moral victory, but was awarded only one farthing in recompense and shortly afterwards was declared bankrupt. He secured a commission from the Fine Art Society to produce a set of 12 etchings of Venice and in 1879 left London for the Italian city. He was to remain there for 14 months and during this time produced an enormous volume of work. It must have been ironic to Whistler that so shortly after the crippling trial, he was to end up in the city about which Ruskin raved.

Unlike the traditional approach of artists travelling to the great city, Whistler chose to depict many of the little-known streets and he deviated from the usual tourist attractions. In this way he crawled beneath the skin of the city, showing the bustle of Venetian life in all its forms. *Upright Venice*, which has the bird's-eye view seen in some Impressionist works of the 1860s and 1870s, was etched over a period of time. He started the plate with the distant view and then, some months later, completed the scene with the busy street in the foreground. At this time Whistler was living in rooms next to Otto Bacher (1856–1909), an American painter and etcher who allowed him to use his printing press.

PAINTED

Venice

MEDIUM

Etching and dry point on paper

SERIES/PERIOD/MOVEMENT

Venice

SIMILAR WORKS

Interior of St. Mark's Venice Walter Sickert, 1896

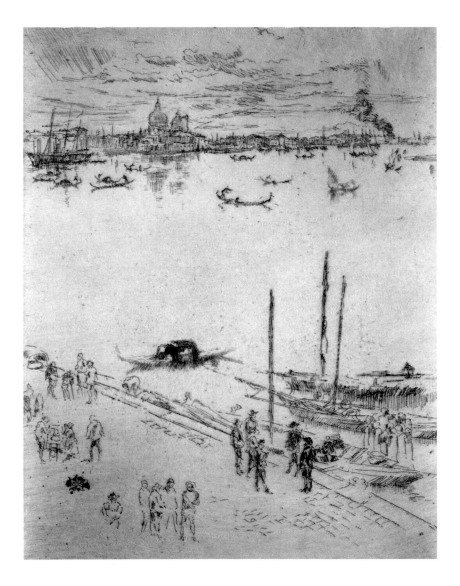

Turner, J.M.W.

Venice: An Imaginary View of the Arsenale, *c.* 1840

This is one of the most stunning watercolours that Turner produced on his last visit to Venice and is a visual feast of colour and compositional drama. The Arsenale was the heart of Venice's maritime power and wealth, and the strong, bold painting, with its dominant architectural features pulling the viewer into the picture, reflects the importance of the Arsenale to the city. Arsenale comes from the Arabic *Dar sina'a*, which translates as 'House of Construction', this name was then adopted by dockyards and munitions stores, even outside Italy. Venice, being the city built on water and surrounded by water, relied heavily on her fleets for both posterity and safety. At the height of her power the Arsenale is said to have employed sixteen thousand people, but by 1822 those numbers were down to only 250. Turner's image conjures up the majesty and grandeur of the Arsenale as she once was, implying this through his technique.

Many of these late watercolours were removed from their sketchbooks and sold during Turner's lifetime and are generally perceived to be some of the greatest examples of his watercolours, of which he was the undoubted master.

PAINTED

Venice

MEDIUM

Watercolour and body colour on paper

SERIES/PERIOD/MOVEMENT

Venice, late period

SIMILAR WORKS

The Grand Canal, Venice James Holland, 1840

Whistler, James
The Doorway, 1879–80

Whistler's visualization of the scenes around him is always thought-provoking and provides us with glimpses into his idiosyncratic nature. His travels to Venice were no exception and, where most artists were floored by the sheer magnitude of Venice's artistic, cultural and romantic legacy, Whistler complained to his sister of having to live 'in a sort of *Opera Comique* country when the audience is absent and the season over'.

The Doorway, 1879-80, was one of the etchings produced for the set of 12 Venice scenes commissioned by the Fine Art Society. *Venice: Twelve Etchings* was exhibited in December 1880 and received harsh reviews from the critics, although *The Doorway* was one that was praised over the others. The etching of the doorway is one of complimenting contrasts. The grand Renaissance doorway in the Palazzo Gussoni has become the door to a workshop, a chair-maker's shop; what was once stately and grand becomes working class. The façade itself a mixture of rigid, geometric lines, adorned with a riot of delicate tendrils. The brightly light doorway enters into a dark, mysterious interior where figures and objects gradually melt into the shadows. The detailing and finesse of drawing are superb, matched by Whistler's unique take on the city as a working machine.

PAINTED

Venice

MEDIUM

Etching

SERIES/PERIOD/MOVEMENT

Venice; Twelve Etchings

SIMILAR WORKS

Piazzetta and the Old Campanile, Venice Walter Sickert, *c.* 1901

The Salute, Venice Sir Charles Holroyd, 1902

Monet, Claude
Le Palais Contarini, 1908

Monet travelled to Venice in 1908 with his wife Alice, intending to treat the trip as a holiday. He had been working intensively for five years on his monumental Waterlily paintings and had reached a period of stagnation and disappointment with these works. Venice was to be a time of brief relaxation before returning to his Waterlilies suitably revived. Instead, on arrival in Venice he was immediately gripped by the beauty of the city on the water, his favourite motif along with flowers, and embarked on an exhaustive period of intense creativity. The end result was 37 canvases, nearly all of which were completed after he had returned home to Giverny.

Typically in his methods, Monet created series of pictures around several different motifs, but unlike his usual practice of showing the effects of different times of day and conditions on a single subject, with the Venice paintings he concentrated on the reflection of light on the water and the buildings façades. Monet would have seen the works by Whistler and Turner of Venice, as well as the traditional paintings of Antonio Canaletto (1697–1768), Gian Antonio Guardi (1699–1760), Giorgione (1477–1510), Titian (1488–1576) and Veronese (1528–1588). *Le Palais Contarini* is one of two paintings of the same subject and demonstrates Monet's concern with depicting both the architecture of the city and the reflection of light, and the building, in the water.

PAINTED

Venice

MEDIUM

Oil on canvas

SERIES/PERIOD/MOVEMENT

Venice, Impressionist

SIMILAR WORKS

The Pink Palace Hercules Brabazon, 1892

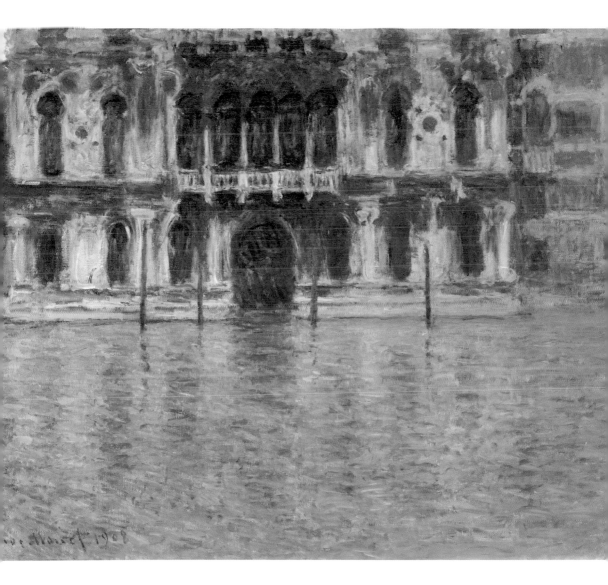

Turner, J.M.W.

Venice: San Giorgio Maggiore at Sunset, from the Hotel Europa, 1840 (detail)

During his 1840 trip to Venice Turner made a series of watercolour studies of Palladio's church of San Giorgio Maggiore, as well as extensive sketches of other sights in Venice. These were to form a core group of 'Venetian' watercolours that afford us his intensely personal and unique vision of the city for his time. It is likely that many of these watercolours were executed on the spot, their lines are fluid and quick and they have the appearance of immediacy that would be hard to recreate from the studio. The watercolourist William Callow (1812–1908) wrote in his autobiography, 'The next time I saw Turner was at Venice, at Hotel Europa, where we sat opposite at meals and entered into conversation. One evening whilst I was enjoying a cigar in a gondola I saw Turner sketching san Giorgio, brilliantly lit up by the setting sun.'.

The incredible volume of work that the city of Venice inspired in Turner, and the quality of work that he produced, is a testament to the regard with which Turner held it. Although he did not write with words, as had his supporter Ruskin, his paintings and sketches spoke for themselves.

PAINTED

Venice, 1840

MEDIUM

Watercolour, body colour and pencil on paper

SERIES/PERIOD/MOVEMENT

Venice

SIMILAR WORKS

The Grand Canal, Venice Richard Parkes Bonnington, 1820

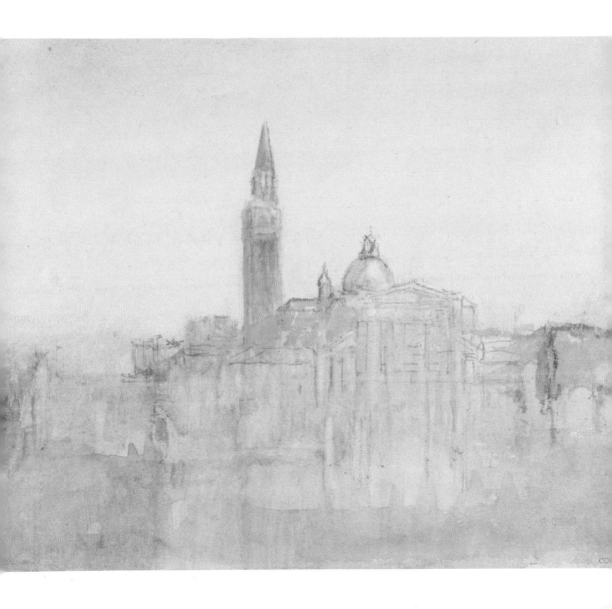

Whistler, James

Nocturne in Blue and Silver: The Lagoon, Venice, 1879–80

This Nocturne painting of Venice done by Whistler during his visit in 1879–80 is one of his most evocative and haunting images of the sleeping city. It was unusual to depict Venice at night, when it was the very light and luminosity of the air there that made it so appealing to artists. However, Whistler has, yet again, inverted this and created the lagoon positively glowing with subdued radiance. The decorative elements of this painting are extremely strong, the ships' masts balancing the *campanile* of St George Maggiore in strong vertical accents, juxtaposed to the horizontals of the boats and their shadows. The picture has the harmony of perfect balance, even down to the pinpricks of light, which inject a human element into an otherwise ghostly scene. It is an intensely atmospheric picture, quite different from his pastel sketches of busy Venetian life.

This painting, with a number of other works, was stolen from Whistler's studio in Paris by Carmen Rossi.

PAINTED

Venice

MEDIUM & DIMENSIONS

Oil on canvas, 50.16 x 65.4 cm (19³/₄ x 25³/₄ inches)

SERIES/PERIOD/MOVEMENT

Venice, Nocturne

SIMILAR WORKS

The Big Poplar II Gustave Klimt, 1902

Night Sketch of the Thames near Hungerford Bridge George Price Boyce, c. 1860

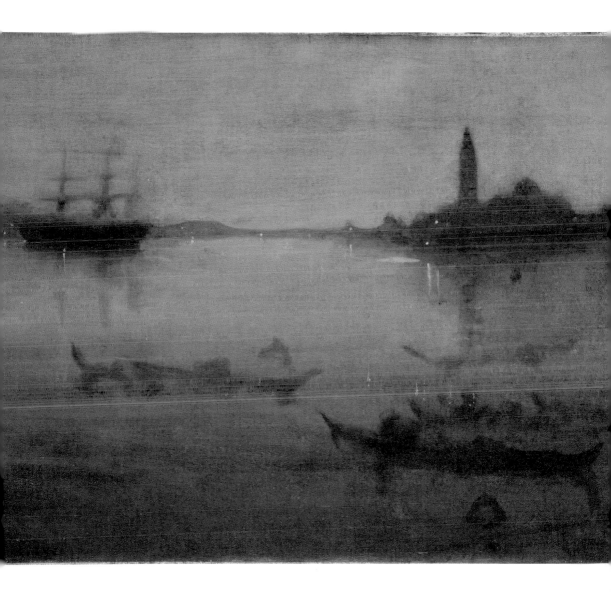

Monet, Claude
San Giorgio Maggiore, Venice, 1908

It is odd that Monet did not travel to Venice earlier in his life, a choice that he regretted upon his arrival. Bearing in mind the number of canvases that he produced as fruits from such a short journey perhaps it is irrelevant that he did not go sooner. It would, however, have been interesting to compare the difference in his approach to the city, had he painted it as a young man. These late pictures from Venice and his famous Waterlily sequence are truly the culmination of a long career studying light and how to translate it through paint. San Giorgio Maggiore was a subject painted by Turner, Whistler and Monet, though in entirely different ways, each artist innovative in their approach and interpretation. Monet's depiction shown here positively vibrates with colour, energy and light, although the clear identification of place and subject are not lost.

In the preface to the exhibition of his Venice paintings in Paris, Octave Mirbeau wrote, 'Claude Monet no longer captures light with the joy in conquest of one who, having seized his prey, holds on to it with clenched hands. He conveys it as the most intelligent of dancers conveys an emotion. Movements fuse and combine and we do not know how to break them down again. They are so smoothly interconnected that they seem to be but a single movement, and the dance is perfect as a circle.'.

PAINTED

Venice

MEDIUM

Oil on canvas

SERIES/PERIOD/MOVEMENT

Impressionist

SIMILAR WORKS

The Piazzetta and the Old Campanile, Venice Walter Sickert, c. 1901

S. Giorgio and the Salute Hercules Brabazon

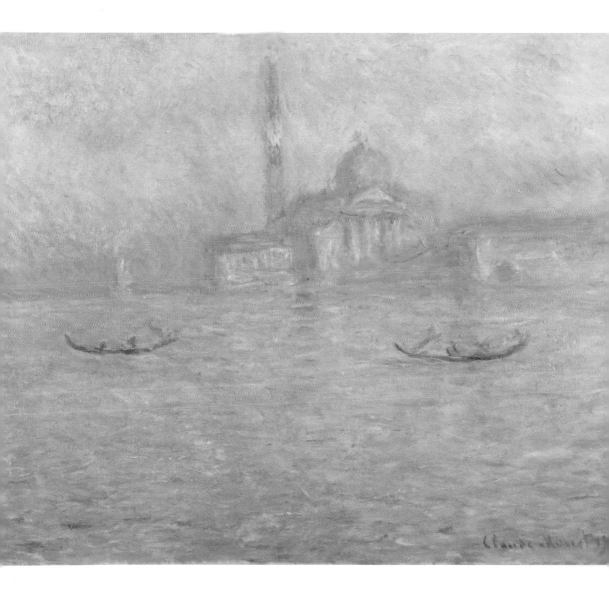

Turner, J.M.W.

St Benedetto, Looking towards Fusina, exhib. 1843

Turner paved the way for British landscape artists visiting Venice. He was also one of the first English artists to do so, behind only Richard Wilson (1713–82), who was greatly influenced by the work of Claude Lorrain and John Robert Cozens (1752–97). Turner would have seen and studied the work of both of these artists at the home of his friend and patron, Thomas Munro. Canaletto was the single-most famous artist to document Venice through his precisely detailed paintings and his influence on subsequent visitors to the city was profound, except with regard to Turner. One of the key factors in Turner's depictions of Venice is his use of colour, which, although often not natural or realistic, was always deeply evocative of mood, spirit and atmosphere. Similarly his compositions were not uniformly topographically accurate. While he sketched in pencil and watercolour from the scene itself, he would, for years afterwards, work from his studies to produce watercolours and oil paintings from his studio in London. Between 1833 and 1846 he exhibited at least one Venetian scene every year, bar 1838 and 1839, at the RA.

St Benedetto is just such an imaginary scene, there is no St Benedetto visible in the direction he has painted and the buildings on the right of the canvas are also mostly fabricated. His composition of converging buildings on either side and the accentuating angle of the gondolas drifting away from the viewer create an enormous depth.

PAINTED

London

MEDIUM

Oil on canvas

SERIES/PERIOD/MOVEMENT

Venice

SIMILAR WORKS

Canal of the Guidecca, Venice Edward William Cooke, 1867

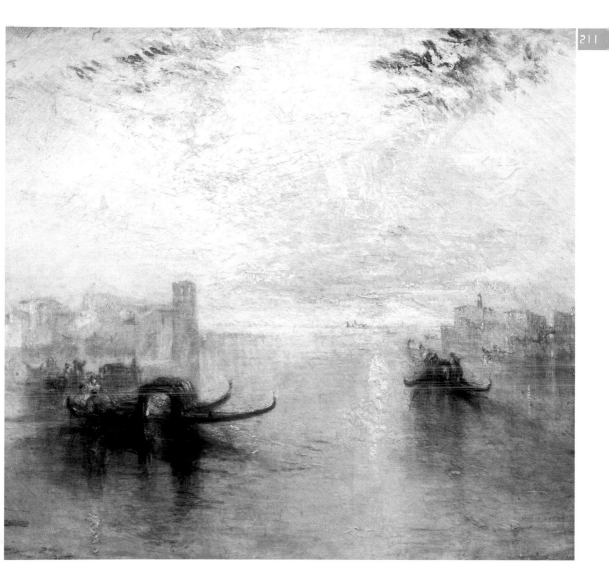

Monet, Claude
View of Le Havre, 1873 (detail)

© Private Collection/www.bridgeman.co.uk

In 1873 Pissarro referred to Monet's art as, 'a highly conscious art, based upon observation, and on a completely new feeling; it is poetry through the harmony of pure colours, Monet adores real nature'.

One of the most extraordinary aspects of Monet's painting was his ability to create intense light, especially that reflected on water, and to create images so often totally at odds with both his own personal traumas and those of the world around him. By 1873 he had returned from London, the Franco-Prussian wars were over and the bloody massacres in Paris a tragedy in the past. By the time of *View of Le Havre*, 1873, Monet had developed his method of short, separate brushstrokes throughout his canvases and had achieved a complete unity of vision through using a single technical device. Boats were a favourite motif of his during these years, the wide expanse of sails creating an excellent plane for reflective light, and more mundanely because they were a popular theme with the middle classes and potential patrons. Here Monet has depicted the buildings along the harbour at Le Havre with strong architectural details, and has placed the viewer within the direct light that falls on to the canvas from the left side. It was an unusual composition for Monet, who tended to depict his boats against an empty sky, although the recurrent vertical theme of the masts and sails of the boats with the tall buildings is very effective.

PAINTED

Le Havre

MEDIUM

Oil on canvas

SERIES/PERIOD/MOVEMENT

Impressionist

SIMILAR WORKS

The Pilots Jetty Le Havre, Morning, Cloudy and Misty Weather Camille Pissarro, 1903

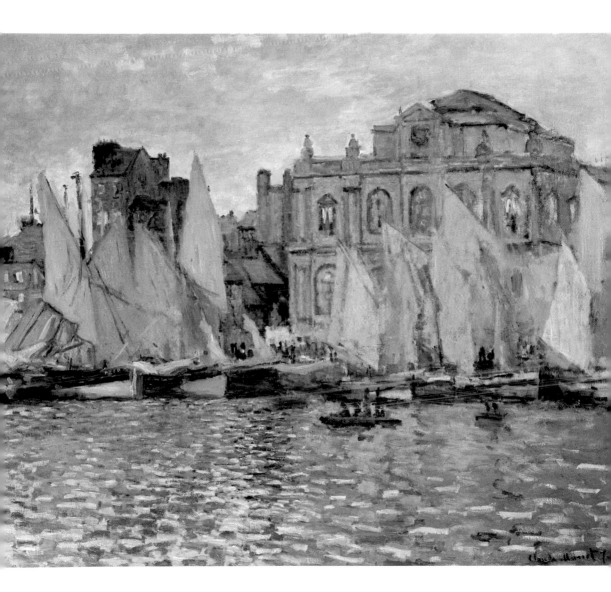

Turner, J.M.W.
The Chain Pier, Brighton, *c.* 1828 (detail)

During this time Brighton was starting to take off, both as a popular tourist spot and as a centre of commerce and industry. In April 1822 the royal tourist ship commenced a regular service from Brighton to Le Havre, running three times a week, and there was also a service running from Brighton to Dieppe. The town was very much a place of transience, people travelling from one place to the next. Lord Egremont, Turner's great patron, had financial interests in both the Brighton Chain Pier and the Chichester Canal. The Brighton Chain Pier was built to the designs of Captain Samuel Brown R.N. and opened in 1823, although by 1896 it was destroyed in a gale and vanished into the sea.

Turner was commissioned to produce *The Chain Pier, Brighton*, along with three other pictures, to hang in the panelling in the Carved Room at Petworth, Egremont's country seat. This painting was later replaced with *Brighton from the Sea*, which retained the basic composition of *The Chain Pier, Brighton*, but had added detail, greater drama and the inclusion of floating debris at the front. *The Chain Pier, Brighton* is interesting in that the delicate depiction of the pier itself becomes secondary to the boldly blocked boats on the left-hand side. In the later painting, the pier has gained greater importance to the canvas and is more clearly the subject and focus.

PAINTED

Petworth House, Sussex

MEDIUM

Oil on canvas

SERIES/PERIOD/MOVEMENT

Petworth Carved Room

SIMILAR WORKS

View of the Hotwells and Part of Clifton near Bristol Samuel Jackson, 1823

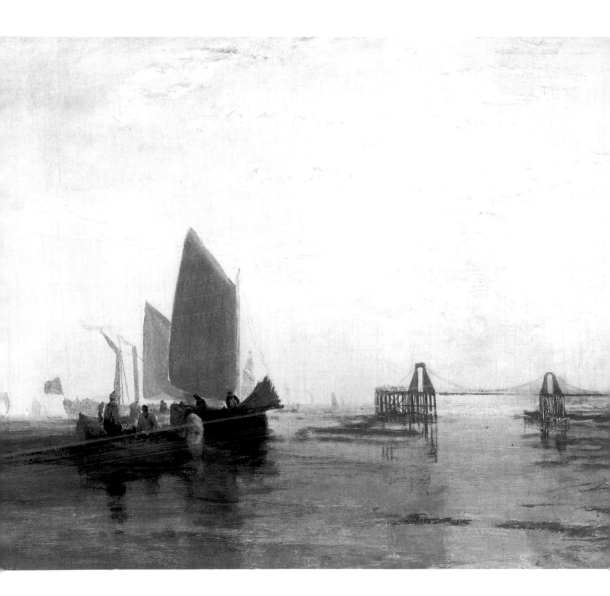

Monet, Claude
Canal à Amsterdam, 1874

Amsterdam was one of Monet's favourite places and, like Venice, afforded him the scenes of buildings along water that he so loved. He first travelled there in the early 1870s having spent some time in London avoiding the conflicts within France. He made many sketches while travelling in Holland and several oil paintings. The bridges in Amsterdam were a main motif for his works there and it is interesting to compare this *Canal à Amsterdam* with *The Drawbridge Amsterdam*, painted in the same year. Both paintings are full of life, bustling with people going about their daily business, and also the life of the water itself. His treatment of the water and the sky in *Canal à Amsterdam* is very similar so that one almost appears a continuum of the other. Bearing in mind the heavy overcast climate and the moisture in the air, his approach is understandable. He has used small brushstrokes throughout the canvas and has created a unified whole by treating the entire painting with the same brushstroke approach. The paint application in *The Drawbridge Amsterdam* is quite different, as seen especially through the treatment of the bridge with the water.

PAINTED

Amsterdam/Argenteuil

MEDIUM

Oil on canvas

SERIES/PERIOD/MOVEMENT

Amsterdam landscapes

SIMILAR WORKS

Fuji from the Nihon Bridge Yedo

Wooden Bridge Sir Augustus Wall Callcott, *c.* 1835

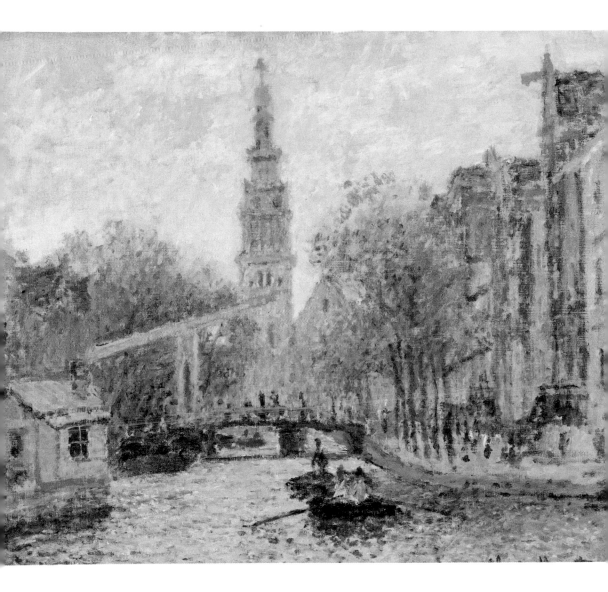

Monet, Claude
The Seine at Rouen (detail)

The Seine and its surrounding countryside were often painted by Monet throughout his life. Like Turner, Monet was attracted to water, and invariably included boats within his river scenes.

In this painting of the Seine at Rouen, Monet has used a wonderful balance of verticals and horizontals in his composition. The line of houses and buildings that winds into the distance provides a strong horizontal ground, enhanced by the expanse of sky that is somewhat reminiscent of Dutch landscapes. Monet has treated the sky and the water in a similar way and the reflection of the sky in the water draws the two elements together. The delicate verticals of the finely painted ship and those in the trees and mooring posts offset the low vanishing point. He has used quite broad areas of colour, with merged paint application for the most part, and has then imposed suggestive brushstrokes to evoke the ripple of the water and the reflections in it. The contrasting handling of paint across the canvas is very effective. The small figure walking down the gangplank to the shore is an interesting addition as he hovers above the water on barely more than a sliver of wood.

PAINTED

Rouen

MEDIUM

Oil on canvas

SERIES/PERIOD/MOVEMENT

Impressionist

SIMILAR WORKS

Entrance to the Port Honfleur Johan Bartold Jongkind, 1864

Honfleur the Port, Stormy Weather Eugène Boudin, 1852

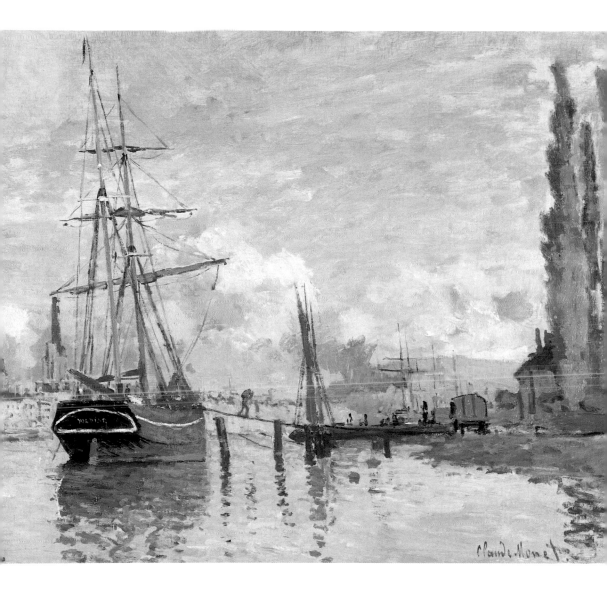

Claude Monet

Turner, J.M.W.

From Turner's Annual Tour: The Seine 1835 Paris: The March aux Fleurs and the Pont au Change, c. 1833 (detail)

During the 1820s and 1830s there was a trend for 'annuals', yearly volumes combining art and literature. Between 1833 and 1835 Turner produced three such books, each entitled *Turner's Annual Tour*, which documented views of the Rivers Loire and Seine. Turner frequently travelled along the Seine, both in the course of his journeys south and due to his affinity with the river as a subject matter. He was also a great admirer of Paris and made many trips to the blossoming European city, although never produced any finished oils from his visits. He did, however, produce countless sketches and drawings of the city, covering both Paris itself and the life within it.

The March aux Fleurs and the Pont au Change shows Turner using a thick application of paint, the figures in the foreground becoming jewel-like in their vivid colouring, which contrasts effectively with the sombre tonal quality of the architectural details behind. The brightly accented figures are frieze-like and lend a Classical air to the composition.

PAINTED

Paris

MEDIUM

Gouache and watercolour on paper

SERIES/PERIOD/MOVEMENT

Turner's Annual Tour, 1835

SIMILAR WORKS

Pont Royal, Paris William Marlow

Whistler, James

Street in Saverne, 1858

© Hermitage, St. Petersburg, Russia/www.bridgeman.co.uk

The 1840s and 1850s saw a revival in etching, a technique that Whistler had learnt while working for the US Coastal Survey in America. The success that Charles Meryon's (1821–68) etchings received in 1849 and 1851 only served to promote the growing trend towards this medium. In 1858 Whistler journeyed through France and the Rhineland with Ernest Delannoy, taking his sketchbooks and copper plates with him. The result of the trip was *The French Set*, a series of 12 etchings, some of which were direct observations from nature and the others resulting from the sketches he made.

Street in Saverne 1858 was number six in the series of 12 etchings and is a boldly modern view of the quiet French street. The treatment of the buildings, with their dramatic shadowing and dominant perspective, is forceful and already Whistler's interest in light and light effects can be seen. Whistler's brother-in-law, Francis Seymour Haden, had quite a collection of etchings, including works by Harmenszoon van Rijn Rembrandt (1606–69) and Sir Anthony Van Dyck (1599–1641), which would have been available for Whistler to study.

PAINTED

Saverne

MEDIUM

Etching in dark-brown ink on pale-blue backing

SERIES/PERIOD/MOVEMENT

The French Set

SIMILAR WORKS

A Village Street Charles Keene

A Street in Venice Charles E. Holloway, 1895

Monet, Claude

Boulevard Saint-Denis, Argenteuil in Winter, 1875

Monet lived in Argenteuil with his family for eight years, until they moved at the end of 1878, and during that period he painted the town and its surrounding area almost constantly. Here he takes his view from a spot on a small pathway, between the railway embankment and the Boulevard Saint-Denis, and creates an interesting multi-directional composition. The strong diagonal lines of the fences guide the eyes in one direction and yet the paths split, turning the attention in the opposite way. The blustery snowstorm drives across the canvas, with the sun, weakly yellow and pink, barely breaking through the heavy wet sky. During the 1860s Monet had collected Japanese prints, as Whistler had bought Japanese art and artefacts, and in this painting the influence of Japanese print makers can be seen. He has used soft pink and blue hues throughout the canvas, from the colouring in the sky to the warm exterior of the buildings and into the snow itself, giving it great density. The dark tones of the fence and the bustling figures, bowed into the driving snow, provide a strong contrast to the delicacy of the rest of the painting and give the picture solid form and depth.

PAINTED

Argenteuil

MEDIUM & DIMENSIONS

Oil on canvas, 60.9 x 81.6 cm (24 x 32⅛ inches)

SERIES/PERIOD/MOVEMENT

Impressionist

SIMILAR WORKS

Snow Effect at Marly Alfred Sisley, 1876

The Road to L'Hermitage in the Snow Camille Pissarro, c. 1874

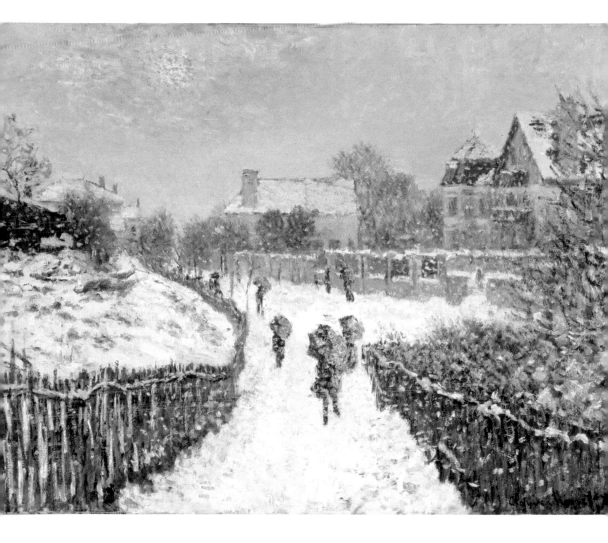

Monet, Claude

The Three Trees, Autumn, 1891

The poplar trees that lined the bank of the river and formed a divide between the river and the meadows at Giverny had been a favourite of Monet's for many years. In 1891, having completed his monumental Haystacks series of paintings, he started on a new series depicting the poplars under the subtle effects of changing light and seasons. He worked on 23 paintings between the late spring and late autumn, so that the effects of the changing seasons were less dramatic than those on the Haystacks, which had been painted during the autumn and winter months.

The thin trunks and small foliage of the poplars provided a wonderful grid composition, dividing the canvas into distinct planes, further embracing the decorative/motif theme of the paintings. He painted all but four of the paintings from a flat-bottomed boat moored below the trees, so that his viewpoint was from below, looking up to the trees. He further extended his dramatic composition by depicting the shadow of the trees in the water as straight verticals, when they would actually not have appeared as such in nature. The diagonal line of trees, which disappear into the distance behind the frontal row of trunks, creates an added dimension in the visual context.

The interplay of decorative composition and vivid colours, which go beyond nature, seem at once to represent the landscape itself and also the 'idea' of the landscape and the concept of light on trees, with an almost dreamlike quality.

PAINTED

Giverny

MEDIUM

Oil on canvas

SERIES/PERIOD/MOVEMENT

Poplars on the banks of the Epte

SIMILAR WORKS

Landscape with a River Alfred Sisley, 1881

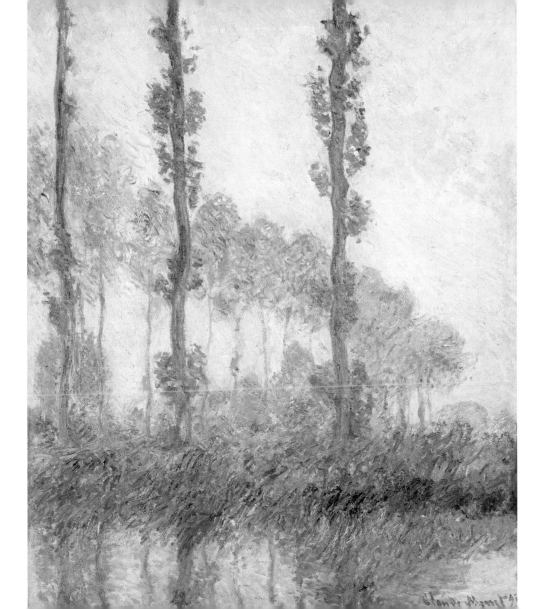

Claude Monet '9

Monet, Claude
Cliff at Dieppe, 1882

In 1880 Monet stayed with his brother on the Normandy coast and this was to spark a six-year involvement with the area, during which time Monet repeatedly painted the dramatic scenery. While spending the summer months in Pourville with Alice and their children Monet returned to an earlier theme in his paintings, that of the middle classes at leisure. His work of the 1880s was very different from his earlier pictures of the 1860s and 1870s and the relationship of his figures within the context of their landscape had changed. The cliff at Dieppe was a monumental natural feature, against which the human element recedes to a decorative motif. The force of nature towers above the tiny people in *Cliff at Dieppe*, 1882; their presence suggested by simple tiny brushstrokes. The house on top of the cliff sits awkwardly, bold and linear against the fluidity of the natural formation, the bright red of the roof further highlighting the disparity between man-made structures and those of nature. The essence of these paintings was his continual exploration of light; the figures becoming incidental to the artist's vision.

PAINTED

Pourville

MEDIUM

Oil on canvas

SERIES/PERIOD/MOVEMENT

Impressionist

SIMILAR WORKS

On the Cliff Top Edgar Degas, 1869

Le Bec du Hoc – Grand Camp Georges Seurat, 1885

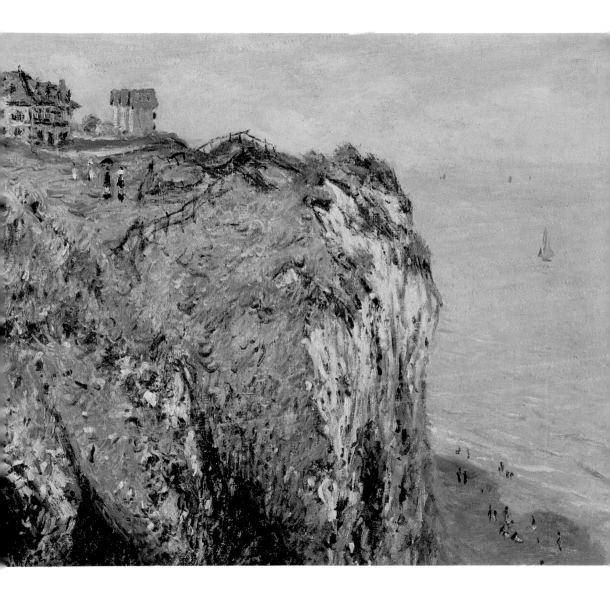

Turner, J.M.W.
Norham Castle, Sunrise, c. 1845 (detail)

This painting, which was never exhibited during Turner's lifetime, has long been attributed with anticipating modern Abstract art. However, this is conjecture only, since the canvas is in all probability not finished. The shimmer of bleaching light creates an astonishing effect and the single cow depicted with minimal dark strokes precisely balances the composition with the shadow of the ruins. It is one of his most inspiringly magical paintings, an ethereal combination of nostalgia, romance and tranquillity. The oil painting was based on a *Liber Studiorum* plate that was classified under 'P' for pastoral and is documented as being from 'the Drawing in the Possession of the late Lord Lascells'.

Norham Castle was one of Turner's favourite subjects and was situated on the English side of the River Tweed bordering Scotland. He first saw the medieval ruins on his trip to the North in 1797 and made a series of sketches of it, later producing two large watercolours and three further watercolours.

PAINTED

London

MEDIUM

Oil on canvas

SERIES/PERIOD/MOVEMENT

Norham Castle

SIMILAR WORKS

Pembroke Castle David Cox, c. 1810

Lydford Castle, Devon Thomas Girtin, 1800

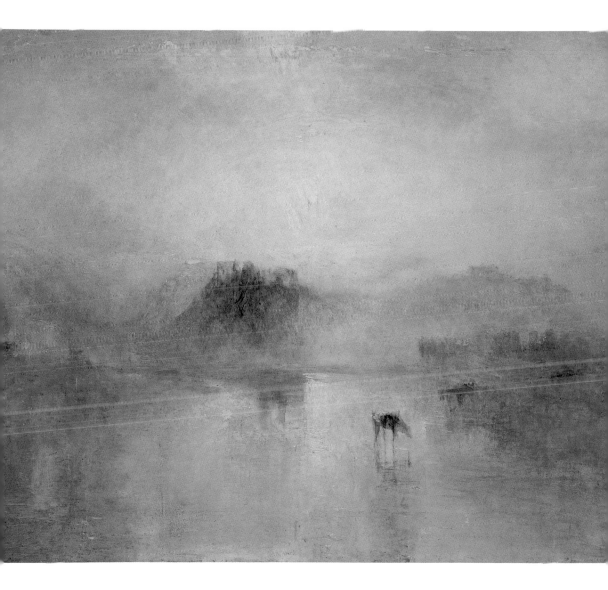

Whistler, James
Sunflowers, Rue des Beaux-Arts, 1892–93

Whistler spent the majority of his adult life travelling between England and France and was immersed in the culture and society of both countries. In April 1892 he moved to Paris, to the rue du Bac, near to the home of his old friend Fantin-Latour, and opened a studio on rue Notre-Dame-des-Champs. He lived in Paris with his wife until the end of 1894 when they moved back to London again on account of her poor health. During his time in Paris and the surrounding areas Whistler worked on a number of etchings and also returned to the practice of lithography. He made a number of plates using the small shop fronts along his road as subject matter and printed them in small numbers.

Whistler was undoubtedly a master etcher and this is seen in his superbly decorative *Sunflowers, Rue Des Beaux-Arts*. The fine lines and ornate detailing are emphasized by his use of strong shadow. The contrasting highlights and dark give the effect of bright sunlight playing across the shop front, and the detailed figures add to the lively scene.

PAINTED

Paris

MEDIUM

Etching and dry point printed on paper

SERIES/PERIOD/MOVEMENT

Paris

SIMILAR WORKS

On the Riva, from Pennell's Window Joseph Pennell, 1883

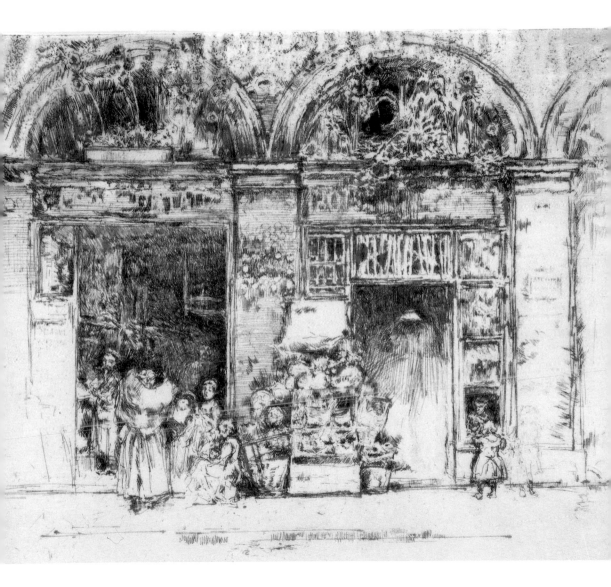

Whistler, James
The Shore, Pourville

Pourville-sur-Mer was a favourite destination for artists, affording fantastic and rugged coastal views within a short distance from the town and ample opportunity to paint the 'tourist' pictures that sold so well during the time of Monet and Whistler. Monet himself spent many holidays painting from here; the sea, air and cliffs providing the perfect vehicle for impressions of light, colour and movement.

The Shore, Pourville is a broadly horizontal composition of narrow planes of colour from the pinks of the beach through the rolling surf, to the dark horizon and the clouds and sky. It is, typically of Whistler, seen as an abstract decorational form of colour and pattern, as well as a pleasing landscape. The two figures provide a focal point that draws the eye down to the left corner, but the wide expanse of turbulent surf to the right immediately draws the eye back. In this way the viewer is constantly surveying the canvas, from one side to the other; a clever technique he has used, which adds to the movement of the sea itself.

PAINTED

Pourville

MEDIUM

Oil on canvas

SERIES/PERIOD/MOVEMENT

Impressionist

SIMILAR WORKS

Mounts Bay and Tolcarne from Trewidden Farm Footpath Norman Garstin, c. 1898

The Sea Gustave Courbet, 1867

Whistler, James

St Ives

Whistler travelled to St Ives in late 1883 with Walter Sickert (1860–1942) and Mortimer Menpes (1855–1938) and was at first singularly unimpressed with the fishing town. 'Well – for dullness, this place is simply amazing! – nothing but Nature about – and Nature is but a poor creature after all – as I have often told you – poor company certainly – and, artistically, often offensive ... The work I am doing may make this exile worthwhile – I have such inspirations too!'

St Ives was a popular spot for artists, being picturesque, quaint and a bustling hive of activity. While there, Whistler executed many watercolours of which *St Ives* is one. The influence of Oriental art and decoration is still strongly evident. His figures are suggested with minimal strokes and appear jewel-like in colour against the soft even tonality of the background washes. The scene is busy with a distinct movement from the bottom right corner diagonally to the top left, aided by the diagonal of the shoreline. The painting calls to mind the stylistic elements of a Japanese woodcut and is curiously flat, with the figures seemingly superimposed on to the beach rather than sitting within the context of the landscape.

PAINTED

St Ives

MEDIUM

Watercolour on paper

SERIES/PERIOD/MOVEMENT

Impressionist

SIMILAR WORKS

Sailing Boats at Southampton John Linnell, 1819

Swanage Charles Conder, *c.* 1901

Monet, Claude

Cliffs and Sailboats at Pourville

This is one of a number paintings Monet executed while staying at the town of Pourville, and is interesting in the way he has used blocks of colour and a stylized technique that calls to mind Oriental woodcuts. The vibrant blue of the sea, against which the white sails shine, is most effective, as is his use of short curved brushstrokes, which reflect the lines of the boats and their sails. The cliffs are as still as the sea is moving, the flatness of their painting in direct contrast to the depiction of the sea and waves. The wind that is blowing across the canvas can almost be felt as the small boats bear down into it and the clouds above appear to rush across the canvas. His use of a limited palette, primarily blue and green, which is seen through the sea, cliffs and sky, draws the whole composition together, while the dazzling white of the sails pull the eye into the middle of the canvas.

PAINTED

Pourville

MEDIUM

Oil on canvas

SERIES/PERIOD/MOVEMENT

Impressionist

SIMILAR WORKS

Summer at Cowes Philip Wilson Steer, 1887

Les Rochers Rouges Hercules Brabazon

Monet, Claude
Le Jetée du Havre, 1868

This is a huge painting, over two metres (six feet) long, that Monet would have painted in his studio and based on sketches he had made of the jetty at Le Havre. It was submitted to the jury for the Salon selection with another monumental work, *Ships leaving the Jetties of Le Havre*, in 1868. *Ships leaving* was accepted, after Daubigny extolled its virtues, and *The Jetty* was rejected, which surprised Monet and his contemporaries. The picture was criticized for the crudeness of the brushstrokes and referred to as being done by the hands of a child. In the words of the caricaturist Bertall, 'Here at last is some truly naïve and sincere art. M. Monet was four and a half when he did this painting ...'

The ferocity of the waves beating against the jetty is tangible and the small figures, bowing against the wind and the elements, reinforce the dominance of nature over man. This would be seen decades later in Monet's paintings of the cliffs at Dieppe. The rapidity with which the painting would seem to have been painted belie the several months of studio work that it actually took. It is likely that Monet would have worked and reworked the canvas, scraping down areas he was not happy with and repainting over the top, which would in part explain the freshness of the canvas.

PAINTED

Sainte-Adresse

MEDIUM

Oil on canvas

SERIES/PERIOD/MOVEMENT

Salon piece, rejected

SIMILAR WORKS

The Jetty at Honfleur Johan Barthold Jongkind, 1865

Turner, Whistler, Monet

Influences

Turner, J.M.W.

From Studies in the Louvre Sketchbook
Raphael's 'Infant Jesus Caressing St John', 1802

At the time that Turner was embarking upon a career as a landscape artist, there were two main schools to fall under, that of the Classical landscape and that of the Dutch landscape. Turner was to be influenced by each to a certain extent. He greatly admired the works of the contemporary artists Richard Wilson (1712/3–82) and J. R. Cozens (1752–97), both of whose work had absorbed elements from the Neo Classical masters Claude Lorrain and Nicolas Poussin (1594–1665), but he had trained for a short time with Thomas Malton, who looked more to the Dutch tradition.

In 1802 the Treaty of Amiens was signed, opening up routes of travel between England and France and giving artists the chance to see the Louvre; Napoleon had begun a systematic period of looting across Europe and housed his prizes there. Bearing in mind that the National Gallery in London was not yet open, the Louvre offered the chance for the public to see the single-most impressive collection of art anywhere in the world. Turner sketched from Old Masters for a period of time, filling his 'Studies in the Louvre' sketchbooks with copies of the works and detailed annotations. His copy of Raphael's *Infant Jesus Caressing St John* shows the delicacy with which he was able to capture the Old Master's line.

PAINTED

Paris

MEDIUM

Pencil on paper

SERIES/PERIOD/MOVEMENT

Studies in the Louvre

SIMILAR WORKS

Study for'Christ and the Woman of Samaria' George Richmond, 1827–28

LXXII - 17

Turner, J.M.W.

From Studies in the Louvre Sketchbook
Copy of Titian's 'Mistress', known as 'Alphonse de Ferrare et Laura de' Dinati', 1802

Titian was to have a major influence on the young Turner and one that he would refer to throughout his career. On his visit to the Louvre in 1802 he made copies from many of Titian's works and was particularly influenced by his use of colour, composition, form and subject matter. Turner's *Vision of Medea*, for example, was clearly based on the structure of Titian's St *Peter Martyr*, which was one that Turner copied in 1802. Alongside the copy Turner made copious notes from which his admiration for the Old Master is clearly felt, 'This picture is an instance of his great power as to conception and sublimity of intellect. The characters are finely contrasted, the composition is beyond all system, the landscape tho' natural is heroic, the figures wonderfully expressive of surprise and its concomitant fear'. On subsequent visits to Italy in 1819 and 1828 Turner again studied Titian's work and on his second trip to Rome he produced the unfinished work *Reclining Venus*, that pays obvious homage to Titian's *Venus of Urbino*, then hanging in the Uffizi in Florence.

PAINTED

Paris

MEDIUM

Pencil on paper

SERIES/PERIOD/MOVEMENT

Studies in the Louvre

SIMILAR WORKS

Portrait of a Lady, Joshua Reynolds

LXXII / 25

Turner, J.M.W.

From Studies in the Louvre Sketchbook
Copy after Titian's 'Christ Crowned with Thorns', 1802

© Tate, London 2005

Joseph Farington (1747–1821), the English landscape painter had a long association with Turner, one that began benevolently and ended less amicably as the older artist failed to comprehend the nature of Turner's art. They met in Paris in 1802 where Farington recorded his shock at Turner's criticism of the blue sky in Titian's *St Peters Martyr* being too blue. This demonstrates how the young Turner felt confident in issuing such a comment about one of the greatest of the Old Masters; Titian was also one of the painters that he admired and was influenced by, but with whom he still had the temerity to find fault. In his diary Farington later wrote, 'Turner strives for singularity and the sublime but has not the strength to perform what he undertakes. His pictures have much merit, but want the scientific knowledge and the Academic truth of Poussin, when he attempts the highest style, and in his shipping scenes he has not the taste and dexterity of pencilling which are found in such excellence in the Dutch and Flemish masters'. It was these two qualities of Classical and Dutch that Turner would meld and send in a new direction by the end of his long career, but it was the influence of Titian, and Turner's study of the Old Masters, that would give him the grounding to do this. His copy of Titian's *Christ Crowned with Thorns* shows him grappling with the complicated figural composition, his anatomical renderings slightly hesitant. Turner's face of Christ reflects the round peasant face familiar to Dutch painting and this form would reappear throughout his work.

PAINTED

Paris

MEDIUM

Pencil on paper

SIMILAR WORKS

The Holy Family with the Infant St John Joshua Reynolds, 1788–89

Turner, J.M.W.

The Sun of Venice Going to Sea, exhib. 1843 (detail)

This painting was accompanied by the following lines from Turner's epic poem, the 'Fallacies of Hope', when it was exhibited in 1843.

Fair shines the morn, and soft the zephrs blow / Venezia's fisher spreads his painted sail so gay, / Nor heeds the demon that in grim repose / Expects his evening prey.

These endorse the pessimistic nature of the painting for Turner, referring both to the peril of fishermen and the forces of the sea, but more allegorically alluding to the decline of Venice. It is one of the most beautifully painted of his later works and it was noted by Ruskin how Turner created depth and recession in the canvas without using obvious perspective tools.

Turner's Venetian works, both watercolour and oils, had a profound effect on the younger contemporary artist, J. B. Pyne (1800–70), who made several oil paintings of the city in the style of Turner's first works, and on the American landscape painter, Thomas Moran (1837–1926). During the last few decades of the nineteenth century Turner's images of Venice were amongst the most popular such pictures and were widely copied. There was particularly a large contingent of watercolourists who were directly and indirectly influenced by Turner's Venetian works. Of these the most notable were Albert Goodwin (1845–1932) and Hercules Brabazon (1821–1906).

PAINTED

London

MEDIUM

Oil on canvas

SERIES/PERIOD/MOVEMENT

Late Venetian

SIMILAR WORKS

S.Giorgio Maggiore from the Dogana J. B. Pyne, 1859

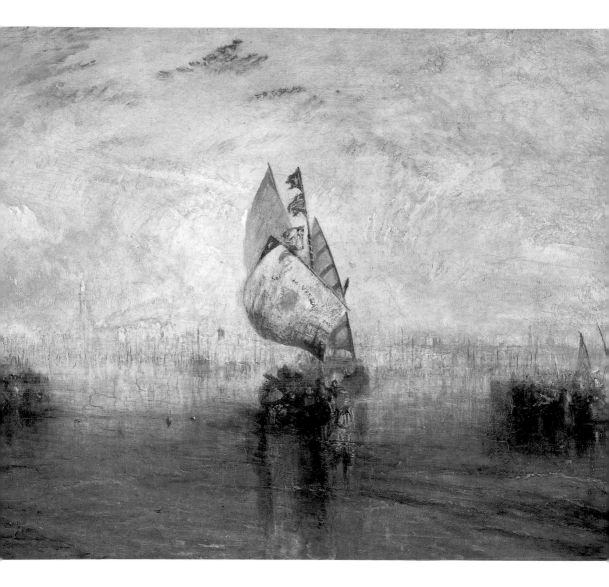

Turner, J.M.W.
Plymouth Citadel, a Gale, 1815 (detail)

Devon was a county that Turner travelled to often, finding it full of picturesque and romantic subjects. Plymouth and the surrounding area had a high population of resident artists, attracted by the scenery and the busy maritime bustle of the city. On Turner's visits he became acquainted with the local artists, especially Ambrose Bowden Johns (1776–1858), who helped prepare Turner's painting equipment during a sketching tour in 1813. Johns worked in a similar style to Turner, although with less assurance and maturity, and occasionally his work was confused with Turner's, something that would not have endeared him to the British master. Turner's influence was seen through the work of Johns and that of Samuel Prout (1783–1852), B. R. Hayden and Edward Calvert (1799–1883) who were all involved in the local Plymouth artistic circle.

 Plymouth Citadel, A Gale depicts the full force and magnitude of nature, against which the buildings sit in linear array. The drawing of the buildings is Classical in nature set against the Romantic painting of the sea and waves. A similar approach to the mass of nature contrasted with the smallness of man and his constructions would be seen in Monet's paintings of the cliffs at Dieppe during the 1880s.

PAINTED

Plymouth

MEDIUM

Pencil and watercolour

SERIES/PERIOD/MOVEMENT

Devon

SIMILAR WORKS

Harwich Lighthouse John Constable, exhib. 1820

An Eruption of Mount Versuvius Clarkson Frederick Stanfield, 1839

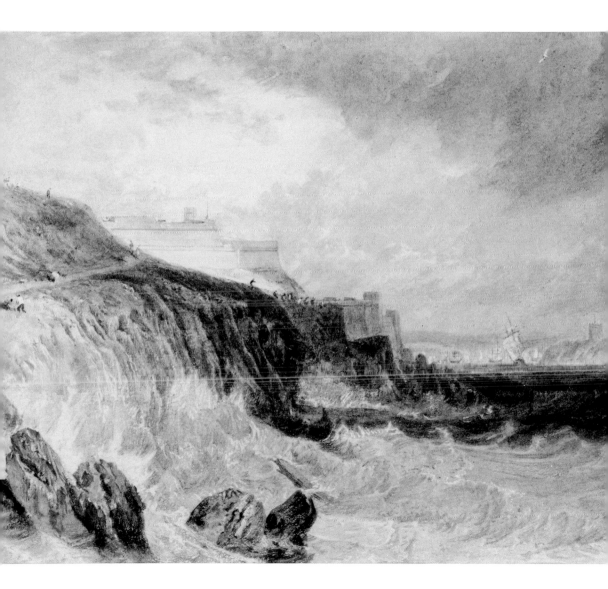

Turner, J.M.W.

Yacht Approaching the Coast, *c.* 1840–45 (detail)

Turner had a strong affinity with all things maritime and boats would become one of the most recurring motifs that he used within his paintings. His childhood was spent living near the busy Thames and from a young age he journeyed to the coast, sketching as he went. It is not insignificant that at this time in Britain there was a fashion for maritime paintings, which was inspired by the role of Britain's fleets in defeating Napoleon and the continuing emergence of Britain as a maritime power to be reckoned with.

The seventeenth-century Dutch seascape painter, Willem Van de Velde (1633–1707) the younger, had an effect on Turner at a young age and it is said that on seeing a mezzotint of one of his paintings, Turner declared, 'that made me a painter'.

Turner's interest in atmospheric effects is brilliantly rendered in *Yacht Approaching the Coast*. The iridescence of the sun shining on the water and reflecting from the clouds is astonishing. The minimal context of the composition, where the painting has been reduced in content to become the realization of a study of light, is a technique that was later seen with Whistler and Monet, although their handling of paint would be very different.

PAINTED

London

MEDIUM

Oil on canvas

SERIES/PERIOD/MOVEMENT

Atmospheric coastal scene

SIMILAR WORKS

Padua J. R. Cozens, 1782

Yarmouth Harbour, Evening John Crome, *c.* 1817

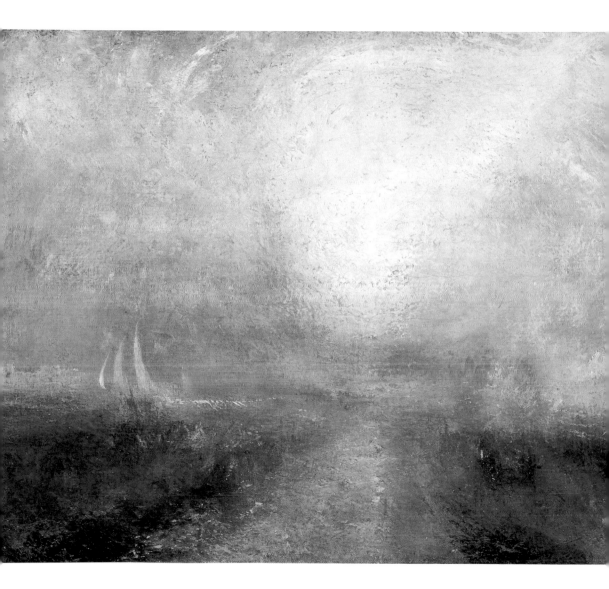

Turner, J.M.W.
The Shipwreck, 1805 (detail)

In 1804 William Falconer's poem 'The Shipwreck' was republished and it may have been this that inspired Turner's dramatic painting of the following year. Turner's depictions of the sea essentially fell into three categories, high-seas drama, of which this is one, atmospheric studies and coastal scenes. This painting has taken the seascapes of Van de Velde as its point of departure, the high drama and movement at odds with the conventional stability of Dutch seascapes. The sublime subject of the painting, with its beautiful terror and impending disaster, reflects the Romantic attitudes towards nature that were popular at that time. The bold colour is reminiscent of the great colourist master, Eugène Delacroix (1798–1863). The image of man in the midst of nature's magnitude was one that Turner often returned to throughout his career.

Charles Turner (1774–1857), the engraver, made many copies after Turner's work and engraved *The Shipwreck*, which was published in January 1808. This was the first of Turner's oil paintings to be reproduced as such and Charles Turner used this to accompany his etching. 'C. Turner has the pleasure to inform his friends, as it will be the first engraving ever presented to the public from any of Mr. W. Turner's pictures, the print will be finished in superior style ...'

PAINTED

London

MEDIUM

Oil on canvas

SERIES/PERIOD/MOVEMENT

Dramatic maritime

SIMILAR WORKS

The Battle of Camperdown Philip James De Loutherbourg, 1799

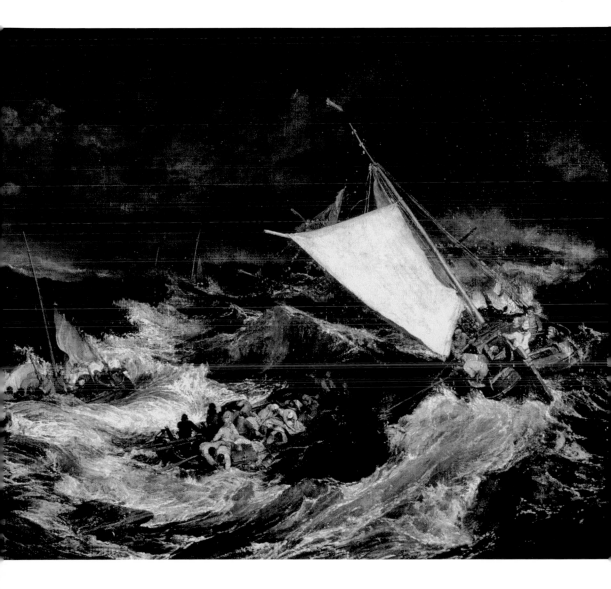

Turner, J.M.W.

Snow Storm – Steam-Boat off a Harbour's Mouth, exhib. 1842

Increasingly through his later works Turner chose to paint great storms and turbulent weather. Whether this was through a heightened pessimism, a foreboding of his demise, or an exploration of effects and techniques, is conjecture, although most plausibly it was a bit of each. He had had a long affinity with a large circle of academics and scientists and his interest in geology, astronomy, electricity and physics is well documented. He was greatly influenced by Mary Sommerville and her experiments to discover the magnetizing power of violet light in the spectrum. In the 1830s Sommerville was studying the phenomena of electricity and magnetism and observed, 'even a ship passing over the surface of the water, in northern or southern latitudes, ought to have electric currents running directly across the path of her motion'.

The mysterious picture can certainly be seen in the light of these modern theories; the swirling water appearing to surround the iron ship, as iron filings do a magnet. The intensity of the storm and the circular motion throughout the canvas is both fantastic visually and horrifically fatalistic, as the ship clearly stands no hope of survival. It is a combination of many styles that he has formulated into his own revolutionary handling of colour and light.

PAINTED

London

MEDIUM

Oil on canvas

SERIES/PERIOD/MOVEMENT

Dramatic maritime

SIMILAR WORKS

The Commencement of the Deluge William Westall, exhib. 1848

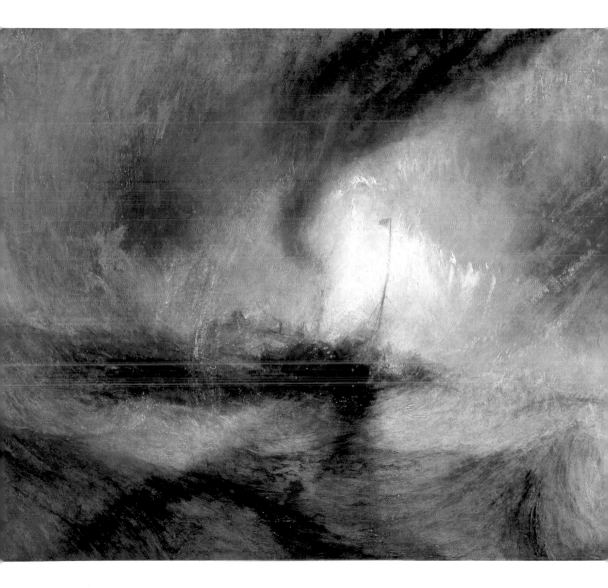

Fantin-Latour, Ignace Henri
Homage to Delacroix, 1864

© Musee d'Orsay, Paris, France, Lauros/Giraudon/Bridgeman Art Library/www.bridgeman.co.uk

During the second half of the nineteenth century there were three main headings under which painters could be categorized by the established art community: Classical, Romantic and Realist. Ingres was the champion of those Classical admirers, Gustave Courbet (1819–77) led the way for the Realists and Delacroix was esteemed as the greatest colourist and proponent of the Romantic movement. It would be this very classification system that would cause so many problems for both Whistler and Monet, two very different, but thoroughly innovative artists who fell beyond the academic headings.

Whistler's art would change significantly through his career, but at the time of Ignace Henri Fantin-Latour's (1836–1904) painting he still admired the techniques of Courbet. Fantin-Latour, Alphonse Legros (1837–1911) and Whistler had formed the Societé des Trois in 1858 and were part of a close-knit community of artists and writers, circulating ideas and theories and engaging in lively debate. Fantin-Latour's *Homage to Delacroix* was painted the year after the great painter died and included in it a self-portrait, and portraits of Whistler, Legros, Jules Hanson Champfleury (1821–89), Edouard Manet (1832–83), Charles Baudelaire (1821–67), Félix Bracquemond (1833–1914), Albert de Balleroy (1828–73) and Edmond Duranty (1833–80). This group clearly aligned themselves with the Realist and Romantic trends, as opposed to the Classical school.

PAINTED

Paris

MEDIUM

Oil on canvas

SERIES/PERIOD/MOVEMENT

Hommage

SIMILAR WORKS

Self Portrait Gustave Courbet, 1845–50

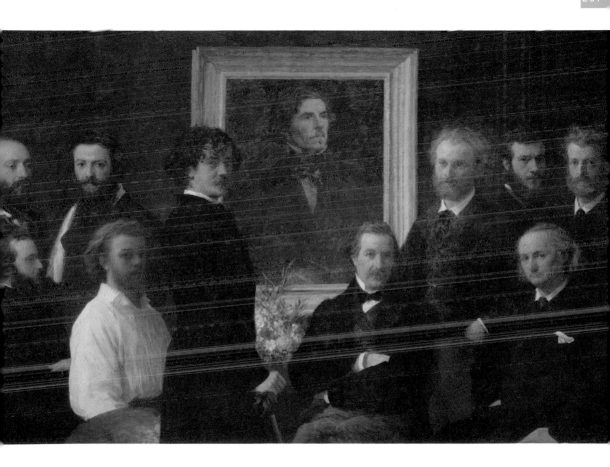

Whistler, James
The Violet Note, 1885–86

During Whistler's long career his artistic style evolved significantly. Having followed the practices of Courbet and the Realists in his early career, in 1867 he rejected their principles and looked to the Classical style of Ingres. The influx of Japanese and Oriental art and artefacts into Europe from the mid 1850s was to have a profound effect on Whistler's style and on his attitude towards the artistic importance of the whole scheme, beyond simply the painting. He took the Classical influence of Ingres, which was so popular in England, and combined it with the colourist flair of Delacroix, the hero in France, and produced a style uniquely his own. In his *Violet Note* there is both a debt to the Classical and to the Japanese with a distinctly oriental feel in pose and design. The jewel red within the purple tonality is a typically decorative motif. Whistler was increasingly becoming involved with a Symbolist type of approach to his art and this would be further established through his close contact with the French Symbolist poet Stéphane Mallarmé (1842–98) around 1888.

PAINTED

London

MEDIUM

Chalk and pastels on paper

SERIES/PERIOD/MOVEMENT

Pastels

SIMILAR WORKS

Violet John Singer Sargent, 1881

Whistler, James

Arrangement in Pink and Purple, 1881–85

© Cincinnati Art Museum, Ohio, USA/www.bridgeman.co.uk

Whistler used the descriptive musical terms 'symphonies' and 'harmonies' and the term 'arrangement' as titles for his paintings to convey a greater sense of the aesthetic nature of the painting and to veer away from his works being seen as 'pictures' of life. His musical terminology is generally accredited to his patron Frederick Leyland in the first instance, as it was he who suggested it, and the concept of the greater artistic endeavour was one that was very important to Whistler. Following in the Oriental tradition of 'art' encompassing everything from the painting to the frame, to the room and the curtains, and so on, Whistler made a point of frequently designing his own picture frames. The decorative element of his art was extremely important, even down to the butterfly signature, which he devised from his initials and which evolved in style from 1869 onwards.

Portraiture was an important source of revenue for Whistler, which was hit by the Ruskin trial, when he became less acceptable to the middle and upper classes. *Arrangement in Pink and Purple* shows the young daughter, Olga, of the Duchess of Caracciolo, a lady rebutted by society due to past liaisons. Whistler has caught Olga on the threshold of maturity; the atmosphere is decadent, contrasted by the white of the girl's dress.

PAINTED

Dieppe

MEDIUM

Oil on panel

SERIES/PERIOD/MOVEMENT

Portraits, 1880s

SIMILAR WORKS

Miss Minnie Cunningham Walter Sickert, 1892

Portrait Study Charles Conder, c. 1901

Whistler, James

Nocturne: Blue and Silver – Cremorne Lights, 1872

© Tate, London 2005

Whistler's paintings of peaceful atmospheric night-time scenes do not form a series in the manner of Monet's Haystacks or Poplars, but are obviously viewed within the context of a continuity in style. He took the simple restricted tonal base of Japanese art and created minimalist compositions reducing extraneous elements, but at the same time maintaining an extent of Realism by staying true to the topography of his subject. His Nocturnes became a perfect blend of the decorative and symbolic with accurate representation. The flat surfaces of colour wash in the Nocturnes allude to Japanese woodcuts, while the treatment of the still water goes back to his study of Canaletto and the Dutch school.

He followed the example of the painter Lecocq de Boisbaudran by memorizing his scenes and then recreating them quickly in his studio. Whistler would also have seen these techniques through the work of William Hogarth (1697–1764), the English artist whom Whistler greatly admired, and Legros. This painting was signed with the decorative butterfly signature and was displayed in a frame that Whistler conceived, decorated with a fish-scale pattern.

PAINTED

London

MEDIUM

Oil on canvas

SERIES/PERIOD/MOVEMENT

Nocturnes

SIMILAR WORKS

Whitby – Fishing Boats John Singer Sargent, 1885

Whistler, James

Harmony in Blue and Silver: Trouville, 1865

Whistler painted *Harmony in Blue and Silver: Trouville* while staying with Courbet at the fashionable holiday spot of *Trouville in Normandy*. Several years prior to this Whistler had produced the painting, *The Coast of Brittany*, 1861, through which the influence of the Realist Courbet can be clearly felt. By the time of Trouville, Whistler was starting to head away from the Realist school and was gradually evolving his own style. This would be cemented during his brief trip to Valparaiso, at which time his dreamy, evocative paintings had clearly departed from Courbet's maxim.

Harmony in Blue and Silver: Trouville again reflects Whistler's interest in Japanese art, a continuing reference throughout his work. The broad, flattened colour washes and the high horizon would have been elements that Courbet would have disapproved of. His use of thin coats of paint, quickly applied, show him handling his oils in the manner of a watercolourist. There is a strong diagonal pull through the painting from the figure at the front, to the sailing boat and on to the sail on the horizon. The solitary figure is believed to be that of Courbet himself. It was fashionable at this time to depict the bustle of bourgeois holiday-makers at the Trouville coastline, something that Eugène Boudin (1824–98) was the master of. Here, Whistler has chosen to show a different view of the area, transforming it to a place of solitude and reflection.

PAINTED

Trouville

MEDIUM

Oil on canvas

SERIES/PERIOD/MOVEMENT

Trouville

SIMILAR WORKS

Beach Scene Gustave Courbet, 1874

11111111111111

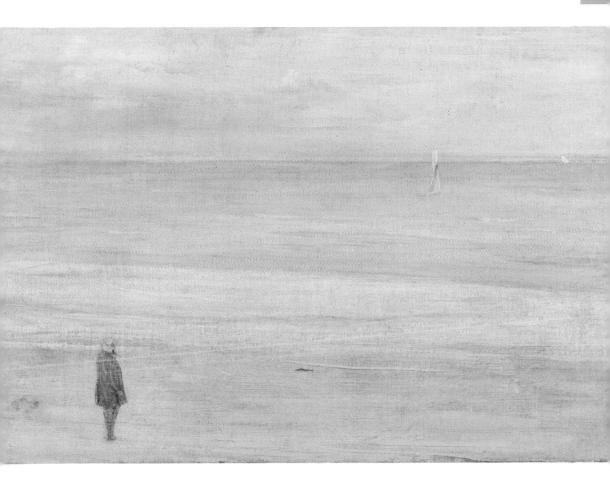

Fantin-Latour, Ignace Henri
Studio at Batignolles, 1870

Fantin-Latour's painting of Manet in his studio surrounded by artists and writers of the day is an intensely Realist portrayal of a group affiliated to the Realist school. It is interesting to note that as Whistler appeared in Fantin-Latour's earlier *Homage to Delacroix*, 1864, so too is Monet to be found in *Studio at Batignolles*. Monet is a shadowy figure at the back and would have been still largely unknown within wider circles, but his inclusion in the painting is significant in the light of his early work.

Whistler had been encouraged by his brother-in-law Francis Seymour Haden to paint *en plein air* and Monet was inspired by watching the landscape artist Eugène Boudin painting in the fresh air around Le Havre. As Whistler was at first influenced by Courbet, Monet, too, was influenced by the Realists Courbet and Manet. Fantin-Latour's painting pays tribute to the influence of Manet over progressive painters of the day, as he was widely regarded as a leader by his contemporaries. The public was not yet ready for Manet's revolutionary approach to art and he was widely criticized and misunderstood, as were Whistler and Monet.

PAINTED

Paris

MEDIUM

Oil on canvas

SERIES/PERIOD/MOVEMENT

Realism

SIMILAR WORKS

Le Repas des Pauves Alphonse Legros, 1877

Portrait of Zacharie Astruc Edouard Manet, 1864

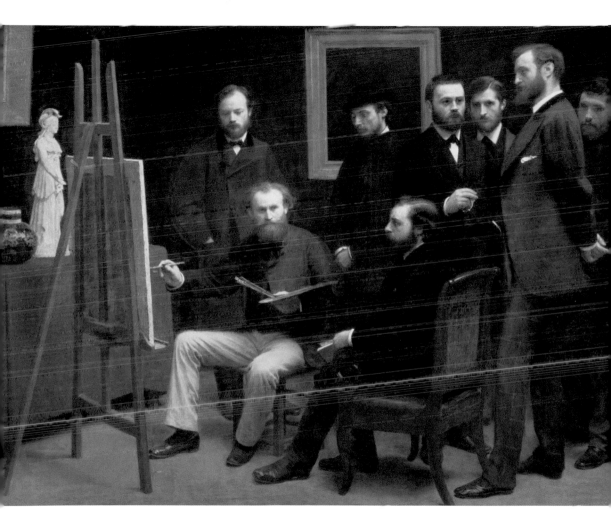

Monet, Claude

Camille Monet and a Child in the Artist's Garden in Argenteuil, 1875

Monet was fortunate that during his lifetime there was a huge circle of artists and writers wheeling amongst each other, breaking new ground in art and literature and fostering an atmosphere of new ideas and theories. As such, he was exposed to a wide range of work by artists. Early influences on him were the works of Boudin and Jongkind (1819–91), the Barbizon school of landscape artists, especially Daubigny, Corot (1796–1875) and Millet (1814–75), the Realist Courbet and the colours of Delacroix. While painting from Gleyre's studio Monet met Auguste Renoir (1841–1919), Bazille, Sisley, Camille Pissarro (1830–1903) and possibly Whistler. Renoir and Monet developed a strong friendship and often painted alongside each other, and Pissarro, Sisley and Monet influenced each other.

During the 1870s Monet was working from Argenteuil and produced a series of paintings of Camille in garden settings. The beautiful pictures full of golden light and blooming flowers were charming representations of the middle class in a bourgeois setting, and were painted to sell to this market. Monet's painting, *Impression, Sunrise*, 1873, had provided a name for the new style of painting that his work, and that of his friends Renoir, Pissarro and Sisley, embodied.

PAINTED

Argenteuil

MEDIUM & DIMENSIONS

Oil on canvas, 55.3 × 64.7 cm (21³/₄ × 24¹/₂ inches)

SERIES/PERIOD/MOVEMENT

Impressionist

SIMILAR WORKS

Young Woman with a Dog, Auguste Renoir 1880

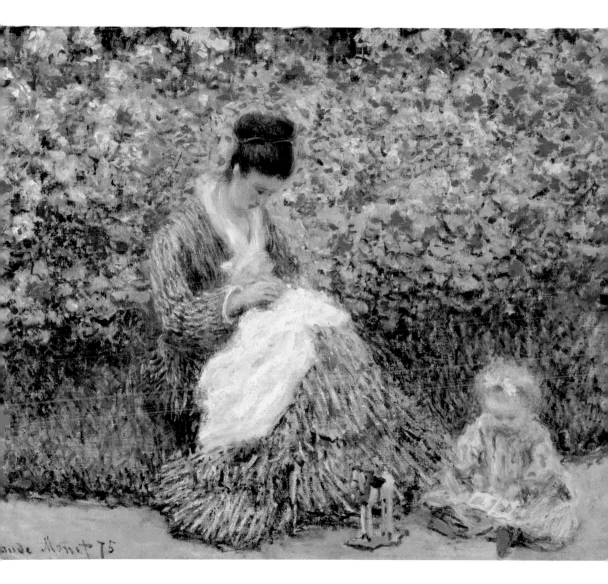

aude Monet 75

Monet, Claude

Wild Poppies near Argenteuil, 1873

'It takes immense genius to reproduce simply and sincerely what you see in front of you,' Edmond Duranty writing for *Le Realisme*, 1856.

The paintings of the 1870s show Monet experimenting with the visualization of pure colour within the landscape. Following with the theories of the chemist Chevreul (1786–1889) he used complementary colours, such as the red of his poppies and the green of the fields, blues and oranges and yellows, to create the vividness so associated with the Impressionist landscapes. Scenes such as *Wild Poppies, Argenteuil* provided him with the perfect subject matter for his exploration of contrasting colours. For Monet, Renoir and the fellow Impressionists, the green of grass was not simply green, but made up of blues and yellows and all the colours that light effects would produce. Monet's dabs of pure colour, and his understanding of the effects of tone and colour as a whole, would later be seen in the work of Georges Seurat (1859–91) as he developed his style of Neo-Impressionsim.

After visiting North Africa and seeing the strong contrasts of brilliant sun and shadow, he became aware of the colours within colours – that a shadow was more than just brown or black. This is the premise upon which Monet's treatment of colour began and expanded.

PAINTED

Argenteuil

MEDIUM

Oil on canvas

SERIES/PERIOD/MOVEMENT

Impressionist

SIMILAR WORKS

Path Winding up through Tall Grass Auguste Renoir, 1876

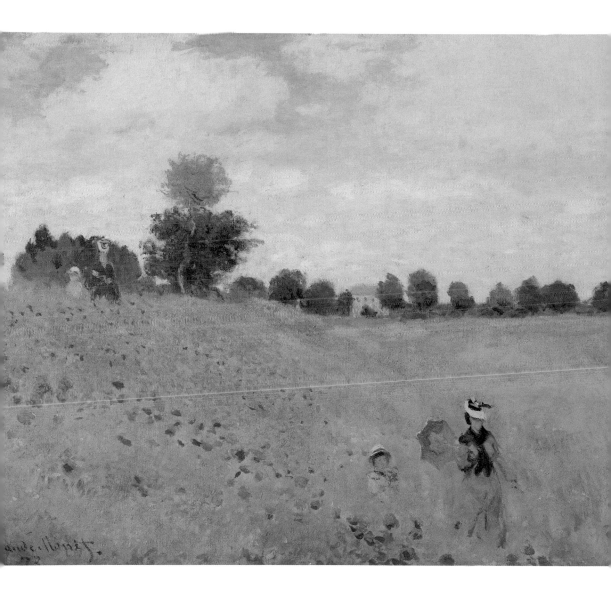

Whistler, James
Sketch for 'The Balcony', 1867–70

The importance of the influence of Japanese art on Whistler is undeniable, but what must be recognised is the discerning method with which he approached this art, and the way he assimilated only those aspects that accorded with his own style. The resulting pictures combine Japanese elements within a Western context. The sketch for *The Balcony* shows the compositional form encompassing the seated figure, and the vertical/horizontal accents through the blinds and horizon as reminiscent of Kiyonaga's (1752-1815) 'The Sixth Month' (from *Twelve Months in the South*,1784) which is particularly interesting because Kiyonaga himself was strongly influenced by Western approaches to perspective. The Japanese woodcuts of Hokusai (1760-1849), especially that of *People on the Temple Balcony* were also a point of reference for Whistler.

The figures in Whistler's sketch are in Oriental dress, and yet the standing figure's pose is suggestive of a draped Classical figure, and the view from the balcony is of the Thames rather than an idealised Japanese landscape. The inclusion of the cherry blossom in the foreground has no purpose other than a decorative value, and may have been added to the picture at a later date.

PAINTED

London

MEDIUM

Oil on panel

SERIES/PERIOD/MOVEMENT

Japonisme

SIMILAR WORKS

A Sleeping Girl Albert Moore, 1875

Spring by the Sea Charles Conder, c. 1905

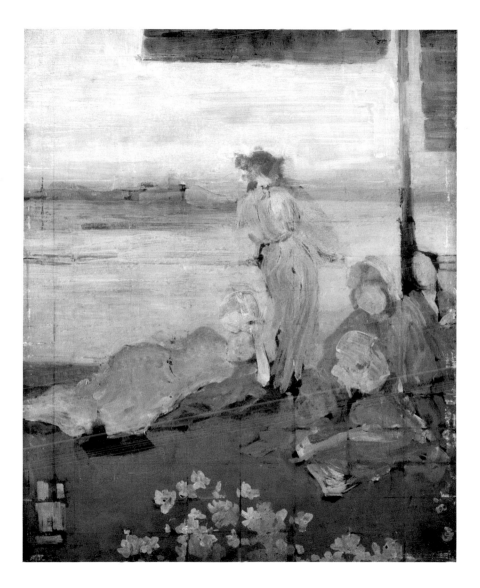

Monet, Claude

La Japonaise, 1876

This was a highly unusual painting for Monet and it is likely that he produced it in an attempt to match his earlier successful Salon piece, *Camille*, 1866. *La Japonaise* depicted Camille in an overtly flirtatious engagement with the spectator, an attitude that was significantly absent from Monet's paintings, virtually without exception. The strongly painted Japanese robe and the head of the Japanese figure stand apart from the figure of Camille, so that the robe itself is of primary importance. The obvious sexual placement and pose of the Japanese assailant figure becomes almost more real than the painting of Camille herself, who appears flat and stylized in contrast. In later years Monet referred to this painting as 'an obscenity'.

The influence of Oriental woodcuts and design had a far greater effect on Monet's contemporaries, especially Fantin-Latour, Whistler, Manet, Degas and Felix Bracquemond. There was a pavilion at the 1867 World's Fair of Japanese art and artefacts and another in 1878, which was a great success. One aspect of Monet's work that may have been influenced by Japanese art was his use of a bird's-eye view for some of his landscapes and this was also seen in the works of Pissarro and Manet.

PAINTED

Argenteuil

MEDIUM & DIMENSIONS

Oil on canvas, 231.8 × 142.3 cm (91 1/4 × 56 inches)

SERIES/PERIOD/MOVEMENT

Japonisme

SIMILAR WORKS

Caprice in Purple and Gold, No. 2: The Golden Screen James Whistler, 1864

Purple and Rose: The Lange Leizen of the Six Marks James Whistler, 1864

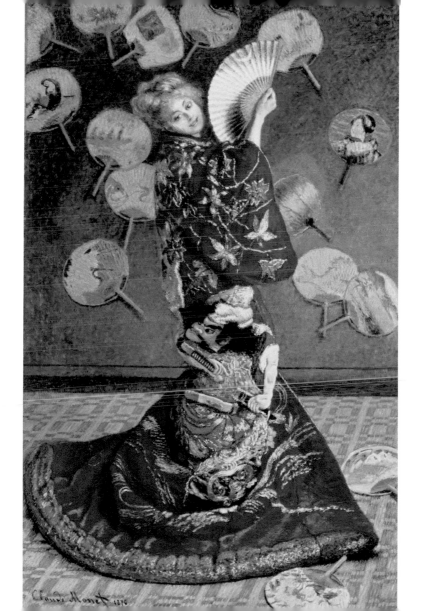

Whistler, James

Sketch for Rose and Silver: La Princesse du Pays de la Porcelaine, 1863–64

The finished painting based on this sketch used Christine Spartali, the daughter of the Greek Consul General in London as the model, although the sketch itself appears to have been based on a model of more oriental appearance. The decorative elements of the sketch, the pose, and the kimono draperies show Whistler at the beginning of his Japanese inspired paintings; at around the same time he painted *Purple and Rose: The Lange Leizen of the Six Marks*, 1864. Both incorporate Japanese motifs and decoration for aesthetic effect within the larger framework of western colour and design. It is interesting to note that although Whistler was clearly influenced by Japanese art, he was highly selective in the elements that he chose to use. In 1863 Whistler had travelled to Amsterdam with Legros, and would have seen the work of the seventeenth-century Dutch interior painters. Both these paintings of Whistler's owe a debt to Vermeer (1632–75) in their handling, while also alluding to Corot and his painting of figures. It is worth noting Whistler's use of decorative and ornamental elements in his paintings, within the context of the development of Art Nouveau, most especially seen in his delicate butterfly signature.

PAINTED

London

MEDIUM

Oil on fibreboard

SERIES/PERIOD/MOVEMENT

Japonisme

SIMILAR WORKS

A Garden Albert Moore, 1869

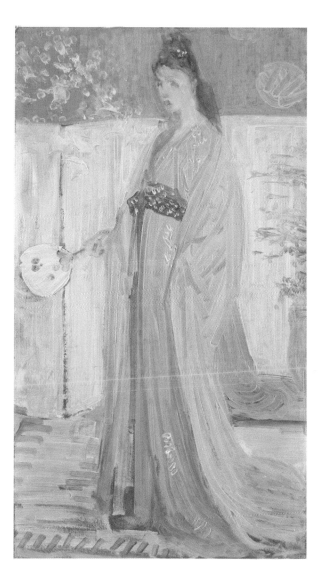

Whistler, James

Arrangement in Grey: Portrait of the Painter, c. 1872

Whistler's portraits of the 1870s were influenced by the Dutch Masters and Diego Velásquez (1599–1660). In 1855 Whistler had travelled to Manchester to an exhibition of Old Masters, amongst which there were 13 paintings by, or attributed to, Velásquez, who had been the initial spark of admiration for Whistler. Velásquez was also greatly admired by the French avant-garde set, particularly Manet, whose works Whistler was also very familiar with. Velásquez's tonal base and figures merging from a dark background can be seen in Whistler's portraits, although he nevertheless made his style of portraiture very much his own.

The Dutch school, most notably Frans Hals and Terborch (1617–81) were also a point of reference for Whistler with his portraiture and it is known that he studied the works of Hals at length in the Museum of Haarlem.

A series of British Portrait exhibitions at the South Kensington Museum from 1866 to 1868 would have had an effect on Whistler and his subsequent portraits of the 1870s. These paintings were masterful renditions of character within formal and minimal compositions.

PAINTED

London

MEDIUM

Oil on canvas

SERIES/PERIOD/MOVEMENT

Portraits, 1870s

SIMILAR WORKS

James McNeill Whistler Sir William Nicholson, 1899

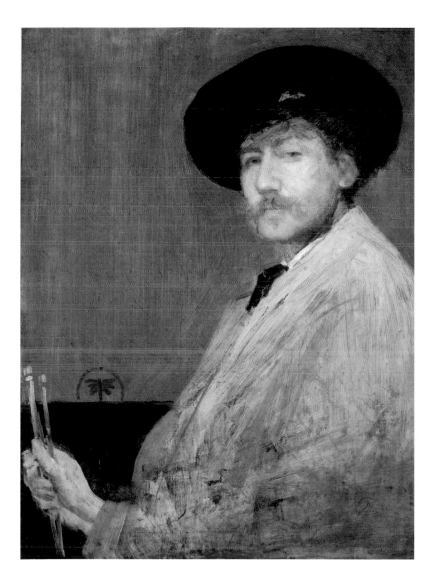

Whistler, James

Symphony in White, No. 2: The Little White Girl, 1864

The model for this painting was Joanna Hiffernan, Whistler's mistress, and an auburn-haired Irish beauty. The picture is vaguely reminiscent of the Pre-Raphaelites, who favoured long-haired beauties in dreamy, ethereal poses with a romantic appeal. The contemplative face of Jo in the mirror prompted Algernon Swinburne to compose the poem, 'Before the Mirror'. Whistler exhibited the poem, inscribed on gold paper and pasted to his picture frame when the painting was sent to the Royal Academy (RA).

The painting was first exhibited in 1865 as *The Little White Girl* and it was not until 1867 that Whistler added *Symphony in White No. 2*. In his famous Ten O'Clock lecture of 1885 Whistler declared, 'Nature, contains the elements, in colour and form, of all pictures as the keyboard contains the notes of all music. But the artist is born to pick and choose, and group with science those elements, that the result may be beautiful — as the musician gathers his notes, and from this chords, until he brings forth from chaos glorious harmony.'. Whistler was creating the 'picture' as a vehicle to evoke sensations through emotive colours and, by referring to them in musical terms, he was able to suggest the harmony of relating tones and colours transcending the subject of the painting itself. This was a practice that was especially felt through his Nocturne paintings and which would be fully realized in the art of the Symbolist painters and into twentieth-century painting.

PAINTED

London

MEDIUM

Oil on canvas

SIMILAR WORKS

Aurelia (Fazio's Mistress) Dante Rossetti, 1863–73

Thoughts of the Past John Roddam Spencer Stanhope, exhib. 1859

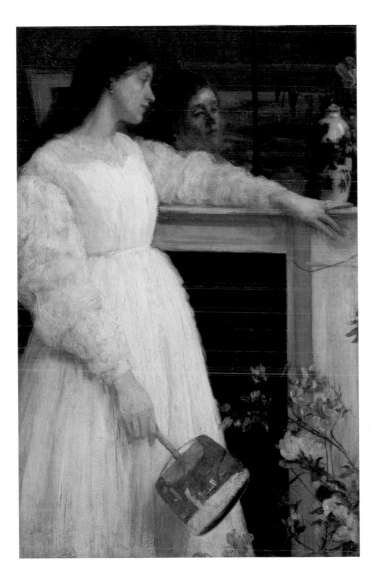

Monet, Claude
Hyde Park, c. 1871

© Museum of Art, Rhode Island School of Design, USA/www.bridgeman.co.uk

Monet first travelled to London in October 1870, staying there for just under a year, during which time he met up with Pissarro. Both artists were taken under the wing of Paul Durand-Ruel, 'But for him we would have starved in London,' Pissarro said of the dealer who was a great supporter of the Impressionists.

In London Monet and Pissarro visited museums and art exhibitions together, as well as painting together on occasions. The sudden exposure to the works of Thomas Gainsborough (1717–88), John Constable (1776–1837), Sir Thomas Lawrence (1769–1830) and Sir Joshua Reynolds no doubt stimulated the artists, but the biggest influence they would come across would be that of Constable and primarily Turner.

Whistler, too, had quite an impact on Monet's works, especially his paintings of Hyde Park. After Monet's first trip to London there was significant change in the subtlety of his application of colour and tone and this could have been through studying Whistler's works. The two artists would already have met in Paris, probably at the Café Guerbois, which was a popular haunt for the avant-garde artists and writers. This painting of Hyde Park is particularly reminiscent of Whistler, with its simple tonal base, and is an unusually sombre painting for Monet.

PAINTED

London

MEDIUM

Oil on canvas

SERIES/PERIOD/MOVEMENT

London, 1871

SIMILAR WORKS

Limay Jean-Baptiste-Camille Corot, 1870

The World's Fair in Paris Edouard Manet, 1867

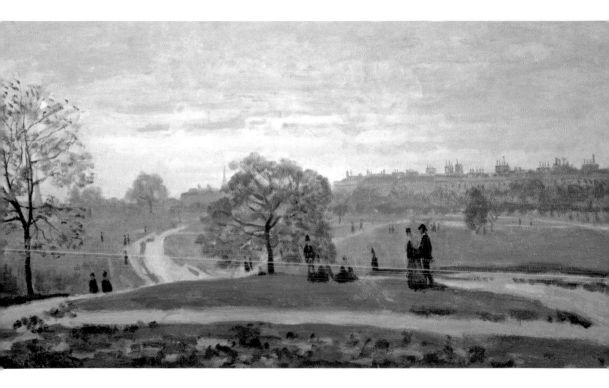

Monet, Claude
The Thames Below Westminster, 1871

This is another of Monet's London paintings that appears to have been conceived in a spirit similar to Whistler's and indicates the closely knit circle that these contemporary artists revolved in. The soft glow of the foggy sky behind the Houses of Parliament and Big Ben and the delicately painted bridge reminds one of Whistler's *Nocturne: Blue and Silver – Cremorne Lights*, 1872. However, Monet makes the painting entirely his own by the inclusion of the dark jetty and the Impressionistic painting of the embankment, the dark boats and the trees. Monet cannot help but put the stamp of 'from nature' on this period of painting and relishes in the gritty here and now of the figures on the jetty and the steam from the tugboat.

There is an overriding sense of detachment from his subject in this first period of London paintings and, for the length of time that Monet was in the capital, his output was small. This could be explained by the artist's own sense of displacement, having left France quickly to avoid the war, leaving Camille and son Jean behind.

PAINTED

London

MEDIUM

Oil on canvas

SERIES/PERIOD/MOVEMENT

London, 1871

SIMILAR WORKS

Chelsea in Ice James Whistler, 1864

Charing Cross Bridge Camille Pissarro, 1890

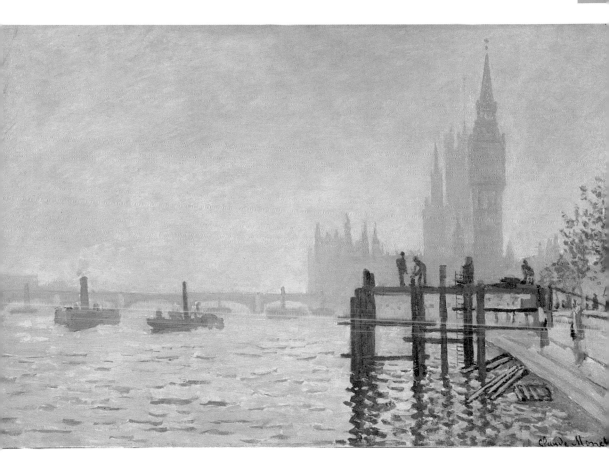

Claude Monet

Turner, J.M.W.
The Scarlet Sunset, *c.* 1830–40

The Scarlet Sunset is an amazing depiction that suggests the composition and feel of the picture with the minimum of lines. Although Turner's style could be described as giving 'an impression' of a light effect, the extent of his influence on the later Impressionist painters is not fully understood. Elements of his handling of colour and tone were synthesized by the Impressionists and he opened the door for pictures that were about more than a pictorial subject.

This picture shows his understanding of the colours in light and portrays his freedom and expression within his watercolours especially. The simple line to suggest the reflection of the sun is extraordinarily modern, on the one hand, and reminiscent of the minimal use of line within Japanese art, although this would not have been something that he would have been influenced by. The soft outlines of the buildings in the distance and the hazy light spread throughout the picture could have inspired Whistler, especially in his Nocturne pieces, and Monet's early London paintings.

Turner visited Delacroix's studio in Paris in 1832 and the two great artists met for the first time. From notes in Delacroix's records it would appear that they did not get on particularly well and Delacroix seemed disappointed by Turner, who he described as 'cold'. Both painters were famous for their exquisite use and understanding of colour, and for their Romantic works, but it is unlikely that they were directly influenced by each other.

PAINTED

London

MEDIUM

Watercolour and gouache on paper

SERIES/PERIOD/MOVEMENT

Romantic, landscape

SIMILAR WORKS

Sunset at Lavacourt Claude Monet, 1880

Monet, Claude

Sunset, 1880

The extent to which Monet and his compatriot Pissarro acknowledged the influence of Turner on their works is rather vague. Extracts published from Wynford Dewhurst's book on Impressionist painting apparently caused Pissarro some consternation who felt that the author had attached too much significance to the influence of English painters on the development of Impressionism in France. In a letter to his son Pissarro wrote, 'This Mr Dewhurst ... says that before going to London Monet and I had no conception of light; yet we have studies that demonstrate the contrary. But what he doesn't realize is that Turner and Constable, while they taught us something, showed us in their works that they had no understanding of the analysis of shadow, which in Turner's painting is simply used as an effect, a mere absence of light.'. How great the influence of Turner actually was on the development of Monet's work cannot be precisely estimated. If Turner's vision of light and reflection was not an inspiration to Monet's treatment of the same effects, then it must at the very least have reaffirmed the predisposition Monet had towards this. Turner's particular aptitude for depicting sunlight in mist and light reflecting on water would also have been of help to Monet.

This painting of the sun setting on the Seine shows the mature artist using vivid colours to evoke the brilliance of the dying sun reflecting in the water. The sunset is reminiscent of Turner, but also of an understanding of Japanese art.

PAINTED

Lavacourt

MEDIUM

Oil on canvas

SERIES/PERIOD/MOVEMENT

Impressionist

SIMILAR WORKS

Entrance to the Straits of Gibralter Gustave Courbet, 1848

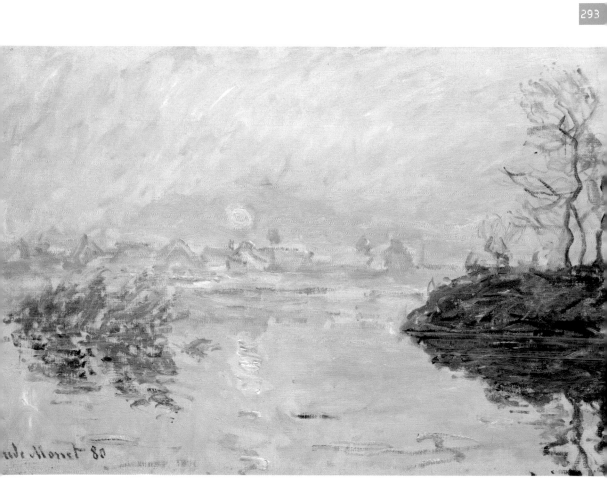

Turner, J.M.W.

Venice: Looking across the Lagoon at Sunset, 1840

© Tate, London 2005

Turner's work seems to have had the greatest influence on a group of American artists, who would have first become familiar with his work through studying engravings. Ruskin, too, was popular across the Atlantic and his exultation of Turner would not have been lost on artistic circles. Most notable amongst the Americans influenced by Turner would be Thomas Moran (1837–1926), who painted Venetian scenes after Turner, and James Hamilton (1819–78). Frederic Church (1826–1900) and Sanford Gifford (1823–80) also painted highly Turner-like scenes and Church in particular truly assimilated Turner's treatment of light, colour and atmosphere. The tail end of the Pre-Raphaelites were also somewhat influenced by Turner, who would at first appear to be at odds with their style. However, John William Inchbold (1830–88) painted several Venetian scenes after Turner, William Holman-Hunt's (1827–1910) Italian watercolours were clearly influenced by Turner, and Albert Goodwin (1845–1932) studied Turner's watercolour style.

This painting was described by Ruskin thus, 'The clouds are remarkable as an example of Turner's frequent practice of laying rich colour on a wet ground, and leaving it to graduate itself as it dried, a few subsequent touches being, in the present instance, added on the right hand. Although the boat in the centre seems a mere scrawl, the action of the gondolier ... is perfectly given in his forward thrust.'.

PAINTED

Venice

MEDIUM

Watercolour on paper

SERIES/PERIOD/MOVEMENT

Venice

SIMILAR WORKS

Scene in Venice Hercules Brabazon

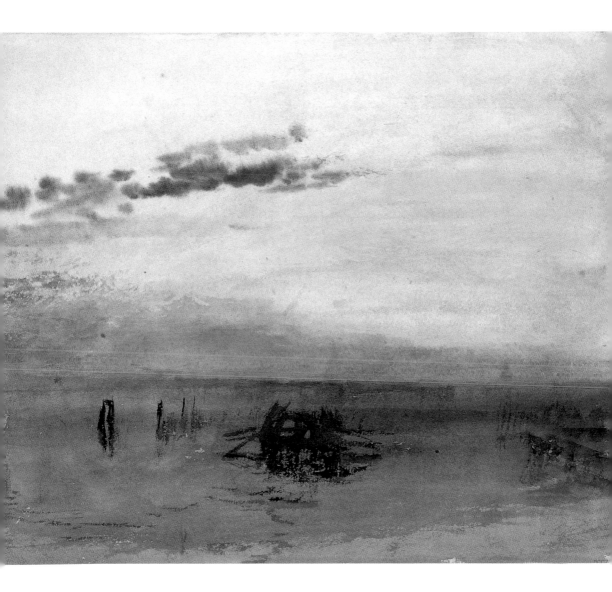

Monet, Claude
Sunset on the Sea at Pourville, 1882

During 1882 Monet painted over two dozen pictures from Pourville and Varengeville. In almost all these scenes he emphasized the enormity of nature in relation to the frailty of people, and the incongruence of man-made features within the natural landscape. These pictures also highlight his developing approach to depicting different light through colour and effect through his brushstrokes.

In *Sunset on the Sea at Pourville* he has completely removed any subject other than the simple effect of the sun setting on the sea, so that the painting is free from any distracting motifs. His colours become unnatural to the human eye and yet create the very colours that make up the prisms of light in nature. The sea and the sky almost become one, the former reflecting the latter, and the picture can be looked at as being an abstract vision through flat colour planes.

Increasingly Monet was becoming absorbed in the depiction of light and was leading towards his great series paintings from the 1880s onwards, the Haystacks, the Poplars, London, Venice and the monumental Waterlily group of paintings.

PAINTED

Pourville

MEDIUM

Oil on canvas

SERIES/PERIOD/MOVEMENT

Impressionist

SIMILAR WORKS

Ciel D'Orage Sur Dieppe Pierre Prins, 1880

Les Iles D'Or Henri-Edmond Cross, 1891–92

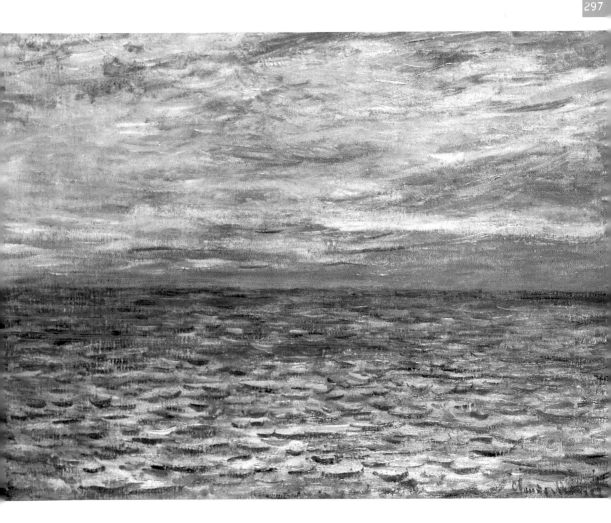

Monet, Claude

Nympheas, *c.* 1905

This series of paintings is that which Monet is perhaps best known for. The Waterlily paintings show him combining all those motifs that he most loved to paint: the garden, water and the effect of light and seasons on both. By this period Monet was financially stable, wealthy and able to exhibit and sell his canvases with ease. The garden at Giverny had been a long process, planned, designed and overseen by the artist, who was a avid gardener. During his years of financial success Monet no doubt employed a team of people to help keep the garden in shape, although he would remain at the helm of the horticultural wonderland. He spent the last three decades of his life recording it, experimenting with different views and techniques. By 1905, and the time of *Nympheas*, he had eliminated conventional viewpoints with a horizon and instead was painting the flat surface of the pond itself. His compositions became complicated spatially concerning the relationships of the horizontals of the water lilies and cloud reflections and the verticals of the reflected trees and reeds. The juxtaposition of those elements, both real and reflected, further created the depth and dream-like quality.

PAINTED

Giverny

MEDIUM

Oil on canvas

SERIES/PERIOD/MOVEMENT

Impressionist, Nympheas

SIMILAR WORKS

A Rose Trellis (Roses at Oxfordshire) John Singer Sargent, *c.* 1886

Thistles John Singer Sargent, *c.* 1883

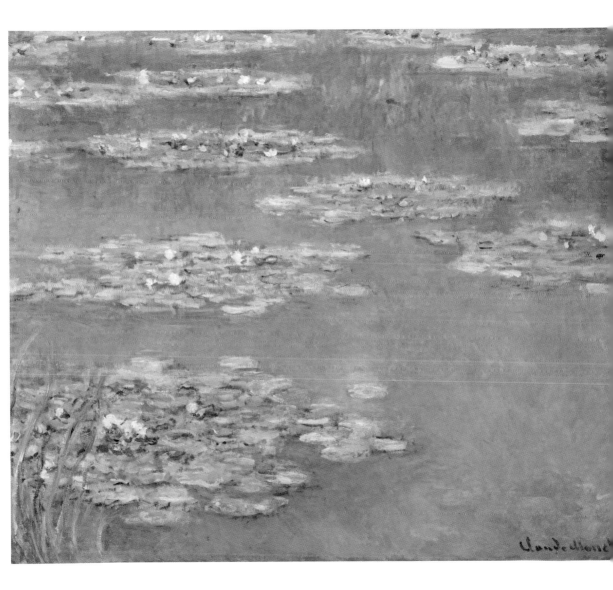

Monet, Claude
Waterlilies: Morning, 1914–18 (left section)

© Musee de l'Orangerie, Paris, France, Lauros/Giraudon/www.bridgeman.co.uk

Monet's beloved wife Alice died in 1911 and following that Monet was relatively unproductive for a period of time. When he came back to his Waterlily paintings in 1914 he made some radical changes in his approach, namely in the scale of the canvases. The pictures of this period were on a monumental scale, most measuring around two metres (six feet) square, far greater than the man himself. He also changed his palette and in these paintings used brilliant spots of colour to suggest the flowers.

Monet was an Impressionist to the end, his last 30 years of painting devoted to the depiction of light and reflection on his pond. The depths beneath the surface of the water and the space behind the picture frame were of utmost importance to him and he finally dispensed with frames altogether, so that his paintings could become a continuum of the world around him. His avant-garde approach to his art and his extraordinary use of paint and colour began the trail for subsequent art movements. In reality, however, Monet stood alone and it was his contemporary Paul Cézanne (1839–1906) who moved into Post Impressionism, and Henri Matisse (1869–1954), who had studied Monet and who became of the first of the Expressionist artists. Whistler was associated with the Symbolists, and Monet and the Symbolist poet Mallarmé enjoyed a close friendship.

PAINTED

Giverny

MEDIUM

Oil on canvas

SERIES/PERIOD/MOVEMENT

Impressionist, Waterlilies

SIMILAR WORKS

Vase of Flowers Odil Redon, 1865

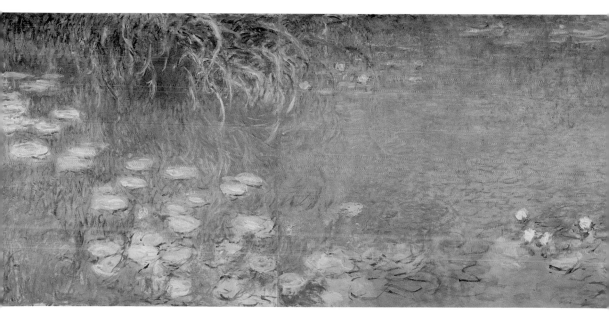

Whistler, James
Walter Sickert, 1885

Walter Sickert trained firstly at the Slade School of Art under Alphonse Legros who was one of the original members of the *Societé des Trois* with Whistler and Fantin-Latour. He later worked in Whistler's studio and became friendly with the Impressionist painters, while remaining on the fringes of the Impressionist circle. Sickert and Whistler had a turbulent relationship over the years, which resulted in them falling out over a review by Sickert of Whistler's work. However, in 1885 Whistler stayed with Sickert and his family in Dieppe, where he painted a number of watercolours.

Whistler's work had a significant influence on that of Sickert's and on the work of Mortimer Menpes who also studied at his studio. Whistler introduced Sickert to Degas, who greatly influenced his paintings of contemporary urban life.

Whistler's caricature is an amusing study of his friend working busily away and puts him in the context of a schoolboy at a desk. This may have been a friendly dig at the younger man who was a former student of his.

PAINTED

Dieppe

MEDIUM

Pen and ink on paper

SERIES/PERIOD/MOVEMENT

Caricature

SIMILAR WORKS

Caricature of Leon Manchon Edouard Manet, 1860

Aubrey Beardsley Walter Sickert

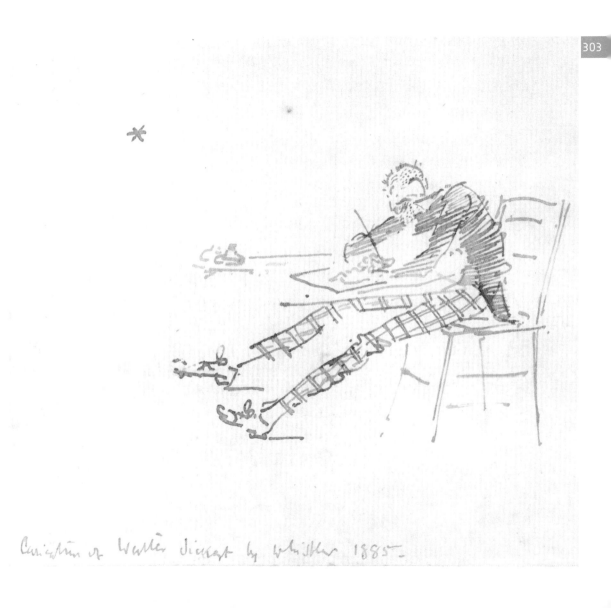

Caricature of Walter Sickert by Whistler 1885.

Turner, Whistler, Monet

Techniques

Turner, J.M.W.

Capital of a Pillar Worked Out in Perspective; Also a Diagram, *c.* 1810–27

In 1807 Turner was elected to the post of Professor of Perspective at the Royal Academy and thereafter produced a series of lectures on different aspects of perspective. To illustrate his lectures he made elaborate and detailed diagrams and *Capital of a Pillar* is one such. He was well armed in the intricacies of perspective, having received training from Thomas Malton Jr. and worked as a draughtsman for the architects James Wyatt and Thomas Hardwick.

He based much of his lecture material on perspective treatises and old perspective studies. Some of these dated back to the sixteenth century, copies of which he researched at the British Museum or had in his own collection. He made around two hundred diagrams such as this to illustrate his lectures, using a fine linear technique to emphasize architectural details. The lecture notes that survive, of which there are a great many, are generally confusing in content and, by all accounts, were not delivered particularly well. No doubt the watercolour-on-paper diagrams helped with his discourse.

PAINTED

London

MEDIUM

Watercolour on paper

SERIES/PERIOD/MOVEMENT

Perspective diagrams

SIMILAR WORKS

West Front of Peterborough Cathedral Thomas Girtin, *c.* 1794

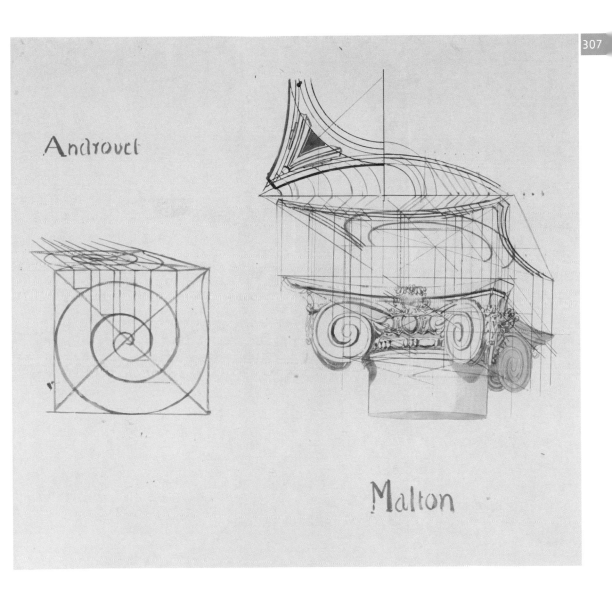

Androvet

Malton

Turner, J.M.W.

From Roll Sketchbook of Venice
Venice: A Boat Near Santa Marta, 1840

Turner made his last trip to Venice in 1840 during which time he executed numerous watercolour sketches, some more finished than others. Many of these had the dream-like quality of *A Boat Near Santa Marta* and are predominantly concerned with atmospheric effect rather than specific topography. He also worked on numerous sketches at the same time, some in different sketchbooks, which serve to record his different responses to the city and settings around him. This picture was executed in a soft palette of watercolours and was painted on to an off-white paper. It was probably part of a roll-back sketchbook, and a group of watercolours on similar sized paper using similar colours and techniques have been traced back to the same sketchbook. The aquamarine and soft orange colouring can be seen again in *The Grand Canal*, with S. Maria della Salute and the *Giudecca, looking towards Fusina,* both of which were painted at around that time. *A Boat Near Santa Marta* is Impressionistic in its representation and the colour extremely pure and vivid. Turner may have attained such clarity of colour by allowing the white of the paper to shine through the paint, a technique that creates an added brilliance, especially effective in the blue of the sky.

PAINTED

Venice

MEDIUM

Watercolour on paper

SERIES/PERIOD/MOVEMENT

Late Venetian watercolour sketches

SIMILAR WORKS

Santa Maria della Salute Thomas Moran

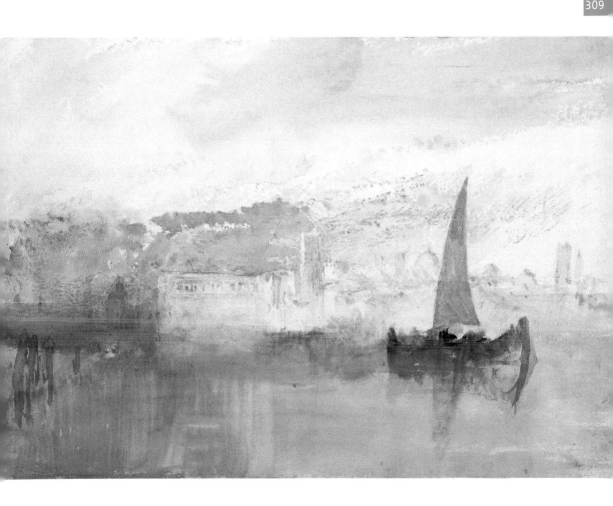

Whistler, James

Grey and Silver: Chelsea Wharf, exhib. 1875

In 1863 Whistler moved to Lindsey Row in Chelsea, not far from Rossetti, and became acquainted with the Pre-Raphaelite circle. By the following year he was working on several canvases of a similar view, that from his balcony across the Thames towards Battersea. Around this time he also started to look towards the tradition of Gainsborough and the techniques of the British Watercolourists, and started to experiment with different glazes and pigments to stain his canvases.

Whistler treated his oil paints much in the manner of watercolours, by greatly thinning them out, and this allowed him to paint much more quickly. He would try and cover a canvas in one sitting and, when this was not possible, would come back to the canvas, rub down the paint surface and paint over it again. *Grey and Silver: Chelsea Wharf* is a good example of Whistler continuing to add layer upon layer of paint, building up the composition and effect with each layer. It has also been suggested that this canvas was worked on over a period of years, during which time he may have changed the initial composition. It is worth noting that Whistler was very particular about his palette, being fastidious in the preparation of his paints and in the arrangement of paints on the palette. To him the palette itself should appear beautiful and harmonious, quite apart from his painting.

PAINTED

London

MEDIUM

Oil on canvas

SERIES/PERIOD/MOVEMENT

Views of the Thames

SIMILAR WORKS

Boats at Anchor Philip Wilson Steer, 1913

A Classic Landscape, Richmond Philip Wilson Steer, 1893

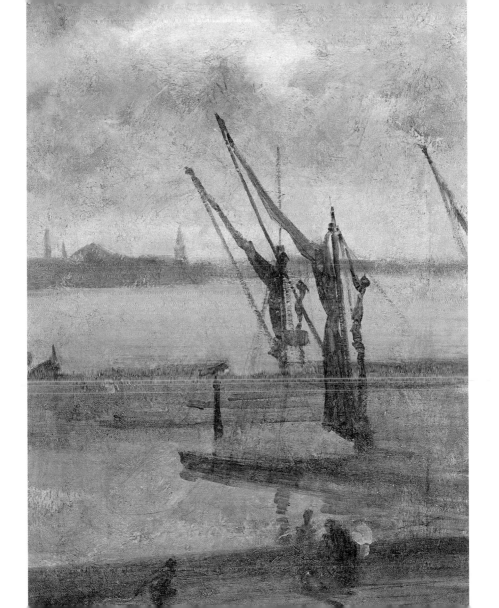

Turner, J.M.W.

Tellhurst Mill, Sussex, c. 1794

At this early stage in his career Turner was still working with Dr Monro, making copies of Old Masters as well as of J. R. Cozens (1752–97) and more contemporary works. He would spend the evenings drawing at Monro's home, often accompanied by Thomas Girtin who went on to become a fine watercolour landscape artist. During the summer of 1794 Turner set out for a sketching tour of the Midlands and then travelled down through North Wales. Around this time he made the sketch of Tellhurst Mill. Water mills were a popular subject matter for Turner during the first part of his career, as were windmills, both becoming redundant in the light of the Industrial Revolution and therefore gaining a romantic, heroic significance.

His sketching technique is a form of expressive shorthand, each line significant to the overall image. His fluid lines were often decorative, purely by the nature of their shape, and were invaluable to him when working in the studio towards an oil painting of the same subject. His earliest known oil painting of a mill is *Watermill and Stream*, c. 1791, and is picturesque and decorative.

PAINTED

Tellhurst, Sussex

MEDIUM

Pencil on paper

SERIES/PERIOD/MOVEMENT

Early sketches

SIMILAR WORKS

Windmill near Cattawade John Constable, 1802

Chalk Church John Constable, 1803

Whistler, James

Early Morning, Battersea, 1861

In 1862 Whistler was earning a living as an illustrator for the periodical *Once A Week*. He was well equipped in this capacity having worked for the US Coast and Geodatic Survey in Washington producing etchings and topographical plans. He had moved to London in 1859 and by 1862 was living with George Du Maurier (1834–96), the cartoonist and illustrator. Immersed in a culture of illustrators and etchers, Whistler set about recording the daily life of the Thames around him. He has since been largely attributed with the etching revival of the 1850s and 1860s.

His etchings of the Thames were developed quite slowly, working on each plate for a period of weeks. The strongly linear nature of these early etchings are interesting in comparison to his later style that moved towards atmospheric effects, quite at odds with his early training. These etchings were in accord with the school of Realism with which Whistler was so taken at the beginning of his career. Through this dry point Whistler can be seen to be experimenting with different lines and marks, to suggest different textures, and has used the strong horizontal composition seen in many Japanese woodcuts.

PAINTED

London

MEDIUM

Dry point

SERIES/PERIOD/MOVEMENT

Thames etchings

SIMILAR WORKS

Battersea Reach Sir Francis Seymour Haden, 1863

Chelsea Reach looking towards Battersea British school

Turner, J.M.W.
From Colour Studies (1) Sketchbook
An Interior with Figures, *c.* 1834

Throughout his long career Turner was hugely prolific, not just in finished works, but in a monumental amount of sketches, some of which are still in their sketchbooks and some of which are on loose sheets of paper. In the Turner Bequest there are over 19,000 works on paper, which provides enormous insight into the working process of the artist. His sketches can roughly be divided into three main categories, sketches done at the location, sketches grappling with compositional arrangement, and sketches experimenting with colour and effect.

Many of the sketches are unfinished, as is this one, and can only hint at Turner's train of thought. This sketch, which combines watercolour and chalk on paper, shows a strong use of colour in the curtain swept to one side and an indicated compositional arrangement with figures. It could have been done at Petworth, the interior colouring and broad brushstrokes are reminiscent of *Music Party, Petworth, c.* 1830–37. Throughout his life Turner would experiment with colour effects and techniques, and the use of chalk and watercolour together is an example of this.

PAINTED

Petworth, Sussex

MEDIUM

Watercolour and chalk on paper

SERIES/PERIOD/MOVEMENT

From Colour Studies Sketchbook

SIMILAR WORKS

After Rembrandt Sir David Wilkie, 1822

COXCI(b) — 5 *5*

Turner, J.M.W.

From Life Class Sketchbook No. 1
Two Sketches of Female Model, *c.* 1832

During his early years at the Royal Academy (RA) Turner drew first from casts and then, in 1792, was admitted to the Life Classes. His early drawings would have been from Classical-type poses and were primarily executed in pencil on paper. Turner was first and foremost a landscape painter and there is certainly a degree of unease through his figure drawings and paintings. He was a notoriously private man and consequently little is known about his personal life. It was a shock to Ruskin, the ultimate of Victorian moral warriors, when cataloguing Turner's work after his death, he discovered a series of life drawings in different sketchbooks that he classified as pornographic. The drawing pictured here is catalogued with the Finberg number CCLXXIX, which would place it in one of the sketchbooks of life drawing that Ruskin actually kept. The rest he burnt. Far from pornographic in any way, the two figures drawn in pencil and with little shading appear to have been executed quickly. The two slightly different poses demonstrate Turner grappling with the best composition. They are outline images with no extraneous details and no clues as to the identity of the model.

PAINTED

London

MEDIUM

Pencil on paper

SERIES/PERIOD/MOVEMENT

Life drawing

SIMILAR WORKS

Academy Study William Mulready, 1842

Whistler, James
Venetian Courtyard: Corte Bollani, 1879–80

Whistler arrived in Venice in 1879 after suffering financial ruin through the Ruskin libel case. He was commissioned to produce 12 etchings by the Fine Art Society, which he did, along with a large number of pastels, etchings and paintings. His views of Venice were often of the bustle of the city itself, steering away from the Romanticism of Turner's views and looking more towards the works of Canaletto and Guardi (1712–92).

Many of his pastels were executed on brown paper that gave an immediate warm ground to work on, not dissimilar to the colours of Venice's mellowed stones. His use of brilliant orange and red here in the Courtyard pastel was seen in most of his pastels done at this time. He uses minimal lines with the maximum effect. The simple white and orange highlights evoke the colour and quality of the brickwork perfectly. He has used a bare linear approach towards the depiction of the buildings, capturing the perspective and again suggesting shape and depth with little to no shading. He contrasted areas of soft blurred colour such as the red on the walls with the clearly defined lines of white that emphasize the texture of the façade.

PAINTED

Venice

MEDIUM

Chalk and pastel on brown paper

SERIES/PERIOD/MOVEMENT

Venice, pastels

SIMILAR WORKS

Street in Venice Jerome Elwell, 1881

Thumbnail Sketches of Whistler's Venice Pastels T. R. Way, 1881

Whistler, James
Count Burckhardt, published 1862

During the late 1850s and 1860s Whistler produced many etchings, often depicting members of his extended family, Deborah Seymour Haden his stepsister, and her daughter Annie. Francis Seymour Haden, with whom Whistler was in close contact on his arrival in London, had an impressive collection of Rembrandt prints that Whistler would have studied in depth. His striking use of *chiaroscuro*, which was a technique he often used in his etchings, was almost certainly indebted to the example of the prints he saw at Haden's London house. Here in *Count Burckhardt*, which is a print taken from an etching, Whistler has used dramatic light effects contrasted with dense areas of textured shade to build up the vivid three-dimensional quality of his subject. For this particular piece he has emphasized the verticality of the arrangement through his extensive use of perpendicular strokes, which plays off against the horizontal in the cross hatching on the wall. The image itself has a dreamy quality, somewhat Pre-Raphaelite in tone, and this is further enhanced by the spatial composition with the figure contemplating the distant view from the window.

PAINTED

London

MEDIUM

Relief print on paper

SERIES/PERIOD/MOVEMENT

Prints from etchings

SIMILAR WORKS

Summer Snow Edward Burne-Jones, 1863

Turner 1775-1851

The Dogano, San Giorgio, Citella, from the Steps of the Europa, exhib. 1842

This oil, which was the first of Turner's works to be exhibited in the National Gallery London, was painted after his last visit to Venice. As was his practice, Turner made extensive watercolour sketches and drawings of Venice while he was there and was then able to work from these back in his studio in London. This painting was based on two watercolours that he painted on his Venetian trip in 1819 and a pencil drawing of the same date. However, this was a view from the hotel Europa that he always stayed in and was therefore very familiar to him As such his compositions were in part based on sketches and in part on memory and artistic licence. This oil painting is extraordinarily delicately painted and he has used much thinner applications of paint than in his other Venetian oils. His technique in this picture is more similar to his watercolour technique of applying broad colour washes. His palette is rich though soft and the colours in the water, which depict the reflecting light, were superbly applied. There is an interesting arrangement at the bottom right of the painting including two vibrantly painted oriental jars and two dogs.

PAINTED

London

MEDIUM

Oil on canvas

SERIES/PERIOD/MOVEMENT

Late Venetian

SIMILAR WORKS

The Grand Canal Venice James Holland, 1835

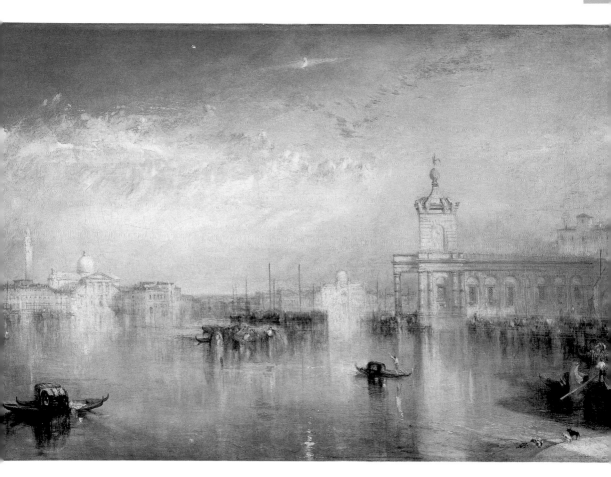

Whistler, James
The Shop Window

Whistler painted a number of shop windows and shop fronts and it seems to be a subject that intrigued him. He depicted his shops in a variety of different mediums, watercolour, pencil, oil, pastel and ink, and from a number of different places that he visited, St Ives, Venice, Amsterdam, London and Paris. It is likely that the abstract quality that the shop front afforded through its squares of glass and colour was the main draw for Whistler in his pictures and this seems to be a quality that he emphasized. In this painting he has used oil paint on a wood panel, the grain of which adds texture and depth to the paint. The paint has been quite thinly applied and the brushstrokes appear to have been dragged across the surface of the panel until dry. This gives the paint a grainy appearance. His palette is fairly restricted and the composition is balanced through a grid of vertical and horizontal accents. The arrangement of the windowpanes and the beams create a visual pattern of their own, offset by the two figures in front of the dark interior.

During the 1890s French artists such as Pierre Bonnard (1867–1947) and Edouard Vuillard (1868–1940) also painted shop fronts and approached their depictions with a similar emphasis on arrangement and pattern to Whistler's.

MEDIUM

Oil on panel

SERIES/PERIOD/MOVEMENT

Shop fronts

SIMILAR WORKS

The Grands Boulevards Pierre Bonnard, c. 1898

Street in Eragny-Sur-Oise Pierre Bonnard, 1893

Monet, Claude

Bathers at La Grenouillère, 1869

Kenneth Clark said, 'The riverside café of La Grenouillère is the birthplace of Impressionism', and Monet's 1869 painting of *The Bathers* would seem to qualify this. Monet and Auguste Renoir (1841–1919) were painting side by side at the swinging holiday town, experimenting with new techniques to depict the effect of light on water more acutely. This painting was done *en plein air* and, as such, Monet developed a rapid method of applying paint to canvas. He would have painted a sketch of the composition on to his canvas at first, providing the linear structure of the picture's arrangement. He creates a curious spatial dynamic, with the depth through the canvas aided by the perspective of the boats and the curve of the river bank The depth of the water is then translated through his use of colour. This picture demonstrates Monet's early experiments with brushstrokes and colour to achieve light on the canvas. His strokes are swift and short, blunt, with a wide colour range to illustrate the surface of the water. He applied complementary colours side by side to add luminosity to the painting and this would be a technique that he would come back time and again. The pattern of brushstrokes here could be described as 'divisionism' a dense pattern of small strokes of colour, a technique that was taken up and expanded by Paul Signac (1863–1935) and Georges Seurat (1859–91).

PAINTED

La Grenouillère

MEDIUM

Oil on canvas

SERIES/PERIOD/MOVEMENT

Impressionist, La Grenouillère

SIMILAR WORKS

La Grenouillère Auguste Renoir, 1869

The Boat Auguste Renoir, 1867

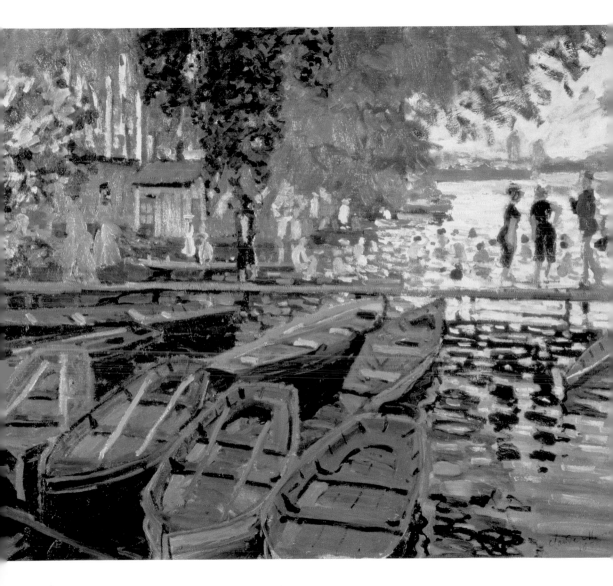

Monet, Claude
Red Boats, Argenteuil, 1875 (detail)

Monet painted the town and surrounding area of Argenteuil through the 1870s and in each instant created pictures of beauty and harmony, which were often at odds with the reality of the moment. Although an adherent of *plein air* painting, Monet chose carefully the elements he wanted to include. There is no hint from his paintings of the filth in the river at Argenteuil, the smell and the sludge or the disarray of a town constructing its industry. In *Red Boats, Argenteuil* he has carefully constructed the composition through the use of the boats, especially in the vertical accents of the masts. Here again he demonstrates his contrasting colours through his blues and orange and reds and greens. The canvas is alive with colour and the depths of the water is illustrated through the purples and blues. The brushstrokes are uniform through the water in their particular choppy style, but the sky is more broadly painted with blurring and merging colours, creating a very definite contrast between the depth of the water and the translucence of the sky.

PAINTED

Argenteuil

MEDIUM

Oil on canvas

SERIES/PERIOD/MOVEMENT

Impressionist, Argenteuil

SIMILAR WORKS

The Seine at Asnieres Auguste Renoir, c. 1879

Port-en-Bessin Paul Signac, 1884

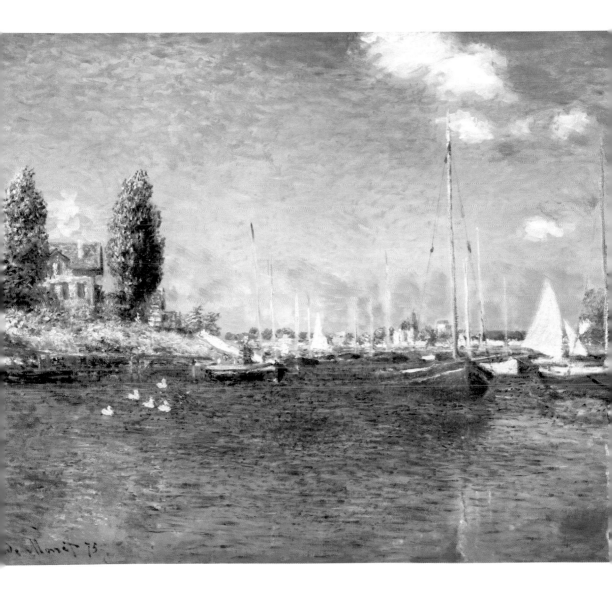

Whistler, James

Nocturne: Black and Gold – The Fire Wheel, 1875 (detail)

This Nocturne painting depicts the nightly fireworks display in Cremorne Gardens, London. The park was on the point of being closed down and was a regular haunt for prostitutes and flamboyant nightlife. Whistler was undoubtedly keenly aware of the mysterious nightly goings on. His Nocturne paintings were outstanding experiments in colour, tone and effect, which Whistler achieved through a number of techniques. He would select the ground for his canvas and then work up from this, using thin layers of paint and applying them almost as glazes. The consistency of his paint has been described as 'sauce', a word that aptly names the liquid oils. He then used a dripping technique of light tones to evoke the fireworks sparking out of the darkness. The crowd of spectators watching the display are suggested with studied brushstrokes and loom as shadows in the dark, mysterious place. The effect of the absorbing dark, lit only by the fire wheel, lends the painting an unearthly, mystical atmosphere – a place where things happened under cover of night. Whistler was fond of the park and was disappointed when it was finally closed down.

PAINTED

London

MEDIUM

Oil on canvas

SERIES/PERIOD/MOVEMENT

Nocturnes

SIMILAR WORKS

5th Avenue Nocturne Frederick Childe Hassam, 1895

Whistler, James

Nocturne: Blue and Gold, St Mark's, Venice, 1880

© National Museum and Gallery of Wales, Cardiff / www.bridgeman.co.uk

Whistler worked in Venice for 14 months from September of 1879 and during that period produced seven or eight oil paintings along with many sketches and drawings. Venice, with its aura of mystery and romance, was the perfect backdrop for Whistler's use of the Nocturne painting. He painted another view of St Mark's Venice, under the same title, but in this he clearly shows the great basilica, complete with scaffolding, due to controversial renovations being carried out. It was quite unusual for Whistler to depict the 'tourist' views of Venice, preferring to show the back streets and inner life of the city.

In the Nocturne pictured here, Whistler has used a simple tonal base with broad colour-wash effects similar to a watercolour style. His use of strong brushstrokes to create the Impressionistic boats jumps away from his soft tonal background, and highlights the effects of a rolling mist, shrouding some areas and leaving others clear. As was his typical technique with his Nocturne paintings, he has again used thin layers of paint, and bright spots of colour to suggest sparkling lights on the horizon.

PAINTED

Venice

MEDIUM

Oil on canvas

SERIES/PERIOD/MOVEMENT

Nocturnes, Venice

SIMILAR WORKS

Whitby – Fishing Boats John Singer Sargent, 1885

Beach at Dusk, St Ives Harbour William Evelyn Osborn, c. 1895

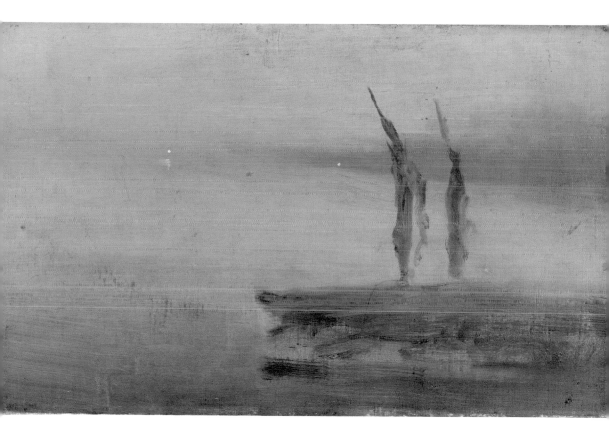

Whistler, James

Rose et Argent: La Jolie Mutine, *c.* 1890

Whistler, who was ever the antagonist and delighted in torturing the press as they had him, published *The Gentle Art of Making Enemies* in 1890. The work, which was a collection of some of the offensive articles that had been written about him and his response to them, was accompanied by the dedication, 'To the rare Few, who, early in Life, have rid Themselves of the Friendship of the Many, these pathetic Papers are inscribed'.

Around this time he painted the ghostly picture *Rose et Argent: La Jolie Mutine*. The figure hovers with no apparent attachment to the ground, a disconcerting effect. He has used a reduced palette, which he always favoured, and used sweeping brushstrokes, especially in the treatment of her flowing black skirts. The single red colour spot on her hat provides the perfect balance to the figure and suggests the influence of the Symbolist painters, as well as adding to the mystery of the painting. Her challenging look is at once both beautiful and frightening.

PAINTED

London

MEDIUM

Oil on canvas

SERIES/PERIOD/MOVEMENT

Late Portraits

SIMILAR WORKS

Madame Paul Poirson John Singer Sargent, 1885

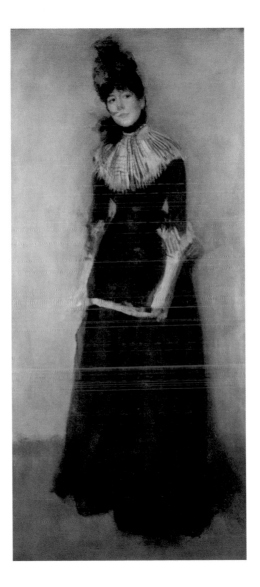

Whistler, James
Brown and Gold, 1895–1900

In the last years of his life Whistler painted a series of self-portraits of an incredibly personal nature that seemed to lay bare the losses and despair that he was suffering. His beloved wife, Beatrice, died in May 1896, which was during the period that he was painting this full-length portrait. The finely painted features of his face depict a man beset with depression and loneliness and are emphasized by being the only element of the painting to receive such detailed attention. The tall figure looms from the background, seemingly part of the dark canvas from which he steps. The highlighting on his left hand, which has been painted with brisk coarse strokes, gives it a life of its own, practically separate from the figure itself, a technique that increases the ghostly nature of the painting.

Whistler had been an admirer of Diego Velásquez (1599–1660) since first seeing an exhibition of some of his paintings at Manchester in 1857. This self-portrait recalls the pose of the Velásquez painting *Pablo de Valladolid* in the Prado.

PAINTED

London

MEDIUM

Oil on canvas

SERIES/PERIOD/MOVEMENT

Self-portraits, late

SIMILAR WORKS

Edwin Booth John Singer Sargent, 1890

Astier Wettheimer John Singer Sargent, 1898

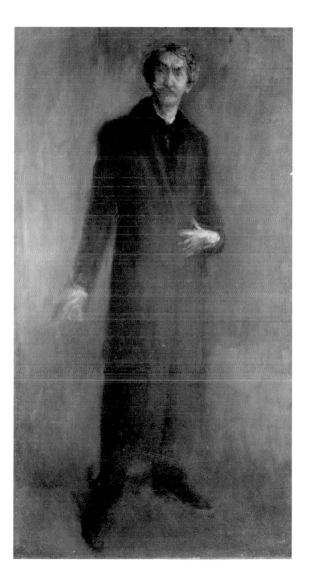

Monet, Claude

Meule, Impressions Roses et Bleues, 1891

© Christie's Images Ltd

Gustave Geffroy (1855–1926), the journalist and biographer of Monet, wrote in 1891, 'for a year the voyager gave up his voyages'. He was referring to a period from 1889 to 1890 when Monet produced virtually no paintings at all. In 1891 Monet started on his Haystacks series of paintings that resulted in 24 canvases, over an intense period of months. As was often the case the artist was deeply troubled by his paintings, feeling unable to create in paint the picture he could visualize. Monet had developed the technique of working on a series of canvases at one time, so that as the sun's position in the sky altered, he could move to the next canvas and continue with his painting. This is a practice that he used again and again with his series paintings.

He had painted the subject of haystacks often through his career but in the paintings of the 1890s the haystacks became the focal point of the picture. He used simple compositional arrangements, paring down the picture elements to the minimal, monumental bulk of the stacks. On these he was then able to record his understanding of light changing through time. His use of colour through these paintings was vibrant until the paintings themselves seem to glow with the radiance of the sun. Here he has applied oranges and reds, set against the blues and purples of the distance. He used a range of different brushstrokes, short dabs and wider sweeps to apply his colour, which was built up thickly.

PAINTED

Giverny

MEDIUM

Oil on canvas

SERIES/PERIOD/MOVEMENT

Haystacks

SIMILAR WORKS

Haystacks at Moret in October Alfred Sisley, 1891

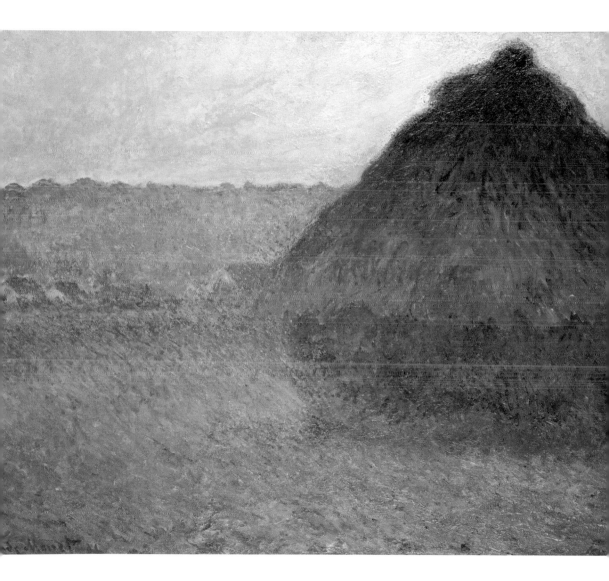

Monet, Claude

Haystacks, Hazy Sunshine, 1891

Monet's Haystack series was apparently begun somewhat by chance. Monet would often recount how one day he was painting a haystack in a field behind his house and the light kept changing, altering the colours and tonality that he could use. He asked Blanche Hoschedé, who was assisting him at the time, to keep bringing him a new canvas and that is how the monumental series first took off.

During the winter months the sunlight had a peculiar quality and radiance, quite different from that during the summer, and Monet embarked on a series of winter effects. The reflection from the white of the snow and frost afforded him a whole new set of light nuances to capture.

In this painting, *Haystacks, Hazy Sunshine*, the topographical realism of the haystack within the landscape is all but gone. There is nothing but the haystack itself and the colour of the light. He has used a heavy cross hatching of short brushstrokes of soft pinks, whites, blues and yellows to build up the overall luminosity of the canvas. The single haystack stands alone surrounded by ethereal light, which lends it an air of magical unearthliness.

PAINTED

Giverny

MEDIUM

Oil on canvas

SERIES/PERIOD/MOVEMENT

Haystacks

SIMILAR WORKS

Landscape at Eragny Camille Pissarro, 1895

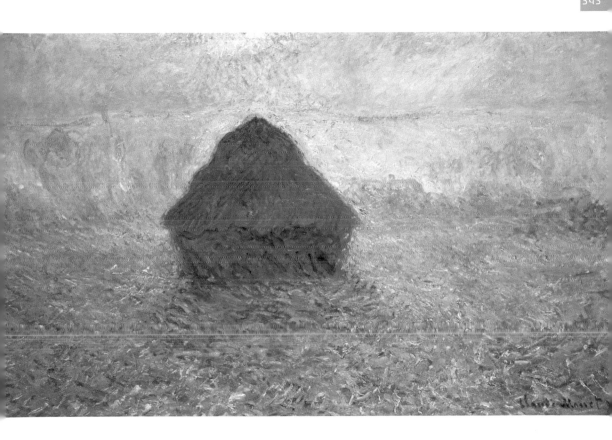

Turner, J.M.W.

Returning from the Ball (St Martha), exhib. 1846

This was one in a series of four paintings that Turner executed to depict four different times of day: morning, noon, sunset and evening. His treatment of light in the paintings is fantastically ethereal, but does not appear to be directly related to the times of day he was trying to emulate. *Returning from the Ball, St Martha* is a companion piece to *Venice, Evening, Going to the Ball;* he painted both subjects twice, once in 1845 and again in 1846, which has led to considerable confusion surrounding which is which. These paintings were largely imaginary compositions of a Romantic, mystical nature. He used a limited colour palette of primarily yellows and reds. Sadly none of the four paintings have survived in very good condition.

In his late oil paintings Turner increasingly adopted his watercolour techniques, building up the surface of his canvas with thin layers of paint. He would invariably use a solid foundation of white and work up layers of glazes to produce the particular luminosity and shimmering effects at which he was so good. Often he would combine this ground with small areas of thick impasto.

PAINTED

London

MEDIUM

Oil on canvas

SERIES/PERIOD/MOVEMENT

Venetian, late period

SIMILAR WORKS

Santa Maria della Salute Thomas Moran, 1908

The Tranquil Lake: Sunset seen through a Ruined Abbey attrib. James Johnson, c. 1825

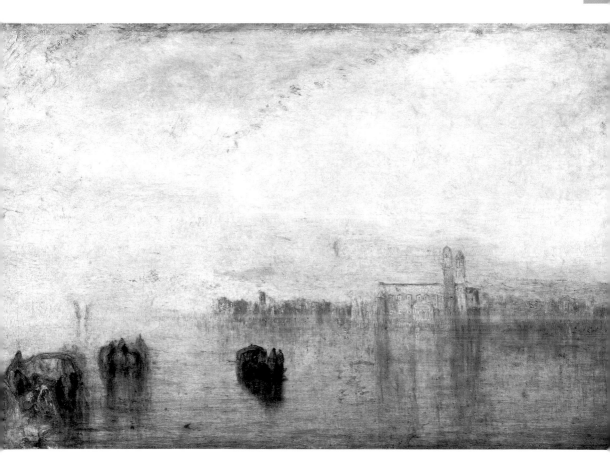

Turner, J.M.W.

Venice: The Piazzetta, with San Marco and its *Campanile*; Night, *c.* 1840

This drawing of watercolour and body colour (gouache) on brown paper is one of a series of sketches that Turner made using a similar approach and methods. There is some debate as to whether or not these drawings were made in 1840 on his last visit to Venice or, in fact, were done on his second trip in 1833.

This drawing demonstrates Turner making use of the brown of his paper to create a dark background, from which he worked up his composition with bright colours. It is interesting to note Turner's choice of paper. He experimented throughout his career with a number of different types of paper and the effect that their surface texture would have on his paintings.

The night-time scene is a lively depiction of the heart of Venice and is slightly reminiscent of the work of Canaletto. His handling is extremely free and quick, suggesting that the drawing was executed on the spot. Turner used a combination of watercolour washes and body colour, using white to highlight and brighten the scene. Turner has used bold contrasts of light and dark here, as the shadows of the night are illuminated by a glow from the right-hand side that adds drama to drawing.

PAINTED

Venice

MEDIUM

Watercolour and body colour on brown paper

SERIES/PERIOD/MOVEMENT

Venetian sketches

SIMILAR WORKS

Canal in Venice Hercules Brabazon

Venice, near Public Gardens George Price Boyce, 1854

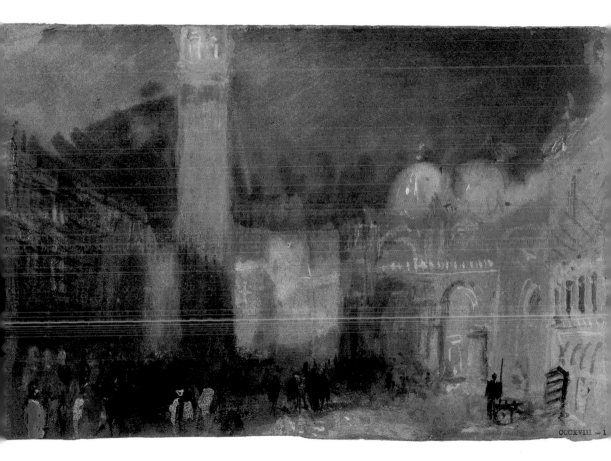

Monet, Claude

Rouen Cathedral, the West Portal, Bright Sunlight, 1894

© Musee d'Orsay, Paris, France/www.bridgeman.co.uk

Monet's approach to the series of paintings he executed of Rouen Cathedral is fascinating on many levels. It was the first time that he used a man-made and rigidly linear structure on which to experiment with his light effects and it was a long way from his fluid Haystacks and natural Poplars. He presented himself with a huge challenge, having been used to an extremely fluid technique of brushstrokes he now had to amalgamate this within the rigidity of a building.

It is interesting to compare Monet's paintings of the West Portal of Rouen Cathedral with the watercolour of *Rouen: The West Front of the Cathedral*, done by Turner in 1832. While Turner shows the whole of the front of the cathedral, both artists show a similar treatment of light playing off the textured surface of the façade.

Here he has used a process of thick strokes of paint, building up the surface of the canvas and introducing white to show the brilliance of the sun reflecting off the mellow stones of the building.

PAINTED

Rouen

MEDIUM

Oil on canvas

SERIES/PERIOD/MOVEMENT

Rouen Cathedral

SIMILAR WORKS

Rouen: The West Front of the Cathedral J. M. W. Turner, 1832

The Church at Moret: Morning Sun Alfred Sisley, 1893

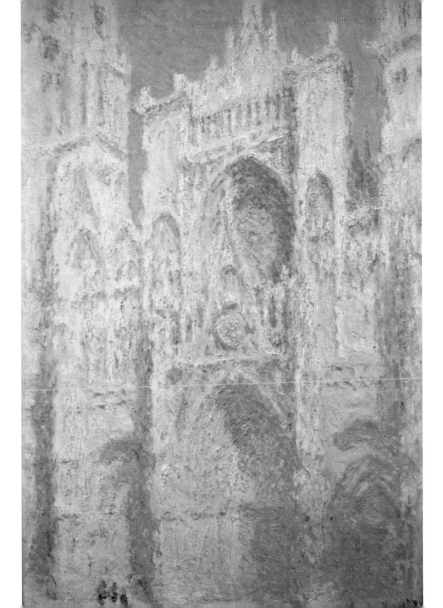

Monet, Claude

Rouen Cathedral, Foggy Weather, 1894

Monet would work on a large number of canvases at one time, a technique that he employed with all of his series paintings. Through correspondence with his wife, Alice, we know that he had up to 14 canvases on which he would work each day in Rouen. He struggled to capture the light as it fell on the building, and complained of it changing so rapidly that he was not able to paint it, 'the sight of my canvases which seemed to me atrocious, the lighting having changed. In short I can't achieve anything good, it's an obdurate encrustation of colours, and that's all, but its not painting ...'.

His use of heavy purple, working up through the canvas to the fog, which is built on paler shades, is truly harmonious and calls to mind Whistler's technique in his Nocturnes, where he used a minimal tonal base and built through it.

PAINTED

Rouen

MEDIUM

Oil on canvas

SERIES/PERIOD/MOVEMENT

Rouen Cathedral

SIMILAR WORKS

Spring Like Morning Emile Schuffenecker, c. 1896

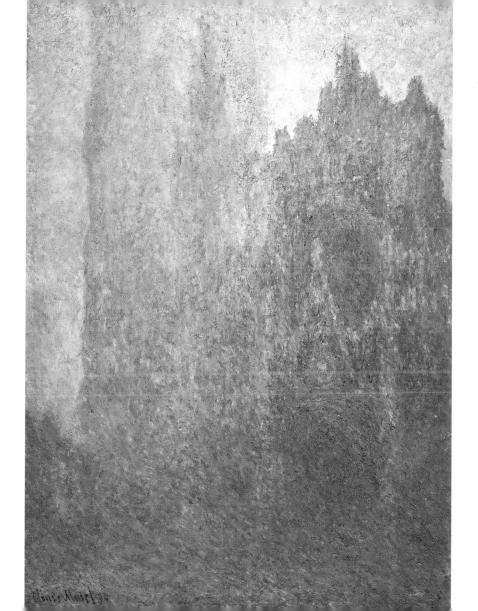

Monet, Claude
Waterloo Bridge

Monet visited London at the end of 1899 in order to paint scenes of mist and fog on the Thames. Returning to an earlier motif was something that Monet had often done and he had first been intrigued with the London fogs on his trip there in 1871. It is characteristic of the artist to produce outstandingly beautiful paintings of subject matter that was in fact tiresome, unpleasant and the product of increasing industrial activity. He stayed for two seasons, producing over one hundred canvases in various states of finish, before returning to Giverny. He went back to London in 1900 and again in 1901, taking many of the canvases that he had meanwhile worked on in the studio with him. The technique of returning both to the motif and to previous canvases was something that Monet developed and had previously used in his Rouen series. As in Rouen, in London he was again beset with problems over the rapidity of the changing light and, after returning again to Giverny, he worked in the studio on the London paintings.

The light piercing through the gloom of the fog shines off the water, with broad strokes of creamy green and pink picking up the tonal base of the picture. The comparison here can again be made with Whistler's Nocturnes, although in this case Monet preferred not to use musical titles.

PAINTED

London, Giverny

MEDIUM

Oil on canvas

SERIES/PERIOD/MOVEMENT

London Series

SIMILAR WORKS

The Bridge at Sèvres Alfred Sisley, 1877

Moret sur Loing Armand Guillaumin, 1902

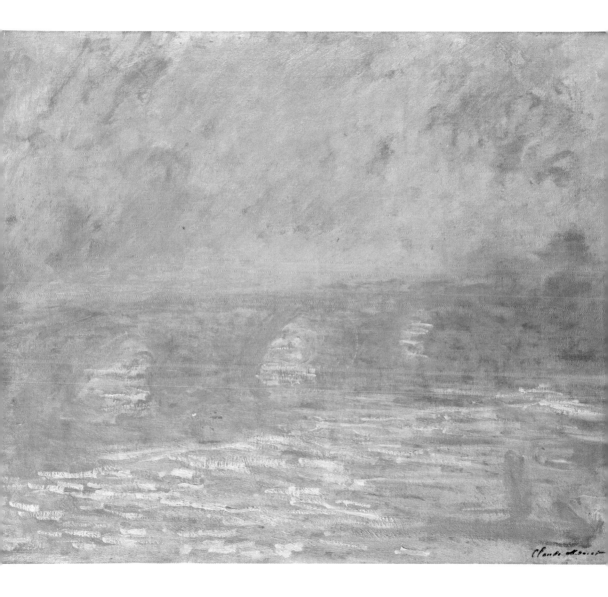

Monet, Claude

Waterloo Bridge, Soleil Voile

'In his desire to paint the most complex effects of light, Monet seems to have attained the extreme limits of art ... He wanted to explore the unexplorable, to express the inexpressible, to build, as the popular expression has it, on the fogs of the Thames! And worse still, he succeeded.' Written by Georges Lecomte for the newspaper *L'Action* following the exhibition of Monet's London paintings in May 1904.

In his London paintings, Monet experimented with two different approaches to the treatment of light. He would either start work on a new canvas immediately, or return to one that had the beginnings of exactly the effect he was witnessing. This process accounts for the vast number of canvases that he started, many of which were never finished. By recording the immediate impression of the atmospheric effect on a canvas, he was able to return to it in the studio and work up the effect he sought. There was an obvious area of tension between the disparity of being an Impressionist painter and yet completing canvases from the studio.

The ghostly picture here is at once both ethereal and magical, while being grounded in the realism of the man-made bridge and chimney stacks. He has used a softer brushwork approach and blurred his paint to produce the foggy atmosphere, from which the bridge rises in illuminated grandeur.

PAINTED

London, Giverny

MEDIUM

Oil on canvas

SERIES/PERIOD/MOVEMENT

London Series

SIMILAR WORKS

Nocturne: Blue and Gold St Marks Venice James Whistler, 1879–80

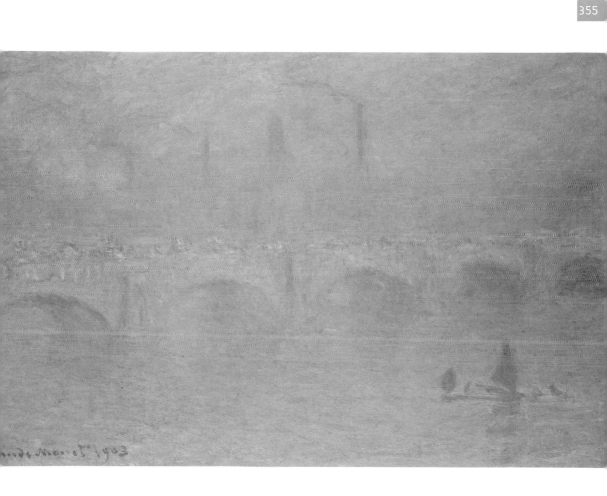

Claude Monet 1903

Turner, J.M.W.

Morning on the Lake of Lucerne; Uri From Brunnen, c. 1842

In 1841 Turner toured Switzerland stopping at Schaffhausen, Constance, Zurich, Splugen Pass and notably Lucerne. He had first visited Lucerne in 1802, at which time he had made a number of sketches, but in his trip of 1840 he produced some of his most stunning watercolours. Lucerne provided the perfect picturesque scenery for Turner and the web of lakes in the surrounding area were, of course, a major source of inspiration for him. He produced a number of studies of the area, from which he later worked for his finished pieces.

Brunnen is a small town on the eastern shore of the Bay of Uri, which is the most southern aspect of the Lake of Lucerne. Turner made many watercolour sketches from this area, such as the one pictured here. In these watercolours he used broad areas of colour wash, with superimposed washes in brighter colours. When working with watercolour he favoured a wet paper to achieve a softer blurring of his colour. The degree of wetness depended on whether or not he was working from a sketchbook, where dry paper was more practical, or from single sheets.

PAINTED

Brunnen

MEDIUM

Watercolour and gouache on paper

SERIES/PERIOD/MOVEMENT

Swiss tour 1840s

SIMILAR WORKS

Meillerie, View on a Lake Rev. William Henry Barnard, 1815

Lycia, TheValley of Glaucas William James Müller, 1843

Turner, J.M.W.

Lake of Lucerne; The Bay of Uri, From Brunnen, c. 1841—42

These watercolour sketches done in the last decades of Turner's life are the sum of a lifetime's study of the 'art' of watercolour. Turner experimented throughout his life with different techniques, different types of paper, both handmade and manufactured, different paints, pigments and application processes. No one understood paint and the technical aspects of painting better than Turner.

The delicacy with which these Lucerne watercolours have been executed is quite remarkable. He has used broad colour washes here, but has worked this piece up to a higher degree of finish than many of his sketches. The way in which the small boats and activity in the foreground have been handled with fine lines and crosshatching, contrasts with the broadness of the paint handling in the background. The luminosity and gentle glow of light on the water is aided by the background paper that shines through the paint.

PAINTED

Brunnen

MEDIUM

Watercolour on paper

SERIES/PERIOD/MOVEMENT

Swiss tour 1840s

SIMILAR WORKS

Flueten on the Lake of Lucerne J. R. Cozens

Toward the Head of Lake Como Francis Towne, 1781

CCCLXIV – 342

Turner, J.M.W.

Lake of Lucerne; The Bay of Uri from above Brunnen, sample study, *c.* 1841–42

The little town of Brunnen, from where Turner made so many watercolour sketches, offered incredible views across the lake towards the twin peaks of the Mythen. The lake itself provided Turner with a large expanse of still water that contributed to the tranquil Romantic nature of the sketches and also afforded him a mirror-like surface to reflect light. These sketches of this lake, although unfinished, still create an extraordinary atmosphere simply through his use and handling of the fluid medium of watercolour. These sketches, and this one in particular, shows Turner working out his composition and arrangement and recording the scene, in order to work up his oil from the studio at a later date. He also produced several finished watercolours including, *Bay of Uri from above Brunnen*, that would again have referred to his sketches.

Turner used a process called 'scratching-out' in his watercolours, which was a method of introducing highlights when working on light-coloured paper. He would literally scratch out a fine line with a sharp tool to emphasize light bouncing off an object, a technique that he used very effectively.

PAINTED

Brunnen

MEDIUM

Watercolour and gouache on paper

SERIES/PERIOD/MOVEMENT

Swiss tour 1840s

SIMILAR WORKS

Harlech Castle Wales David Cox

Turner, J.M.W.

The Bay of Uri on Lake Lucerne, from Brunnen, c. 1841–42

This scene, from a slightly different angle, has been constructed with pencil lines as well as the watercolour washes and gouache accents. It was not unusual for Turner to use a number of different mediums such as this in his sketches and he often combined watercolours with gouache, sometimes referred to as body colour. Gouache is basically an opaque watercolour containing a white base. This gives a chalky look and creates more depth through the colour. The combination of gouache and watercolour is extremely successful, the one complementing the other.

His use of the boats, here in the foreground, again contrasts with the hazy mountains, which are so soft in application that they appear to merge seamlessly into the sky. The English landscape painter Joseph Farington(1747–1821) wrote about Turner's watercolour techniques, 'Turner has no settled process but drives the colours about till he has expressed the ideas in his mind.'. This very succinctly sums up Turner's method, which continually evolved through his life as he found new ways of expression through his paint.

PAINTED

Brunnen

MEDIUM

Watercolour, pencil and gouache on paper

SERIES/PERIOD/MOVEMENT

Swiss tour 1840s

SIMILAR WORKS

View from Isola Borromea, Lago Maggiore J. R. Cozens, c. 1783

Estuary Thomas Girtin, 1797

Whistler, James
The Limeburner, 1859

Not long after moving to London from Paris in 1859, Whistler started on a series of etches depicting the busy life along the Thames. These early etchings are interesting to compare to his later style, because at this time he was still under the influence of the Realists and this approach is very evident in these etches.

The Limeburner is a vividly recalled scene in minute detail and has tremendous transgression from the foreground through to the background of the Thames. The spatial arrangement is complex, but brilliantly done. The composition is highly vertical and Whistler has primarily used thin parallel vertical lines throughout, with the exception of the heavy crossbeams. He often included figures of men working or going about their daily business in these early etches, but this figure is actually known, W. Jones, the limeburner, which makes it more personal. Limeburners did well at this time, as lime was in great demand, for building and for obscuring the smell of the Thames, which at that time was rancid. Lime would be delivered along the Thames in large barges and would then be burned before it could be used by builders.

PAINTED

London

MEDIUM

Etching printed on tissue thin japan with pale mat staining

SERIES/PERIOD/MOVEMENT

Sixteen Etchings of the Scenes on the Thames and Other Subjects

SIMILAR WORKS

Fifty three Stages along the Tokaido Highway Hiroshige

Series of Scenes of Paris Charles Meryon

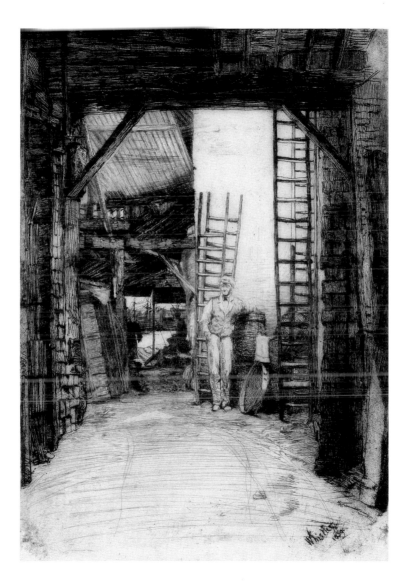

Whistler, James
Nocturne: Palaces, 1879–80

Whistler started his career primarily as an etcher and an illustrator and would continue to return to this medium. It is interesting to consider his appreciation for this very detailed and linear form of art, in view of his atmospheric and Impressionistic works, the two seemingly at odds with each other. However, Whistler had a huge appetite for decoration and the decorative content of his work. Within this context his etchings afforded him the opportunity to play with the decorative line, which he does whilst maintaining a truth to nature. It is testament to his incredible eye that he could see decorative features in the most mundane places.

Palaces is one of his etchings that merges the divide between atmospheric and decorative linear composition. Using etching and dry point, and printed on to antique laid paper, which has a mess pattern impressed upon it, this print evokes a ghostly atmosphere, where the seam between buildings and water and reflection runs into one another. He has used a series of vertical lines to accentuate the height of the buildings carrying on through their reflection, and then contrasts this with dense crosshatching to build up form and shadow. The highlighted buildings appear to float out of the shadowy dark behind them, an approach not dissimilar to the one he used in his London Nocturnes.

PAINTED

Venice

MEDIUM

Etching and dry point on antique laid paper

SERIES/PERIOD/MOVEMENT

Venice etchings

SIMILAR WORKS

Venetian Night James McBey, 1925

Back Canal Mortiper Menpes

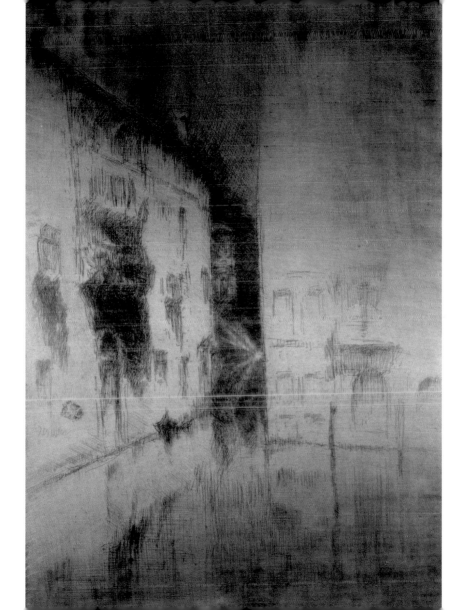

Whistler, James
Nocturne, 1879–80

Whistler etched on copper plates with an etching needle and would carry these with him when walking through Venice so that he was able to etch on site. Both this *Nocturne* and the *Nocturne; Palaces* were unusual in Whistler's approach due to his system of inking and wiping the plate that turned each impression into a virtual monochrome. He has etched his composition of boat and skyline using primarily vertical lines. Then, by wiping his plate with ink, and further shading the ink from the darker outside edge towards a lighter centre, he has created extraordinary effects of light. He also experimented with the acid used for his etching, in order to create variations in the deepness of his line. This in turn affects the shading and texture of the final impression.

After each impression was taken from his plate, he would invariably make small changes to it. Similarly, with each impression he would alter his ink and so create different effects of weather and light.

PAINTED

Venice

MEDIUM

Etching and dry point on paper

SERIES/PERIOD/MOVEMENT

Venice etchings

SIMILAR WORKS

A Rainy Night Venice Otto Bacher, 1880

Grand Canal from the Salute, Venice Otto Bacher, c. 1880

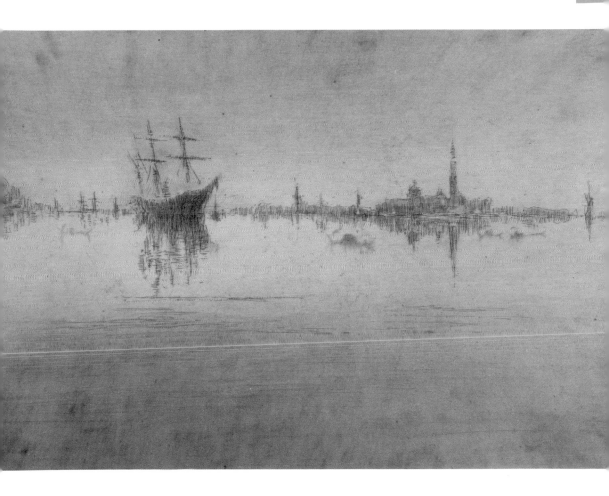

Monet, Claude

Rouen Cathedral Façade and Tour d'Albane, Morning Effect, 1894

There must have been a certain symbolic significance in Monet's choice of Rouen Cathedral as his subject. This was a time in France when there was a spiritual revival in the country and people were again looking to the Church for guidance. Monet himself was not religious and in his paintings of the cathedral he has obscured pertinently Christian elements. He has also taken the cathedral as his motif and divested it of any human element in all but one of the pictures, which effectively reduces it back to one of his studies, as opposed to giving the paintings any greater meaning.

Here Monet has used a palette of blue and pinks. He first built up the image of the cathedral façade with thick layers of paint, primarily blue, the exact colour of deep morning shadows. He has concentrated the pinks from behind the buildings on the left of the canvas to suggest the sun slowly rising up from behind the cathedral. The Albane Tower, bathed in a shimmer of iridescent light, takes on an ethereal magical appearance, not at odds with its religious symbolism.

PAINTED

Rouen

MEDIUM & DIMENSIONS

Oil on canvas, 106.1 × 73.9 cm (42³/₄ × 29¹/₈ inches)

SERIES/PERIOD/MOVEMENT

Rouen Cathedral

SIMILAR WORKS

The Church at Moret, Rainy Weather, Morning Alfred Sisley, 1893

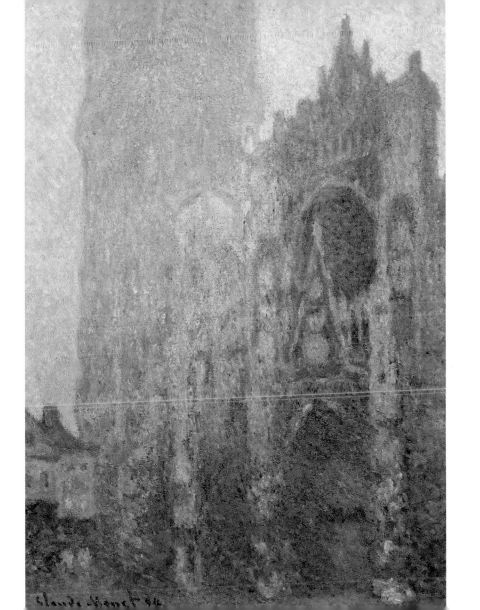

Monet, Claude

La Cathedrale de Rouen, Effet D'Apres-Midi (Le Portail, Plein Soleil), 1892–94

Monet was his own harshest critic and, when viewing the beauty and eminently positive aspect of his paintings, it is hard to imagine the difficulty he went through to achieve them. He worked on the Rouen series in his studio before exhibiting the pictures, adding strokes of colour and building up the surface of each canvas until it all but became three-dimensional.

His canvases went on exhibition in 1895 at which point Monet explained, during an interview, that he wanted to paint the atmosphere that lay in between him and the object, rather than the object itself.

This depiction of the cathedral is full of the brilliance of strong sunlight, which has bleached out colour completely and is almost the opposite of many of his other Rouen paintings. His palette is nearly all cream and yellow, with a complementing blue sky just showing through above the façade. His painting comes in and out of focus, blurred and soft at the left top and detailed towards the right. This would be how the eye would interpret the image with bright sun falling from the left.

PAINTED

Rouen

MEDIUM

Oil on canvas

SERIES/PERIOD/MOVEMENT

Rouen Cathedral

SIMILAR WORKS

The Church at Moret, Afternoon Alfred Sisley, 1893

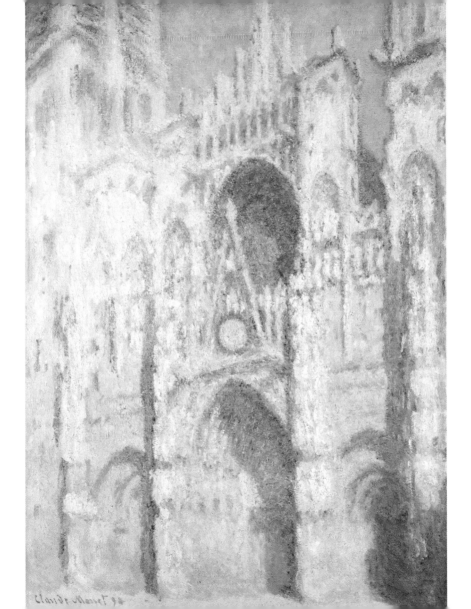

Monet, Claude

Rouen Cathedral in the Setting Sun, 1892–94

Edgar Degas (1834–1917) famously recounted how one day he saw Monet arrive by carriage at Varengeville to paint. Monet got out, looked at the sky and declared he was half an hour too late and that he would have to come back the next day. Such was Monet's absolute dedication to the exact depiction of the moment of light as he saw it.

The setting sun has bathed the cathedral in rose and hues of blue and purple, a harmonious combination that immediately draws to mind Whistler. Monet again has the curious zooming in and out of focus, a technique that would be seen on many of his Rouen paintings. He has used thick applications of paint and particularly used a circular formation of brushstrokes to emphasize the cavities of the porch, the dark rose at their centre jumping forward from the surround. He has used thick blue/white areas to highlight the key architectural features and to suggest light bouncing off the pale stones.

PAINTED

Rouen

MEDIUM

Oil on canvas

SERIES/PERIOD/MOVEMENT

Rouen Cathedral

SIMILAR WORKS

The Church at Moret: Evening Alfred Sisley, 1894

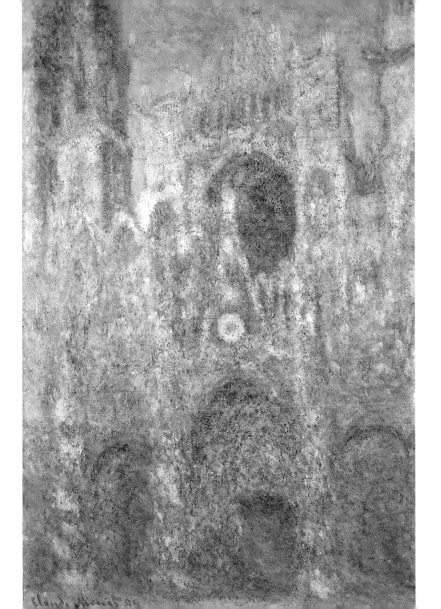

Monet, Claude

Rouen Cathedral, Effects of Sunlight, Sunset, 1894

In *Effects of Sunlight* Monet has used a slightly different approach with a much stronger use of browns and dark tones for key architectural features. This is to emphasize the shadows that the bright sun has thrown, but is less harmonious in overall effect. His brushstrokes here are more pronounced and rapid, with less blending together. The deep purple shadow on the bottom third of the façade is offset by the sky, painted with the same tonal range. This makes the top two thirds of the cathedral stand out in highlighted brilliant sun. The painting title does not imply an afternoon timescale, but the colouring and effect does, especially in the evocativeness of the lengthening shadows on the front.

His use of brilliant colour harmonies were obviously not from nature, but were an abstraction built upon the decorative nature of the series. This use of vibrant colour would again be seen in his later paintings of the Japanese bridge in his garden, where the colours are fiery, jewel-like and rich.

PAINTED

Rouen

MEDIUM

Oil on canvas

SERIES/PERIOD/MOVEMENT

Rouen Cathedral

SIMILAR WORKS

The Church at Moret after Rain Alfred Sisley, 1894

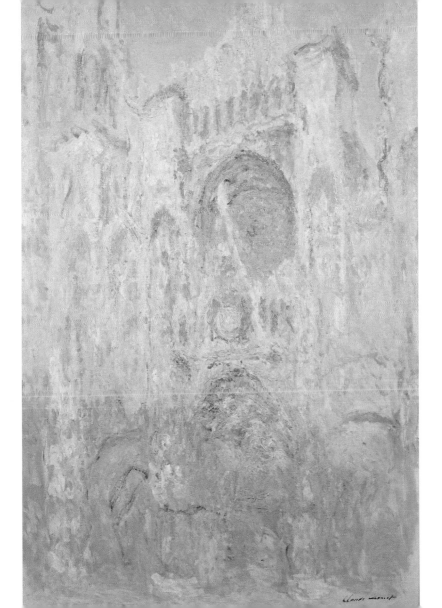

Author Biographies

Tamsin Pickeral (author)

Tamsin Pickeral has studied Art and History of Art since she was child, and lived for some time in Italy furthering her appreciation of the subject. She has travelled extensively through her life, and has recently returned to the UK after nine years spent living an unusual life on a cattle ranch in the US. 'Life was never dull,' the author said, 'between writing books, studying art, chasing cows, training horses and keeping tabs on my husband.' She now resides in Norfolk, with her cowboy, where she continues to write about art and horses, two of her favourite topics.

Michael Robinson (Foreword)

Michael Robinson is a freelance lecturer and writer on British Art and Design history. Originally an art dealer with his own provincial gallery in Sussex, he entered academic life by way of a career change, having gained a first class honours and Masters degree at Kingston University. He is currently working on his doctorate, a study of early modernist period British dealers. He continues to lecture on British and French art of the Modern period.

Picture Credits: Prelims and Introductory Matter

Pages 1 & 3: J. M. W. Turner, The Sun of Venice Going to Sea, © Tate, London 2005.

Page 4: Claude Monet, Promenade Near Argenteuil, © Musee Marmottan, Paris, France, Giraudon/Bridgeman Art Library/www.bridgeman.co.uk

Page 5 (l to r top): J. M. W. Turner, The Angel Standing in the Sun, © Tate, London 2005; James Whistler, The Storm – Sunset, © Fogg Art Museum, Harvard University Art Museums, USA, Bequest of Grenville L. Winthrop/www.bridgeman.co.uk; Claude Monet, Impression: Sunrise, Le Havre, © Musee Marmottan, Paris, France, Giraudon/Bridgeman Art Library/www.bridgeman.co.uk

Page 5 (l to r bottom): J. M. W. Turner, Petworth House: Figures In The White Library, Possibly Lord Egremont, © Tate, London 2005; James Whistler, Arrangement In Grey And Black No. 1: Portrait Of The Artist's Mother, © Musee d'Orsay, Paris, France, Giraudon/Bridgeman Art Library/www.bridgeman.co.uk;; Claude Monet, The Dinner, © Buhrle Collection, Zurich, Switzerland/www.bridgeman.co.uk

Page 6 (l to r top): J. M. W. Turner, Venice: San Giorgio Maggiore at Sunset, from the Hotel Europa, © Tate, London 2005; James Whistler, Nocturne in Blue and Silver: The Lagoon, Venice, © 2005 Museum of Fine Arts, Boston, Massachusetts, USA, Emily L. Ainsley Fund. All Rights Reserved. / www.bridgeman.co.uk; Claude Monet, San Giorgio Maggiore, Venice, © Private Collection, Phillips Fine Art Auctioneers, New York, USA/www.bridgeman.co.uk

Page 6 (l to r bottom): J. M. W. Turner, The Scarlet Sunset, © Tate, London 2005; James Whistler, Nocturne: Blue and Silver – Cremorne Lights, © Tate, London 2005; Claude Monet, Sunset, © Private Collection, Peter Willi/www.bridgeman.co.uk

Page 7: J. M. W. Turner, Returning from the Ball (St Martha), © Tate, London 2005; James Whistler, Nocturne: Blue and Gold, St Mark's, Venice, © National Museum and Gallery of Wales, Cardiff/www.bridgeman.co.uk; Claude Monet, Rouen Cathedral, Effects of Sunlight, Sunset, © Musee Marmottan, Paris, France, Giraudon/Bridgeman Art Library/www.bridgeman.co.uk

Further Reading

Baron, W. and Shone, R., *Walter Sickert*, Yale University Press, 1992

Bataille, G., *Manet*, Skira, 1994

Blunden, M and G, *Impressionists and Impressionism*, Rizzoli International Books, 1980

Butlin, M. and Joll, E., et al, *Paintings of J. M. W. Turner*, Yale University Press, 1987

Denker, E., *Whistler and his Circle in Venice*, Merrell Publishers, 2003

Dorment, R. and Macdonald, M. F., *James McNeill Whistler*, Tate Publishing, 1994

Dunstan, B., *Painting Methods of the Impressionists*, Watson-Guptill Publications, 1992

Gaunt, W., *Turner*, Phaidon Press, 1992

Hamilton, J., *Turner and the Scientists*, Tate Publishing, 1998

Hayes Tucker, P., Shackelford, G T. M., et al, *Monet in the 20th Century*, Royal Academy, 1998

Hermann, L., *Turner Prints: The Engraved Work of J. M. W. Turner*, Phaidon Press, 1994

Hillier, J., *Hokusai*, Phaidon Press, 1978

Holmes, C., *Monet at Giverny*, Weidenfeld Nicholson Illustrated, 2001

House, J., *Monet*, Phaidon Press, 1981

Katz, R. and Dars, C., *The Impressionists in Context*, Crescent Books, 1991

Levy, M., *A Concise History of Painting: From Giotto to Cézanne*, W. W. Norton & Co. Ltd, 1977

Macdonald, M. F., Galassi, Susan Grace, et al, *Whistler, Women and Fashion*, Yale University Press, 2003

Macdonald, M. F., *Palaces in the Night: Whistler in Venice*, University of California Press, 2001

Macmillan, D., *Scottish Art 1460–1990*, Mainstream Publishing, 1996

McConkey, K., *British Impressionism*, Phaidon Press, 1989

Moffett, C. S., Rathbone, E. E., et al, *Impressionists in Winter*, Philip Wilson Publishers, 2001

Perkins, D., *Turner: The Third Decade*, Tate Publishing, 1990

Powell, C., *Italy in the Age of Turner: The Garden of the World*, Merrell Publishers, 1998

Reynolds, G., *Turner*, Thames & Hudson, 1969

Rodner, W. S., *J. M. W. Turner: Romantic Painter of the Industrial Revolution*, University of California Press, 1998

Rosenblum, R., Stevens, M., et al, *1900 Art at the Crossroads*, Royal Academy of Arts, 2000

Rosenthal, M., *Constable the Painter and his Landscape*, Yale University Press, 1986

Scott, R., *Artists at Walberswick*, Tate Publishing, 1994

Shone, R., *Sisley*, Phaidon Press, 1994

Smith, G., *Thomas Girtin: The Art of Watercolour*, Tate Publishing, 2002

Spalding, F., *Whistler*, Phaidon Press, 1994

Spate, V., *Claude Monet: The Colour of Time*, Thames & Hudson, 2001

Spencer, R., *Whistler Retrospective*, Hugh Lauter Levin Associates, 1995

Stainton, L., *Turner's Venice*, British Museum Press, 1990

Stevens, M., *Alfred Sisley*, Yale University Press, 1992

Sutton, D., *James McNeill Whistler: Paintings, Etchings, Pastels & Watercolours*, Phaidon Press, 1966

Swinglehurst, E., *The Life and Works of Monet*, Parragon Publishing, 2000

Taillandier, Y., *Monet*, Bonfini Press, 1995

Walker, J., *Turner*, Thames & Hudson, 1989

Whitfield, S. and Elderfield, J., *Bonnard*, Tate Publishing, 1998

Wilkinson, G., *Early Sketchbooks, 1789–1802 (Turner)*, Barrie & Jenkins, 1972

Wilson-Bareau, J., *Manet by Himself*, Little, Brown, 2004

Wilton, A. and Lyles, A., *The Great Age of British Watercolours, 1750–1850*, Prestel Publishing Ltd, 1997

Index by Work

General Index